Treasures of
The Powerhouse Museum

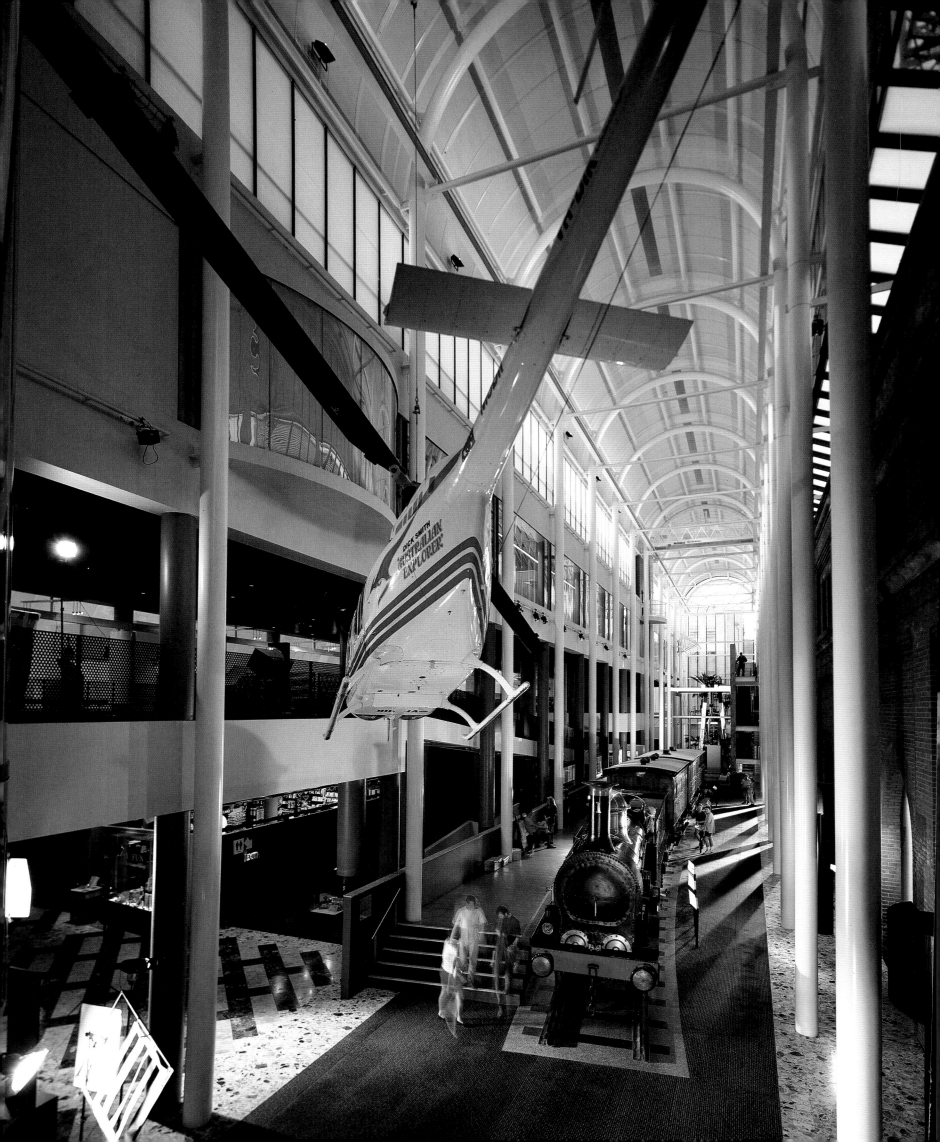

Treasures of
The Powerhouse Museum

Terence Measham

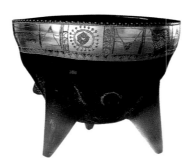

Powerhouse Publishing Sydney

Produced by Lou Klepac
and The Beagle Press for
The Powerhouse Museum
Designed by Catherine Martin
Text editor Bruce Semler
Printed by Toppan, Singapore

First published 1994
by Powerhouse Publishing, part of the Museum
of Applied Arts and Sciences
PO Box K346 Haymarket NSW 2000 Australia

Cover:
Computer generated image by Icarus Klepac

Endpaper:
*Mountbatten Brailler, the Australian
designed and manufactured braille equivalent
of a portable electric typewriter with memory
(detail).* Photograph by Jane Townsend

Frontispiece:
*Interior of museum with the Bell 206B
JetRanger III helicopter, Australian explorer,
flown by Dick Smith in the first solo
circumnavigation of the world in 1982–1985.*
Photograph by Jon Love

➤ *The Powerhouse Museum*
Photograph by Andrew Frolows

Minister's Message

*S*ydney's Powerhouse Museum is unique among museums of the world in its blend of history, heritage and high-tech excitement. Where else would we find, side by side, engines, aeroplanes, machinery, computers, musical instruments, exquisite jewellery, costumes and artefacts of all kinds in one of Australia's most thrilling environments?

It is certainly the largest museum of any kind in Australia, comparable to the Deutsches Museum in Munich and with equal display space to the National Air and Space Museum in Washington.

The only other museum with anything like its varied collection is the National Museum of American History. But its collections relate only to American artefacts; the Powerhouse Museum celebrates the applied arts and sciences of Australia and the world as a whole.

This book offers a glimpse of the Powerhouse's treasures. It is intended as a showcase for an institution founded on the belief that a society's culture embraces not only books, paintings or theatre, but its science, technology and industry.

The photographs, taken mainly by the Powerhouse's own photographers, present objects of varied sizes, ages, contexts, functions and materials. They do justice to the absorbing text by Terence Measham, under whose guidance (as director of the museum since 1988) many of the objects depicted in this book have been acquired.

Above all the book is a tribute to the spirit and industry of craftspeople, inventors and designers in Australia and around the world – to the creative genius of people everywhere.

Peter Collins QC, MP Minister for the Arts

Foreword

*m*useums may be interesting for their architecture and their modes of display – as the Powerhouse certainly is – but it is the objects in their collections that are the core of the visitor's experience and the professional standing of the museum.

This book highlights a selection of the many 'treasures' in the Powerhouse Museum collection and offers a glimpse into its immense diversity.

While some of the objects illustrated and discussed here have been in the collection for almost a century, a remarkably high proportion are recent acquisitions. This is a direct reflection of vigorous collection building in recent years, especially since the museum –

now over a century old as an institution – re-opened as the Powerhouse in 1988. The early 1990s, in particular, have seen the museum assert itself as a significant player on the Australian and international auction scene. In an institution which does not have the resources of a Getty Museum or a Metropolitan Museum, this demands careful targeting, based on sound curatorial connoisseurship and effective direction, in a framework created by coherent policy.

A key element of the museum's philosophy is that the collection is regarded as just that: *'the collection'*, one huge diverse collection. This is in contrast to a number of older institutions which think and manage in terms of separate specialist collections loosely gathered under one institutional umbrella. Stories are rife in the museum world of rigid territorial boundaries between collection fields and their curators. Such demarcation is unthinkable in the Powerhouse, where management and development of the collection is run on an integrated and interdisciplinary basis.

The centralised collection development system means that Terence Measham not only formally approves every acquisition – large or small – but becomes actively involved in major acquisitions. In the case of expensive acquisitions which require advance endorsement by the Trust, he inevitably also has an advocacy role.

This may perhaps explain, in part at least, the director's enthusiasm as evidenced in the following pages, his extensive knowledge of the objects and his unique perspective on their inter-relationships.

The text that follows presents Terence Measham's personal view. This individualised insight into an extraordinary collection is distinguished by its author's breadth of interest and the connections he sees between items which many museums might have kept well apart, both physically and conceptually.

Ken Brimaud President, Board of Trustees

Preface

*O*ver the last few years, the Powerhouse Museum, a New South Wales government museum, has pursued an active publishing policy. Many exhibition booklets, catalogue essays, research reports etc. have been issued and there are many more in the pipeline. Besides all these, in a period of three years we have produced four substantial books, but all of these publications have covered only single aspects of the collection. There is a book on decorative arts, one on 1950s design and another on Australian products, and, most recently, we published a book on the technology of space exploration. An elaborate CD ROM package is in advanced development and more books are planned.

Everyone connected with the museum is proud of our publishing record, but there has remained an urgent need for a book which might give the public some idea of the most important characteristic of the Powerhouse Museum – the breadth and diversity of the collection, which is unrivalled anywhere else in the world.

I have attempted to meet this challenge, yet no single book of this size could hope to discuss comprehensively so large and complex a topic. So I have made choices. I have excluded some of our more illustrious possessions if they have been published many times before. The Hope furniture, currently on loan to the Louvre and on exhibition in Paris, is a notable omission. Another is the Macquarie chair, despite the fact that I rate it as one of the half-dozen most important objects in the museum's collection.

My preference here has been to give more space to things the museum has acquired in the last five or six years. If such a topical approach means that we shall need another book sooner rather than later, so be it!

So the present book cannot be definitive. It has been written while continuing with my role as chief executive officer of the museum. I have had considerable help. I am grateful to the Board of Trustees, who gave me instant approval when I proposed the book to them. The acquisitions presented here owe their presence to Trustee decision-making which is, without exception, serious and deeply considered. It is also free. Our Trustees, past and present, contribute a wealth of wisdom for the benefit of the museum, all without recompense. They are a joy to work with!

My curatorial colleagues too have put their extraordinary, often encyclopaedic, knowledge at my disposal. I am grateful for their comments but accept all responsibility for what is printed.

Nothing would have been written without Irma Havlicek, who has project-managed the book and carried out liaison with all museum departments involved, such as Registration, Conservation, Library, Photography and Curatorial. In a complex organisation with several major programs on the boil, her powers of tact, diplomacy, and her natural friendliness were great assets.

My debt to Christine Lewis, my executive officer, for ensuring that museum business continued in an orderly fashion, is immeasurable. I am grateful to Jennifer Sanders and Michael Landsbergen, our two divisional Assistant Directors, for the same reason. Marie Geissler and David Dolan already know how much I have benefited from conversations with each of them over several years.

Finally, it has been a pleasure to work with Lou Klepac of The Beagle Press, an old friend whose company is always stimulating; and Bruce Semler, the book's editor, also an old associate from Canberra days.

Terence Measham Director

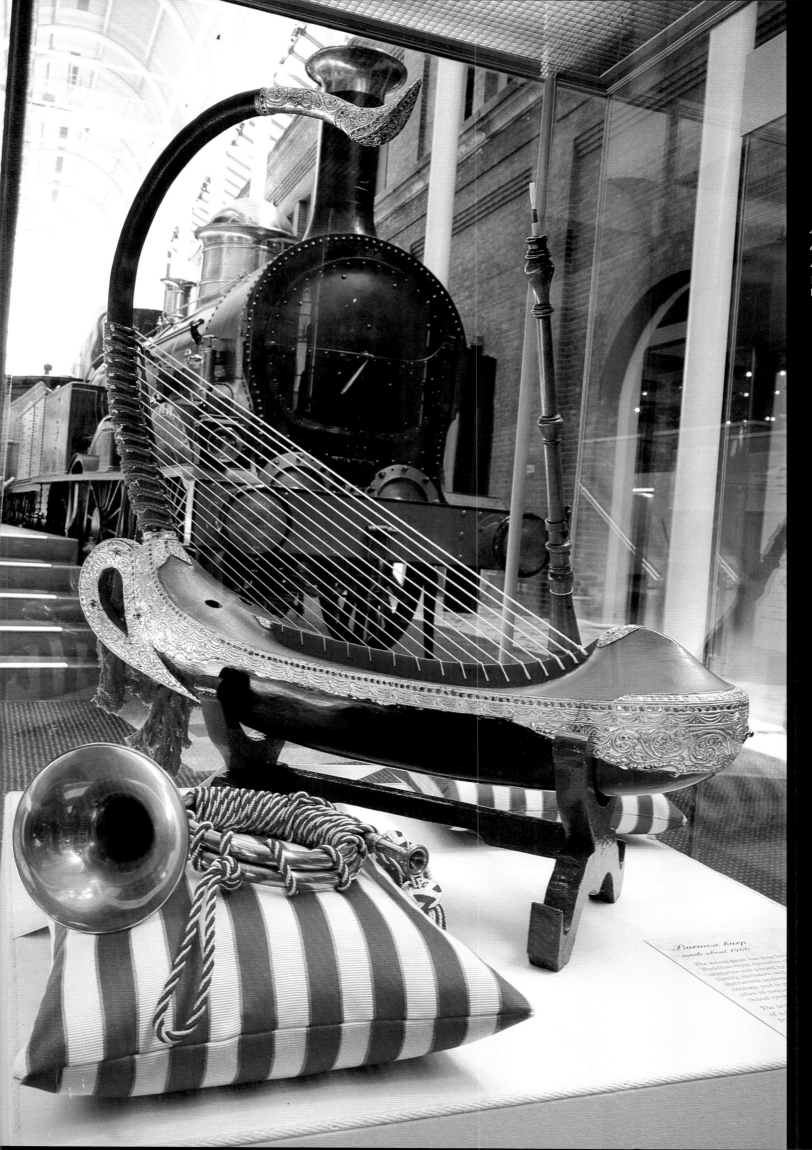

Musical instruments on display in front of Locomotive No. 1.
Photograph by Penelope Clay

Burmese harp
made about 1960

The saung-gauk has been used in Buddhist royal ceremonies for centuries and is played by family members and instrument makers of the century, who...

The un... of a...

The Powerhouse Experience

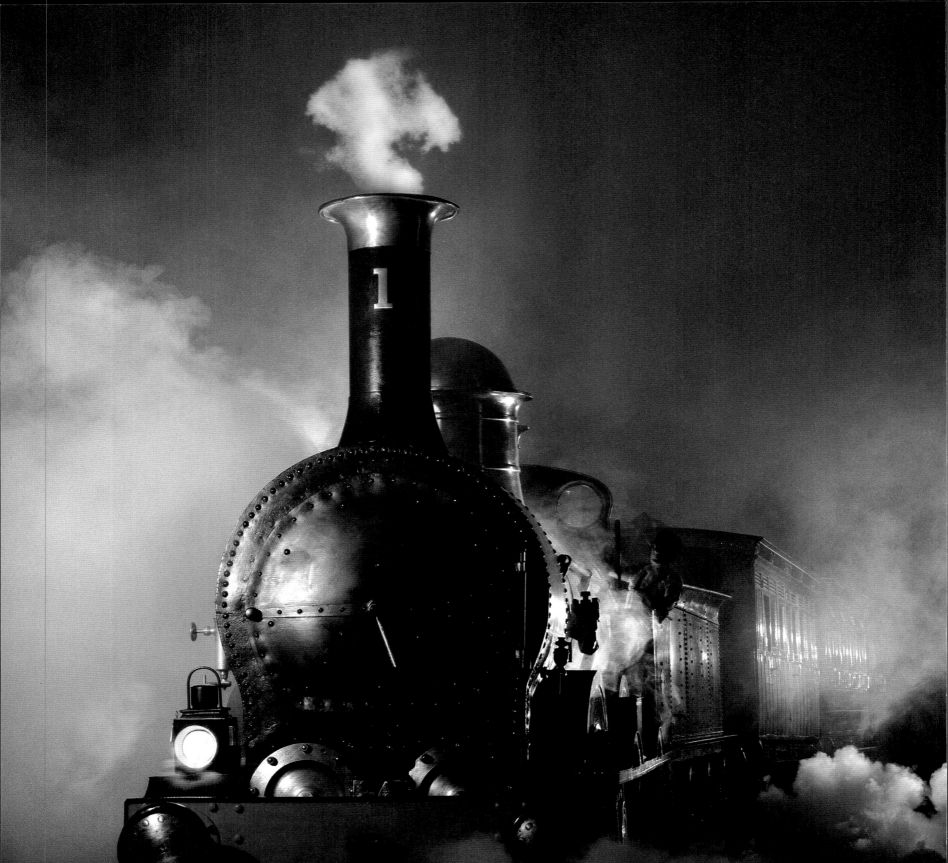

The Powerhouse Experience

most of the visitors to the Powerhouse Museum are family groups and one of their most frequent comments is that it really isn't like a museum at all. Instead of the expected deathly hush there is a good deal of noise – perhaps from a fairground organ or the computerised belches from Loco No. 1, the museum's most prominent exhibit. In the general happy ambience of such sounds, small children are seldom heard to cry, in marked contrast to their behaviour when dragged around shopping centres, for example.

The initial positive impact is heightened by the many interactive devices that characterise the displays in this highly individual museum. A visit to the Powerhouse is not a passive experience, a mere standing still looking at unfamiliar things – a tedious prospect for parents as well as children. Other exhibition environments, like theme parks, for instance, may offer ingeniously simulated experiences, but a true museum offers the real thing. Replicas are rare in any good museum and models are used sparingly. Scale and size are vital to the visitor's experience of reality, for the museum deals in primary material; what

≺ **1.** *Locomotive No. 1 pulled the first passenger train from Sydney Station (near where Redfern Station is today) to the Long Cove viaduct (near the present site of Lewisham) on 24 May 1855; height 422 x width 220 x length 750 cm. Gift of the NSW Government Railways, 1884.* Photograph by Greg Piper

2. *Merry-go-round (detail) designed and constructed by the museum as a context for the display,* Fun at the fair. Photograph: Powerhouse Museum

it principally offers its visitors is authenticity. All else is subordinate to that, and, indeed, reality and authenticity are quite sufficient to intrigue, entertain and enthral the public.

It is the extraordinary breadth and diversity of the Powerhouse collection that provides a unique experience for its visitors. In size, the collection numbers some 350 000

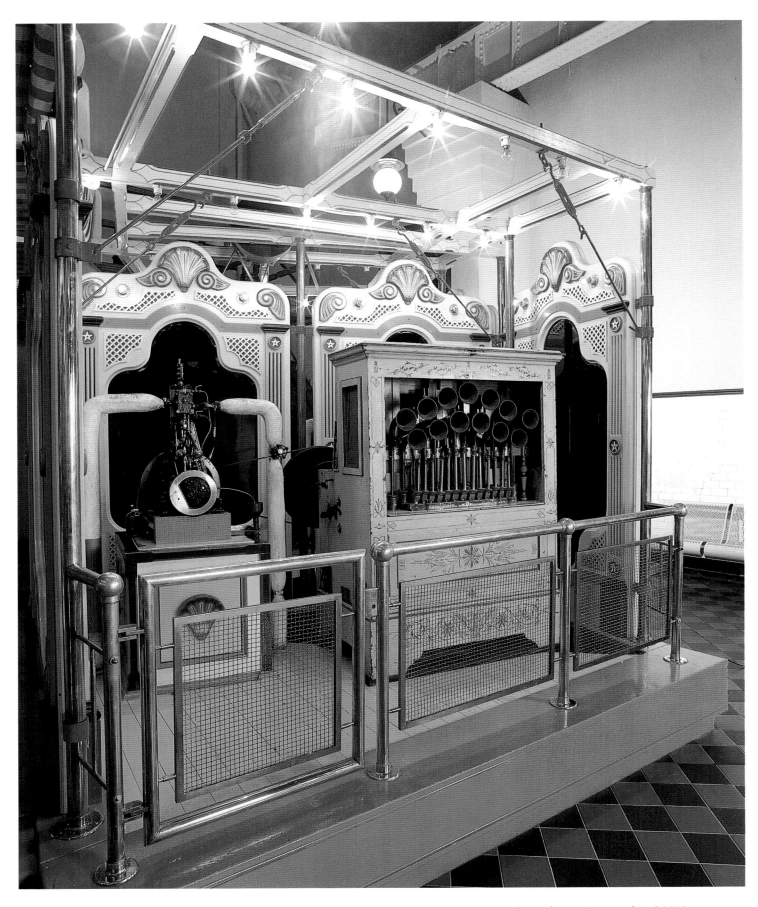

2. *The museum constructed this merry-go-round for the display,* Fun at the fair. *The barrel organ from about 1890 (purchased 1958) is powered by a Savage steam engine (purchased 1985). It is in the* Steam revolution *exhibition, sponsored by Sydney Electricity.*

Photograph: Powerhouse Museum

3. *Detail*

objects although only about 10 000 can be on view at any time. In scope, it includes just about every type of thing that humankind has made. It does exclude paintings and drawings as purely aesthetic objects, but may include them for other reasons, such as the illustration of an object or machine.

Craftwork is collected at the Powerhouse and may include sculptural, non-functional forms. An abstract form produced through, say, a ceramic process tends to be deemed craft rather than art and thus more suitable for a museum of decorative art than an art gallery. It is not the purpose of this book to attempt to define such boundaries, which are necessarily vague in any case. There are inevitably some areas of overlap.

A casual stroll through the Powerhouse Museum might easily take two hours or more. The many galleries and display spaces include large and cavernous ones as well as nooks and crannies. There are objects small enough to hold in your hand, such as that classic design of pistol, an 1873 Colt revolver and others big enough to contain several people. After looking at a porcelain plate from France, or

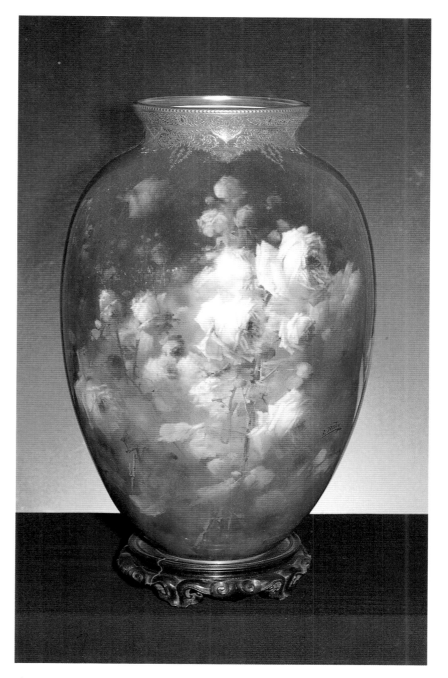

3. *Bone china Doulton vase painted in enamel colours by Edward Raby (1892–1919) about 1901, the top finished with raised gold decoration; height 61 cm. Gift of John and Arthur Shorter, 1952.*
Photograph: Powerhouse Museum

➤ 4. Hand-embroidered and decorated with glass beads, this rare example of a Central Asian suzani was made in Bokhara, Uzbekistan, about 1800. Suzanis were used as hangings, curtains or bedcovers, and were often part of a dowry; width 173 x length 254 cm. Purchased 1992.
Photograph: Powerhouse Museum

selections from the finest collection of Royal Doulton pottery in existence, one might look up and behold the spectacle of an enormous suspended sea plane. There are costumes and toys, boats and motorcars, cradles and space suits. There is a full suit of Samurai armour from Japan, and a suzani from Uzbekistan in Central Asia, both extremely rare treasures.

There are magnificent textiles from everywhere, including superb examples made by Aboriginal crafts-people from several cultural traditions in Australia. In various parts of the museum are wind instruments and string instruments representing many different countries and nationalities. Even a score of the *Messiah* from which Handel himself probably conducted a performance. The Powerhouse is a museum of creativity, representing human ingenuity through the ages. One of the earliest objects is a four thousand year old cuneiform tablet in Sumerian, an example of the early appearance of writing and, as the museum shows, a remote ancestor of present day computers. The earliest dated textile in a collection of some 30 000 is a fragment of Coptic cloth, third century AD.

The history of museums is well mapped. A few centuries ago there existed small private collections, highly idiosyncratic, of miscellaneous objects of curiosity. These were kept in small rooms, cabinets, known across Europe by a variety of names, such as wunderkammer or raritatenkabinett (in Central Europe), gabinetto (in Italy) or simply closet of curiosities (in England). Favoured friends and visitors would be admitted to marvel at such things as coins and medals, armour and weapons, jewellery and whale bones. Until people knew better, the horn of a unicorn was a considerable attraction.

Many sources have fed into the development of museums. There were treasuries in ancient Athens and libraries and centres of learning such as the great one at Alexandria in Egypt from 307 BC. Much later, in the middle ages, monasteries and cathedrals were the repositories of rare treasures and relics.

It was in the nineteenth century, in the industrial age, when museums came into their own as centres for public learning and instruction. Great museums such as the Victoria and Albert in London's South Kensington were created in response to the rise of industry as a way of curbing the excesses of mass production and contributing to the design education of dramatically expanding populations. The V & A, together with the science museums that grew up around it, were founded as a direct consequence of the Great Exhibition of 1851 in London.

In the latter half of the nineteenth century, international exhibitions of products, including machines, furniture and all kinds of design became the fashion as various nation states competed to outdo one another.

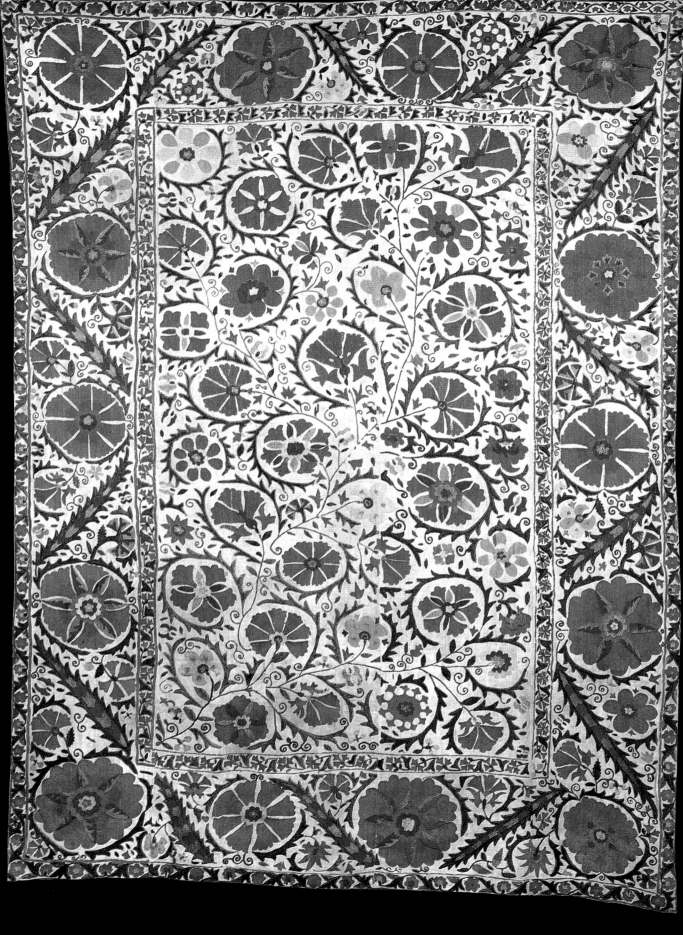

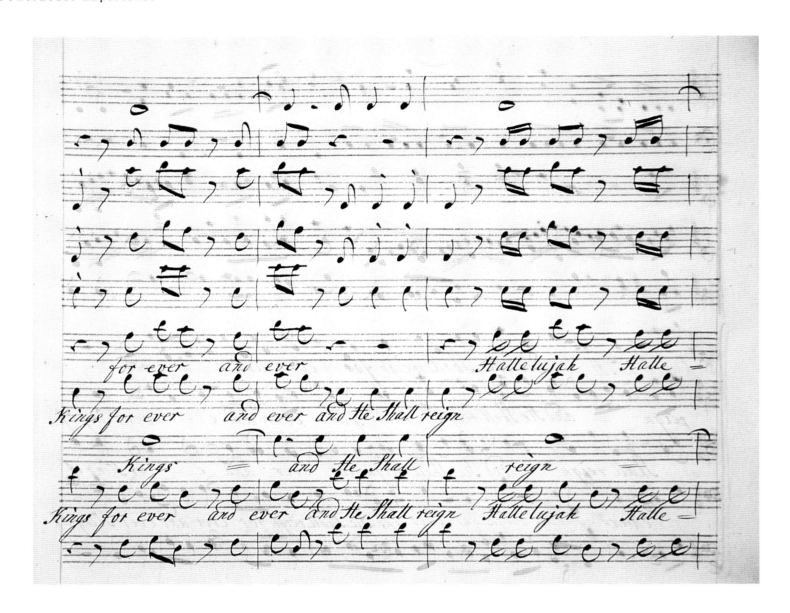

for ever and ever Hallelujah Halle —

Kings for ever and ever and He shall reign

Kings and He shall reign

Kings for ever and ever and He shall reign Hallelujah Halle —

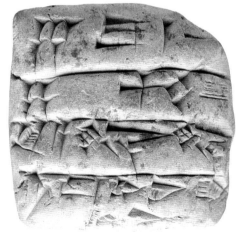

▶ 6. *Terracotta cuneiform tablet from Drehem, Sumer, dating from 2041 BC. It is a receipt issued to Alulu, a regular supplier of carcasses, for five sheep, one lamb and four grass-fed male kids to be used as a royal offering; height 2.8 x width 2.8 x depth 1 cm. Purchased 1985.*

Photograph by Jane Townsend

▶ 5. *Manuscript copied from George Frederick Handel's own conducting score of* Messiah, *which he composed in 1741. This manuscript dates from between 1745 and 1747 and is by a scribe in the circle of Handel's principal copyist, John Christopher Smith; height 24.5 x width 30.5 x depth 4 cm. E A & V I Crome collection, 1984.* Photograph by Andrew Frolows

Australia, rich in so many natural resources, especially gold, hosted its own first great exhibition in Sydney in 1879. From that initiative, and from some of those exhibits, a new museum was born and eventually grew, through several name changes, to the present day Powerhouse Museum.

Not everyone believes in such diversity as the Powerhouse collection represents. Arguments are made for varying degrees of specialisation and the hiving off of several of its collecting fields, such as coins and medals,

7. *Silk batik made about 1985 by Nyukana Baker (born 1943) of Ernabella Arts, South Australia, which was set up in 1949 to create employment opportunities for young women of the local Aboriginal community, the Pitjantjatjara people; width 89 x length 1005 cm. Purchased 1986.*

Photograph by Penelope Clay

8. *Coarsely hand-woven linen textile from the third century AD. The naturalistic floral motif such as this was common in Egypt during the Coptic period; height 9.5 x width 6.7 cm. Gift of Professor Said El Sadr, 1972.*

Photograph: Powerhouse Museum

stamps and musical instruments, as well as the whole area of social history in which the museum has taken a lead for a decade. This has even been extended to the whole of decorative arts, which have been criticised as an extravagance the museum cannot afford if attention is to be concentrated upon the science and technology on which, so the argument goes, future wealth depends.

Against this, many commentators, even economists, now stress the importance of broad culture in wealth creation: the importance of ideas, the importance in particular of cultural values which we carry in our heads. Our experience of life and society is not split into hard-edged categories. Everything is connected to everything else. Less and less confidence is now invested in an accountant's approach to life, however valuable accountancy is as a limited tool.

It has to be admitted that resources are stretched to maintain collections in fields so diverse as space technology, aviation, land transport, medical technology, lace, textiles, costume and dress, ceramics, furniture, numismatics, philately, horology (clocks), retailing and other forms of social history, manufacturing, and communication and information technology. The Powerhouse is indeed an heir to the tradition of the cabinet of curiosities but its size is thoroughly modern. With more than 20 000 square metres of display space, it is the largest museum by far in Australia and large by any standards in the world.

It is easy to get lost in this great museum – and that's part of the fun. Visitors explore and make their own discoveries, their own connections. Self-directed learning is a valuable mode of education and the museum is by no means prescriptive. No doubt this is a major reason why the experience it offers appeals so strongly to families; there's something for everyone, for all ages.

Well-known English scientist and writer on cultural matters, C P Snow, commented as long ago as 1959 on the profound division between education for sciences and technology and education in arts and culture. Little progress has been made in the last thirty years in repairing this disastrous division which still sees students opting for the one culture or the other. There is little encouragement or provision for a rounded education, and even more disturbing is that nowhere is it recognised that science and technology are as much a part of culture as painting, theatre or music. So the museum, with its comprehensive cultural representation, does address a deep need in our society.

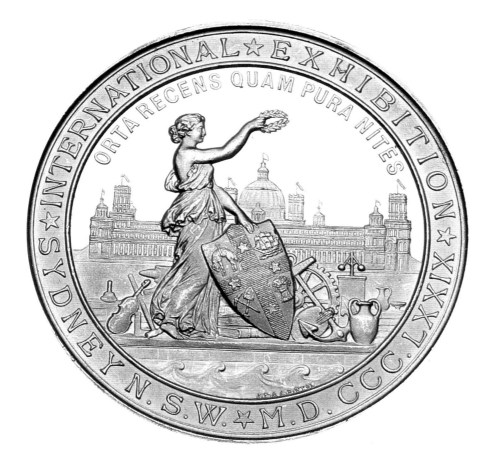

9. *1879 Sydney International Exhibition gold medallion. Only eleven of these were struck and this is one of only two known still to exist; diameter 5 cm. Purchased 1977.* Photograph by Penelope Clay

Frequent visitors to the Powerhouse become familiar with examples of human achievement and creativity in both artistic and technological fields.

There are two linking factors that provide a sense of unity that binds such diverse aspects of the collection together. These are design, and usage or function. The pre-eminence of design at the Powerhouse is significant. Every object in the collection is the result of a deliberate and determined act. Things did not come into existence through an accidental process. This is the one place in Australia where designers of all types can find stimulating examples. It is not fanciful to conclude, for example, that the surge of energy, imagination, and notable creativity among young Australian fashion designers owes much to access to the Powerhouse's pre-eminent fashion collection and the prominent profile which the museum has asserted in the field of fashion and *haute couture*.

The second of these two unifying factors, usage or function, reaches those parts of the collection which design, so to speak, cannot. Although every object has been designed, an object may well be used in a manner different from that intended by its designer. A rich source of such examples is the Australian bush tradition in which packing cases and oil drums were put to any number of uses – for example, as a commode. Users of a product might assign to an artefact a significance or status undreamed of by its maker – we all use chairs to stand on, for example, or telephone books as props. Wire coat hangers often become antennae on cars.

*t*he relationship between Australian artefacts and those made in other countries must be continually addressed by any Australian collecting institution. There are divergent opinions here. Some take the view that an emerging Australian cultural identity is stifled by glamorous international acquisitions which command high prices and thus stretch or exhaust acquisition budgets. Precious resources, so the view goes, should be reserved exclusively for the collecting of Australian artefacts, which in any case come cheaper,

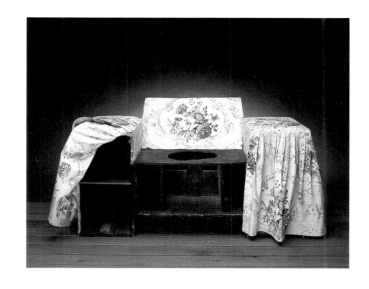

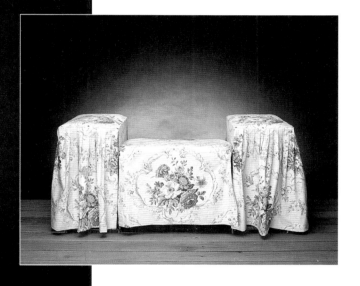

10. *Jack Male, of Sydney, made this commode chair from kerosene boxes for his new wife in 1909; height 55 x width 107.5 x depth 37 cm. Gift of Mrs Marjorie Quick, 1989.* Photographs by Peter Garrett

Interior of museum showing Locomotive No. 1 which pulled the first passenger train in Sydney in 1855.
Photograph by Jon Love

so that these can be exhibited to Australian citizens who will thus be encouraged to take a deeper pride in their own national achievements.

A contrary view asserts that Australians are not unduly threatened by exposure to examples from diverse cultures and accepts that Australia is not separate from the world but part of it, and a contributing part. As this is my own position, readers can expect to find in the following pages examples of Australian creativity or ingenuity which have already enriched the wider world or which have the potential to do so. (The Powerhouse Museum itself is a case in point.) A robust cultural identity has long been manifest in Australia and is all the more interesting because it continues to absorb a wide variety of immigrant cultures. Chinese, German, several different Mediterranean and Pacific cultures as well as Vietnamese, Thai, Indian – are a few of the more obvious. There are no less than 130 languages spoken in Sydney alone. People from all these and other cultures seem eager to embrace and contribute to Australian life, while they willingly share the riches of their own cultures with the rest of Australian society.

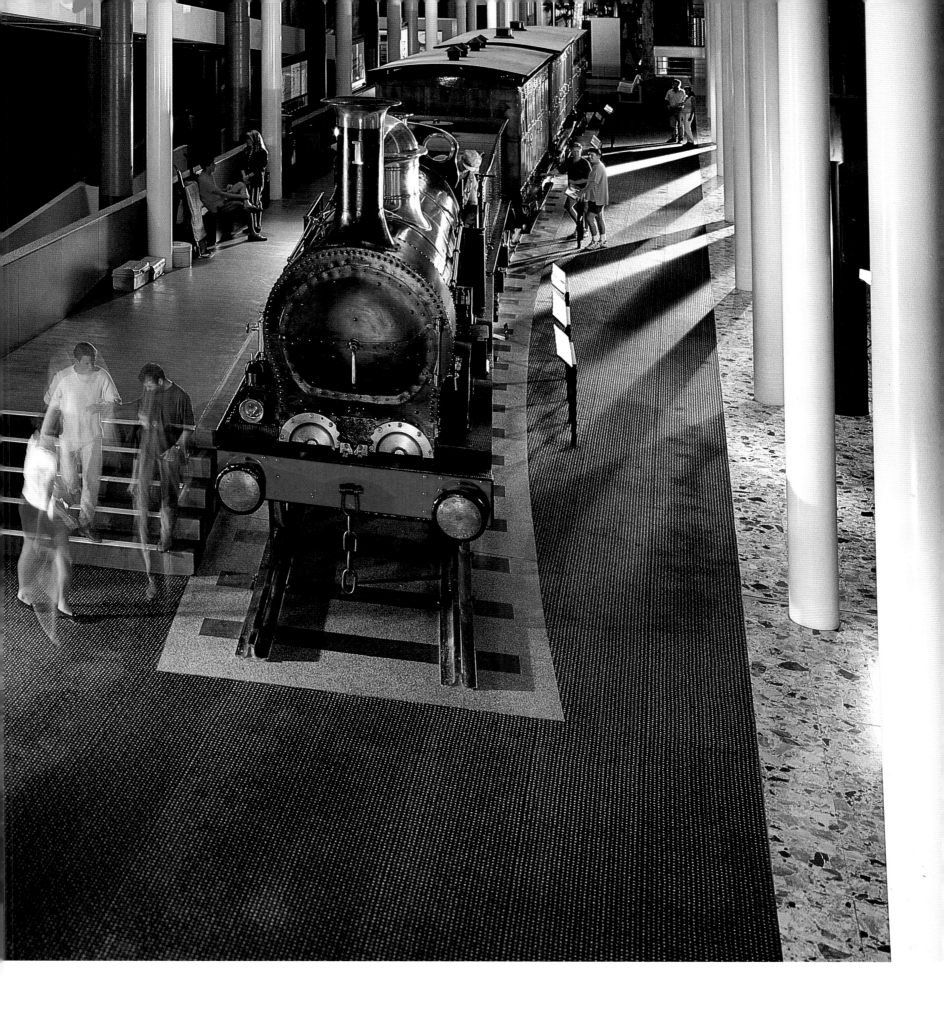

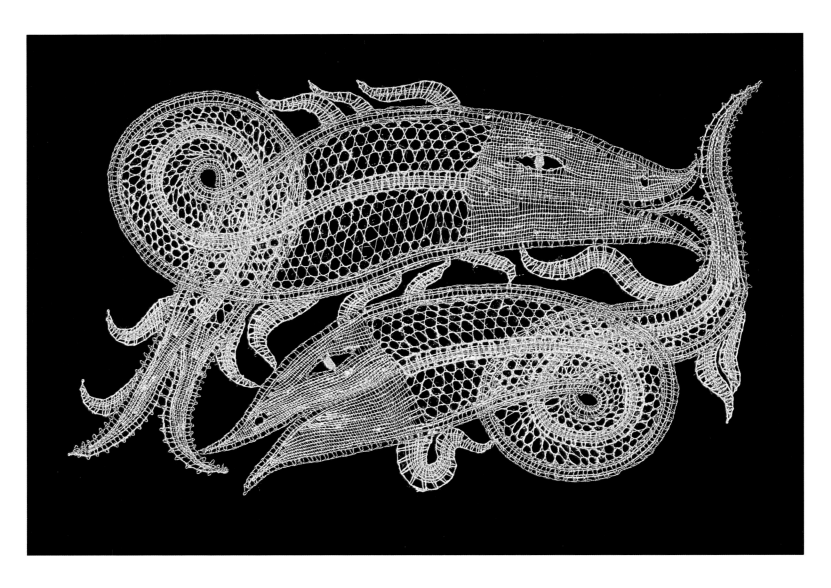

▲ **11.** *Contemporary bobbin lace panel* Two fishes, *made in Czechoslovakia by Ludmila Kaprasová in 1987; height 29 x width 47 cm. Purchased 1988.* Photograph by Peter Garrett

11. *Detail*

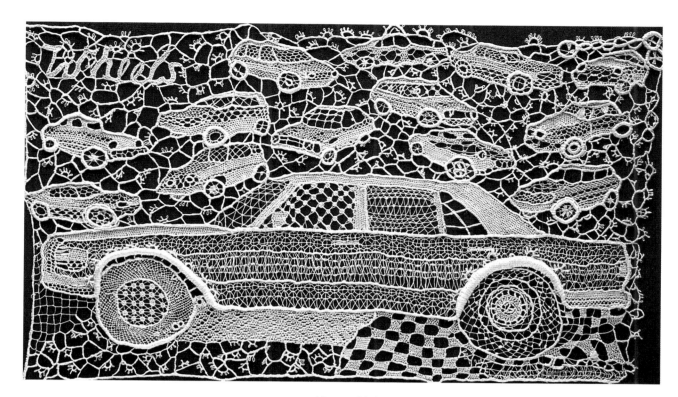

12. *Needle lace panel,* Wheels, *made by Jean Goldberg, Australia, in 1985; height 52.5 x width 45.5 cm. Purchased 1987.*
Photograph: Powerhouse Museum

Numerous examples in the Powerhouse Museum show how Australian craftspeople, designers and innovators have derived stimulus and encouragement from works produced by other cultures. This is overwhelmingly true, for example, of ceramics.

Lace-making is a specially interesting case. The museum's large collection of international lace has encouraged and strengthened a growing and impressive local lace-making tradition. The affairs of so small a nation as Australia are inevitably contingent on the affairs of bigger nations and bigger economies. That does not prevent Australia contributing a share, even a disproportionate share, as in the case of medical research, to the sum of human creativity, and creativity is essential to survival and essential to industry. The museum is therefore dedicated to industry and industrial and scientific innovation. It is also dedicated to success and to providing examples of achievement to encourage others. This sometimes involves looking at interesting failures, products such as the Leyland Australia P76 car, which failed to make the grade but whose conception, testing and trialing benefited later designers.

Alongside its devotion to industry, the museum recognises the creative nature of play. Accordingly it explores the theme of play, of games, in a number of ways. Its large number of interactive devices, some 250 of them, most computerised, are outside the scope of this book although the museum's singing Christmas tree was too irresistible to exclude.

Similarly, the Powerhouse's science centre – *Experimentations* – 780 square metres of hectic interactivity, is a popular extension of the museum experience, all the more educative because of its object-rich surroundings. It is the contemplation of these objects, and their variety, that makes up the theme of this book.

The following sections of the book represent the collections by way of a number of categories. To a large extent these categories are interchangeable. For instance, many innovations listed in technology could easily have been described under design and vice versa. The section on costume and body adornment also contains items that represent design and technological design innovations. It is all a matter of how we choose to look at things and the connections that we wish to make.

Innovations in Technology

Innovations in Technology

*t*he most valuable treasure in the Powerhouse
Museum collection is neither a precious stone nor a gold
ornament, nor, indeed, any of the thousands of works of
decorative art, valuable though they most certainly are.
No, with a value in money far exceeding any other single
object, the most precious treasure in the collection is a
machine, an engine! A very large machine, more than
nine metres in height. It is the rotative steam engine
manufactured in Britain by Boulton and Watt a few years
before the British began settling in Australia. In cash
value, it is much more valuable today than the best
paintings by Gainsborough or Reynolds with which it is
contemporary. It is probably equal in cash value to the
most expensive paintings ever auctioned, those by Vincent
van Gogh, Renoir and others of their generation. The
Boulton and Watt engine was donated to the museum by
Whitbread's Brewery, London, making the brewery
almost certainly the greatest benefactor, or sponsor, in the
history of what is now the Powerhouse Museum.

In museum circles, money values are generally
considered unmentionable even though the public is
usually curious about them. That very ubiquitous interest
is what makes museums and art galleries coy about the
figures. Most curators believe that such an obsession with
money, which is certainly evident in the media, obscures

13. *Boulton and Watt steam engine, built in 1784, the third rotative
(wheel-turning) steam engine ever built. It is the oldest engine of its
kind to survive anywhere in the world. It is more than 9 metres tall
and weighs 13 tonnes. The restoration of the steam engine was
carried out by the Technical Restoration Society.* The Boulton and
Watt exhibition *is sponsored by Toshiba International Corporation
Pty Ltd. Gift of Samuel Whitbread, 1888.*
Photographs by Andrew Frolows and Peter Garrett

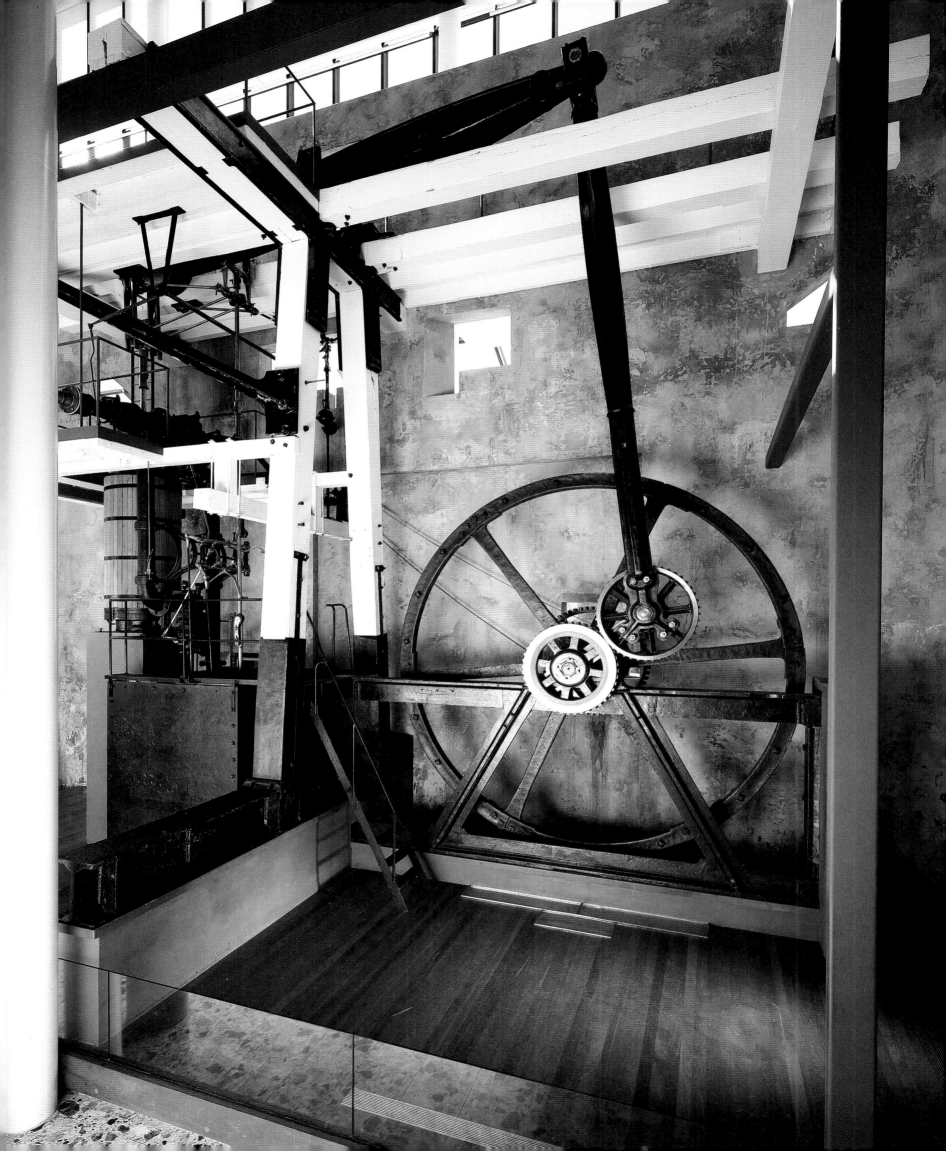

13. *Boulton and Watt steam engine (details right and opposite).*

other, non-pecuniary values. And yet museum professionals, by the very nature of their dealings with private collectors or auction houses, must follow financial trends as accurately as possible. Many curators accept this challenge with some reluctance because the curatorial obsession is usually with ideas, the messages and concepts that are embodied in an object. The special expertise of curators is connoisseurship, a gift for detail, that at times borders on the myopic. Together with their loyalty to the museum, curators inevitably value their relationship with private collectors, dealers or artists and designers themselves. There is a genuinely symbiotic relationship between arts curators and private dealers who do so much to bring on and establish talent. In the whole field of decorative arts, a great deal of knowledge is generated by dealers and private collectors who both donate and sell objects to museums. The situation works well for all concerned but there is always the danger that it could become too cosy and that is one of the reasons why the Board of Trustees is important. The Trustees, generally speaking, are able to take a detached and judicious stance. They act in the best interests of the museum but they also represent the citizenry that the museum serves. They are the people's representatives.

One complication in the matter of collection values is that, with rare exceptions, museums do not engage in dealing. They seldom sell their objects to other collection agencies or to dealers. In order to sell an object or otherwise dispose of it, the museum must first go through the ritual of 'deaccessioning' it, a process that, in the case of the Powerhouse, requires the assent of the Board of Trustees. The museum carries out rigorous collection assessment and, having exercised due caution, is able to cull material that is incomplete, in poor condition or of no real significance. Museums have long memories and work on long time lines during which values and fashions can change significantly. An object which may have languished in the storeroom for decades can be promoted quite quickly to pride of place in the most prestigious gallery. Such dramatic transformations of attitude are not uncommon in art galleries. For instance, Claude Monet, nowadays thought of as the most important Impressionist painter, was considered the least interesting over the two decades or so following his death. All this helps to explain why museums need extensive storage facilities.

*t*he Powerhouse Museum's Boulton and Watt engine is not just rare, it is unique. It was the third rotative steam engine ever produced and it is now the oldest one in existence. It was manufactured in 1784, at the Boulton and Watt factory in Birmingham, in the Midlands of England,

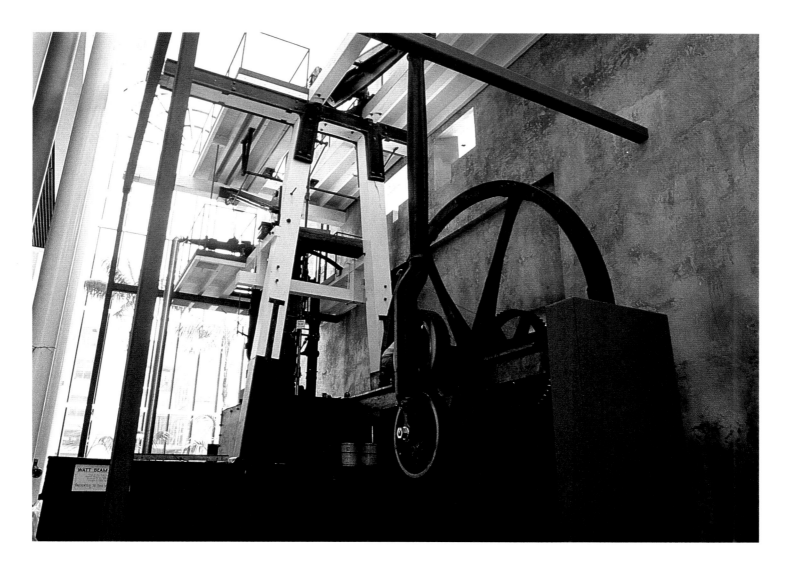

the cradle of the industrial revolution and the scene of so much new scientific thinking in the eighteenth century, and also the home of Wedgwood pottery. Josiah Wedgwood was himself one of the new breed of thinkers willing to try out any likely new technique.

The Boulton and Watt still works. It is still steam driven. A multitude of museum visitors witness its hissing and sighing motion. A great many people who would count themselves to be well informed or well educated assume that this giant machine is of nineteenth century origin. It is interesting to see how many have to adjust their historical grasp when they realise that it is a piece of genuine eighteenth-century technology, older than European settlement in Australia.

The designer was none other than the famous Scottish inventor James Watt (1736–1819), popularly credited with the invention of the steam engine as we know it. Matthew Boulton (1728–1809) was the entrepreneur and

businessperson whose abilities were essential to Watt's commercial success.

The technological significance of the rotative engine can scarcely be overestimated. Hitherto, the up-and-down motion of beam engines was useful for pumping work, usually in mines, but not much else. James Watt devised the sun and planet gears to convert reciprocating motion to rotary motion, which meant that the power of steam could be directed to a boundless range of applications. From the standpoint of the late twentieth century, it almost seems comical that this giant machine was dedicated for more than 100 years to the production of beer at the Whitbread brewery in Finsbury, London, where it began work in 1785. (Finsbury is now a fashionable inner district of London but in the eighteenth century was distinctly rural.) It needs to be remembered, however, that in the 1780s, beer was a positively healthy alternative to almost any other drinkable liquid.

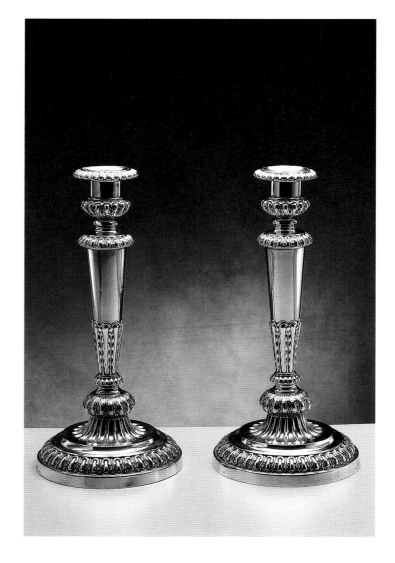

14. *Matthew Boulton was Birmingham's leading silversmith and Britain's largest producer of Sheffield plate (silver rolled onto both sides of a copper sheet). Matthew Boulton and Co. made these candlesticks in 1813–1814. Acquired in 1991.*
Photograph by Jane Townsend

Whitbread's retired the Boulton and Watt in 1887. It so happened that a certain opportunistic professor from Sydney was in London at the right time and he persuaded the brewery to donate the august engine to the new Technological, Industrial and Sanitary Museum (as we were then called) in Sydney. Professor Archibald Liversidge (1847–1927) was one of Sydney's leading thinkers in the later nineteenth century. He held a science Chair at Sydney University and he was a museum Trustee. He devoted his long career to the promotion of science and technology in education and Sydney owes much to his intellect and his energy. The museum owes him an incalculable amount.

For many, James Watt is the more famous of the two who produced this machine. But others know that Matthew Boulton was also a fascinating personality who commanded the respect of the most distinguished architects and designers of his day, men like Robert Adam, for example. Today there are many collectors who know the name of Boulton as the maker of some of the finest and most sophisticated metalwork in the neoclassical and regency styles.

Nowadays, examples of Boulton's silverware and Sheffield plate are represented in many of the best collections in leading museums around the world including the Victoria & Albert, London; the Los Angeles County Museum of Art; the Museum of Fine Arts, Boston; and, of course, the Powerhouse Museum, Sydney. Illustrated is a pair of sterling silver candlesticks of 1813, which the museum acquired in 1991. Decorated in a relatively elaborate but restrained manner, these candlesticks are an excellent example of English neoclassical style of the early nineteenth century.

*t*he museum has ceased, for all practical purposes, to discriminate between information technology and communications technology. The two streams have converged to such an extent that we now think of them as the same thing. Information technology is a priority theme for the Powerhouse and we seek to document leading-edge technology in that field. Technological advance *per se* is not the primary concern and some of us prefer the more

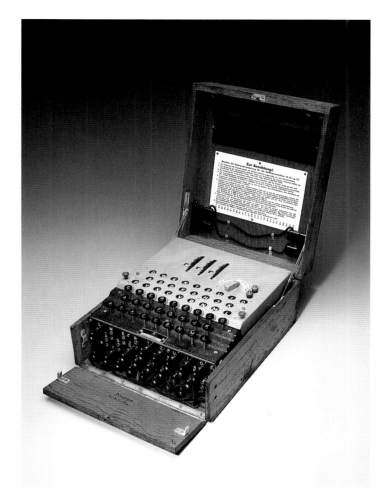

neutral term *change* to *advance*. In any event, as a museum our primary concern is the effects of technological change on the community, or better still, the interaction between society and technology. After all, society produces it.

We are less and less interested in technological archaeology and we are less and less influenced by nostalgia. We have ceased to accept every successive variant of the typewriter offered to us. Nonetheless we are still ready to embrace a machine of spectacular significance in the history of information technology. We were fortunate in bidding successfully for just such an item at Sotheby's, London, in March 1994. This is a little machine made in 1940, no bigger than an old typewriter, no bigger than an old style portable gramophone, which had the most profound, the most radical effect on the rest of the twentieth century. It is a rare example of an *Enigma* ciphering machine. Originally patented in 1919, this one is a Wehrmacht (German army) model, a portable version for use in the field. When Hitler launched his *Blitzkrieg* at the start of World War II, he needed a highly effective communications system to link and control his tank divisions, his field artillery and his ground attack aircraft, the famous Stuka dive-bombers. Everything depended on speed and secrecy. The *Enigma* ciphering machine was the perfect answer. Its typewriter-style keyboard was linked electrically to a series of drums which translated messages

into meaningless jumbles of letters which were instantly converted back to sense by receiving *Enigmas*.

Codes were changed frequently, making intercepts virtually impossible to decipher. And this is the real significance of the *Enigma* codes. Because they were so effective, the British put enormous resources into cracking them. In 1940, the same date as the museum's *Enigma* machine, a team of mathematicians and code-breakers was established at Bletchley Park, a country estate in Buckinghamshire, fifty miles north of London. This secret group, known as Ultra, was successful in breaking the *Enigma* codes. Their efforts included the development of computer technology with far reaching consequences. One of the Ultra team was Alan Turing (1912–1954), a brilliant Cambridge mathematician nowadays regarded as a pivotal mind in the development of the computer.

Since 1990, the museum has concentrated on recent innovations in technology in Australia in particular. The

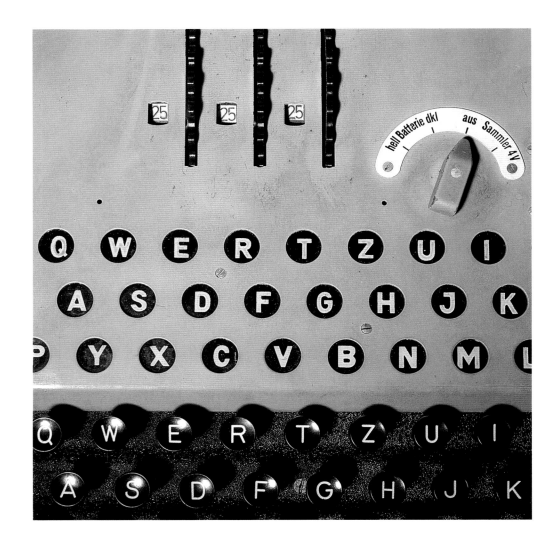

15. Enigma *ciphering machine (with open keyboard) made in 1940 and used by the German army in World War II to encipher and decipher military information; height 15 x width 26.5 x length 35.5 cm. Purchased 1994.*
Photograph by Jane Townsend

◄ 15. *Detail*

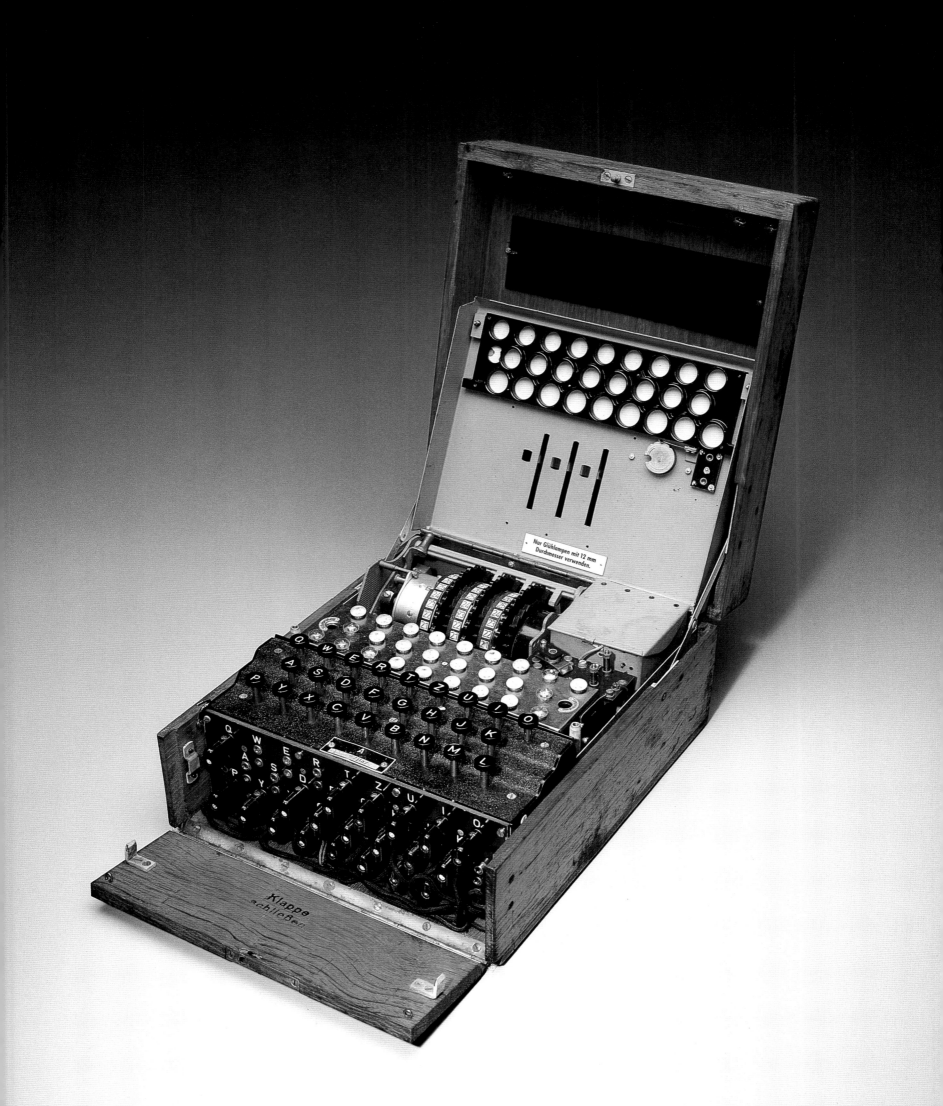

<< **16.** *Flight instrument details and cockpit conversations are recorded by the flight recorder. Although originally designed and prototyped in Australia, it was first manufactured in the UK where this one was made by Vinten Limited; height 25 x width 22.5 x depth 25 cm. Gift of Vinten Limited, 1992.* Photograph by Sue Stafford

17. *A section of the first-generation Australian radar guidance antenna panel for the Interscan guidance network, developed in Australia by the CSIRO; height 260 x width 145 x depth 80 cm. Gift of CSIRO (Division of Radiophysics), 1984.*
Photograph by Andrew Frolows

museum now maintains a permanent exhibition frankly directed towards the local audience rather than international visitors and tourists. The idea is to hold up to Australians a mirror of their own creativity, their own innovations and their own successes. Most Australians are aware of local innovations that had to go overseas for development and eventual success. The most outstanding example of this unplanned export of intellectual property is the so-called *black box*. This was the voice and instrument recorder invented by the Australian Dr David Warren in 1953 in the aftermath of Comet jet airliner crashes. Warren's black box was designed to record evidence that would enable investigators to find out why an aircraft has crashed. Warren's far-sighted contribution was dismissed in Australia and production was undertaken in the United Kingdom instead. Today, the flight recorder is essential equipment on all sizeable aircraft. The museum's example looks less like a black box and more like a red egg.

Aviation is a major theme in the culture of Australia. Australian cities are distant from one another and all are distant from the principal cities of other countries. So air travel looms large in the national imagination. It is not accidental that many of Australia's national heroes were or, indeed, are, aviation pioneers. Neither is it by chance that Australia's national airline, Qantas, is able to boast the best safety record in the world. And so it is that Australia

has produced a number of firsts in aviation technology. In the 1970s, the Commonwealth Scientific and Industrial Research Organisation (CSIRO), a government body, developed the Interscan MLS (microwave landing system), a sophisticated and economic guidance system for aircraft approaching their destinations. Although it was developed some twenty years ago, this system still has much global potential, particularly because of its low cost.

The black box or flight recorder just discussed is always cited as an example of Australians' tendency to give away their innovations, their own intellectual property, because only foreign interests have the wit to develop them. But there are cases where the opposite is true. There are products devised in other countries which have gone into development and production in Australia. One such is the Mountbatten Brailler. This marvellous piece of equipment is the first update since the Perkins Brailler of 1951 which

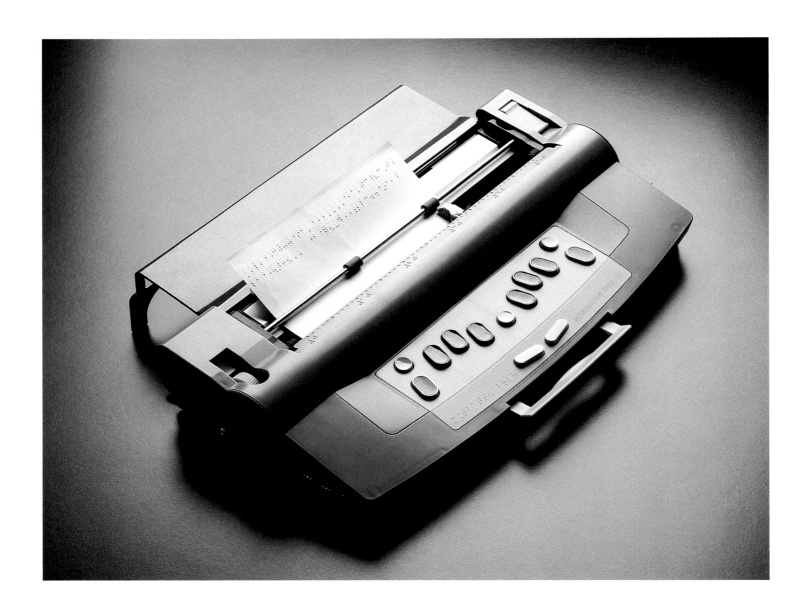

18. *Mountbatten Brailler, the Australian designed and manufactured braille equivalent of a portable electric typewriter with memory. When connected to a computer and printer or speech processor, it can translate braille into typescript or speech and vice versa; height 8.7 (closed) x width 24.5 x length 45.3 cm. Purchased 1990.* Photograph by Jane Townsend

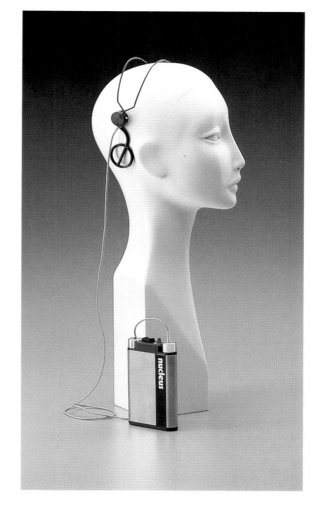

19. *Australian developed and manufactured, the Cochlear Implant or 'bionic ear' enables some profoundly deaf people to perceive sound and eventually understand speech; height 3.2 x width 15.2 x length 23 cm. Purchased 1986.*
Photograph by Geoff Friend

looks like a chunky but simplified typewriter. The new Mountbatten brailler looks like an elegant and simplified version of a personal computer. Which is what it is. It can 'speak' to all the other office equipment so that its sight-impaired operator can play a fully integrated role in a busy office and cooperate with her or his sighted colleagues. This new, computerised brailler was prototyped in Britain where it was funded by the Mountbatten Trust. Development and production of this British idea was carried out in Australia by Quantum Technology.

Perhaps the most impressive Australian product in recent years, in terms of imaginative innovation, successful development and astonishingly effective marketing, is the bionic ear, a system that enables the profoundly deaf to sense and interpret speech. In this case, the marketing strategy incorporates serious customer- service and after-sales care.

The correct name of this outstanding Australian innovation is the Cochlear Mini System 22. The system was originally conceived by Professor Graeme Clark, of Melbourne, who invented a method of transmitting coded speech patterns to the nerves of the inner ear. In order to implant the device which both receives signals and then stimulates the nerves, major surgery is required. And as the signals received are inevitably coded, patients have to be encouraged, in effect, to learn a new language. This encoding is carried out by a neat speech-processor worn conveniently on the patient's belt. It is linked to a microphone and a transmitter, both of which tiny devices are worn behind the ear. With financial assistance from the Australian government, the system was trialed, tested and developed to its present high level of sophistication by Cochlear Pty Ltd, a company set up and brilliantly led by entrepreneur Paul Trainor. Cochlear set up a world-wide network of clinics. The bionic ear is a wonderful success story, combining scientific research and inventiveness, and private business acumen with enlightened governmental encouragement and tangible support. It is the story of a successful vision, the kind of story the Powerhouse exists to tell.

Not all products are as saintly or as profound as the bionic ear but their success is still a matter for interest and celebration. Café Bar, for example, is not a glamorous product. It fills a workaday need to supply instant coffee in workshops and canteens. Nevertheless, its elegant design

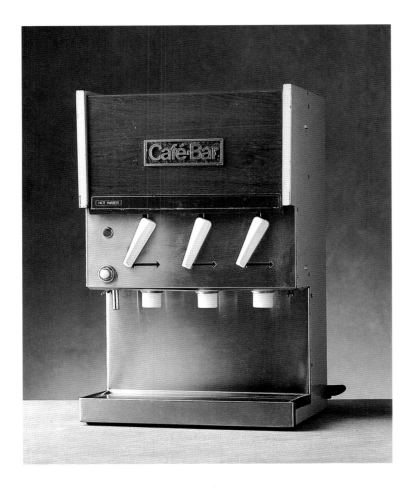

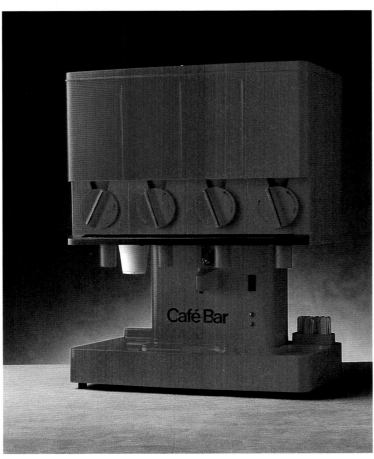

◄ **20.** *Café Bar 'Mini' 3, introduced in 1965; height 49.5 x width 31.5 x depth 25.5 cm. Gift of Café Bar International, 1990.*
Photograph by Andrew Frolows

⅄ **21.** *From 1972 until 1988 the 'Compact' was popular. Designed by David Wood of Nielsen Design Associates, it was marketed to 34 countries; height 61 x width 45 x depth 28 cm. Gift of Café Bar International, 1990.*
Photograph by Andrew Frolows

is to be seen all over the world. Indeed, it is so ubiquitous that people are frequently surprised to find that it is Australian. Café Bar is a particularly interesting case because its notable success is due to its painstaking development, its continual improvement. Its design has been updated by Nielsen Design Associates, who gave it a modern computer-like stylish look so that it blends in with smart office equipment. Of all products, Café Bar gives the lie to and shows the silliness of the cliché: 'If it ain't broke, don't fix it'. Many things can become dated without necessarily being broken. Unless a manufacturer is prepared to upgrade and improve constantly, then the way is open for a competitor to steal a march.

The examples so far mentioned are all of notable Australian successes in recent times. The whole subject of these successes and the factors that contribute to them or detract from them is treated in the book *Making it*, written by Rob Renew and published by Powerhouse Publishing in 1993. The image on the cover of Renew's book is reproduced here not only because it is frankly attractive but also because it represents a sophisticated advance in Australian industry. It is not generally known that the Royal Australian

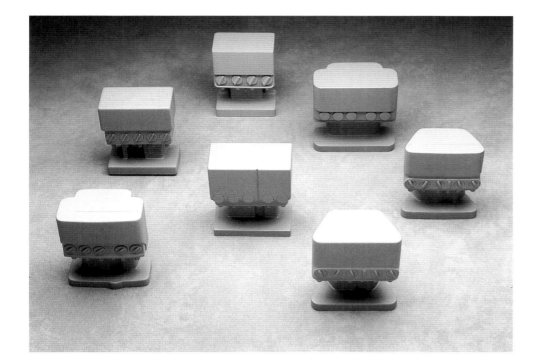

22. *Seven styling models, revealing the way the design of Café Bar 'Quintet' evolved between 1988 and 1990; height 12.5 x width 9 x depth 5.5 cm. Gift of Café Bar International, 1990.*

Photograph by Andrew Frolows

Mint operates a profitable corporate arm which exports currency to many client nations. The Mint's Optical Surface Profiler, introduced in 1991, enables it to copy coins and dies with extraordinary accuracy and efficiency. Developed for the Mint by CSIRO, the Optical Surface Profiler is an excellent example of an Australian innovation with wide applications. The same is true of the Australian Broadcasting Corporation's digital audio editing system, known as D-CART.

In June 1991 the ABC moved their radio operations from a motley assortment of offices and buildings on William Street, east of Sydney's business district, to their newly constructed headquarters building in Ultimo, next to the Powerhouse Museum, on the west of the city. This was the ideal moment to improve and rationalise their radio broadcast systems. They had already solved the challenge of broadcasting across the nation over several time zones. It often causes amazement and frank incredulity to foreign visitors, particularly Americans, when they are informed that the distance between Sydney and Perth, or Sydney and, say, Broome, WA, is comparable to the distance between New York and Los Angeles. So a radio announcer can scarcely say 'And now the six o'clock concert of the Sydney Symphony Orchestra . . . ' and expect that to suffice on the other side of the continent where the time is different. Through the

1980s, the ABC had developed an effective solution consisting of a hard-disk based digital audio time-zone delay system. This was the brain child of their own senior engineer, Spencer Lieng. As a result, a time call broadcast in Sydney goes out two hours later in Perth at accurate local time. The next stage was to develop this digital system further to the point where it could provide editing, mixing and replay facilities so that studios and newsrooms would run entirely without reel to reel tape and cartridge tape machines. For this stage, the ABC sought tenders. The ABC's own Design and Development unit, brilliantly led by the already mentioned Spencer Lieng won the tender and came up with D-CART.

D-CART is a multi-user digital recording, editing and playback system which allows material to be stored, edited in several different ways simultaneously, mixed, with different effects added at will. The potential applications of the system quickly came to seem unlimited. For example, it could solve problems in public announcements in complex rail transport systems. 'The train now approaching platform X will call at the following stations but will not stop at etc. etc.' Such messages can be instantly edited on D-CART to keep account of instant changes of conditions. So successful is this multi-user digital system that it has aroused interest around the world. The ABC found it necessary to set up a

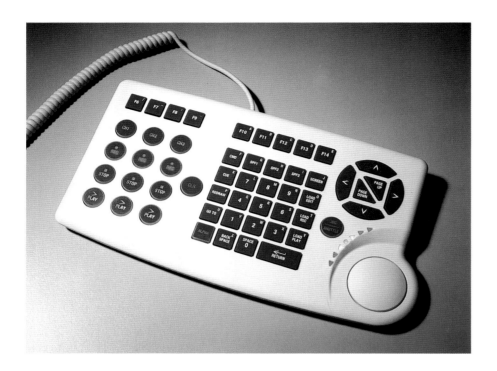

23. *Studio console for D-CART, the multi-user digital recording, editing and playback system which was developed by the Australian Broadcasting Corporation and is being marketed internationally; height 3.8 x width 33 x depth 17.6 cm. Gift of ABC D-CART Marketing, 1994.* Photograph by Jane Townsend

separate marketing arm dedicated to D-CART sales which have gone to the BBC Westminster for recording all parliamentary proceedings; ABC Radio Networks, New York; Europe-1 Telecompagnie, Paris; Omroep Limburg, The Netherlands; CBC Toronto (3 systems), Canada; Standard News, Washington DC, USA; Westdeutscher Rundfunk (WDR), Cologne, Germany; Radio and Television Hong Kong; CBC Ottawa, Canada; CBC Montreal, Canada; and Televisa, Mexico.

*I*n uncertain times, true success stories are encouraging. They show what can be done. But failures are also instructive. Things can go wrong for a variety of reasons and it is educative to try to follow and understand them. When the museum acquired its Leyland Australia P76 in 1992, it did so in the conscious belief that the P76 was a heroic failure. Leyland Australia set out in the late 1960s to produce a car specially designed for the Australian market. Their market research told them that Australians preferred large family cars with generous boot

capacity and plenty of power. The answer which their Australian team provided in response to this challenge was released in 1973. Big the car certainly was – enormous in fact! Its V8 aluminium engine delivered ample power yet was claimed to be relatively economical and efficient (a claim few would dispute twenty years later on). For its day, the car's shape was somewhat unusual, hinting at a wedge with the tail rather high and the body sloping downwards to a low, slim nose. Yes! Exactly the styling that soon afterwards became ubiquitous. The design was a refined one in a number of ways. Its windscreen wipers were recessed and invisible rather than the tacked on excrescences that we still see on so many vehicles. The P76 was equipped with a number of safety features such as an isolated fuel tank, side safety bars and a safety engine-hood. All of this impressed motoring journalists who pronounced it the *Wheels Car of the Year* in 1973. The public did not share their enthusiasm. The car may have been economical but it looked heavy and thirsty.

24. *Developed and manufactured by the CSIRO, the Optical Surface Profiler (OSP 150), produced the image of the 20cent coin (right). Nine coins (currency of Australia, New Zealand, Papua New Guinea, Cook Islands, Western Samoa, Fiji, Thailand, Bangladesh and United Arab Emirates), manufactured by the Royal Australian Mint with quality assurance provided by the Optical Surface Profiler, were a gift of the Royal Australian Mint, 1992.* Photograph courtesy of CSIRO.

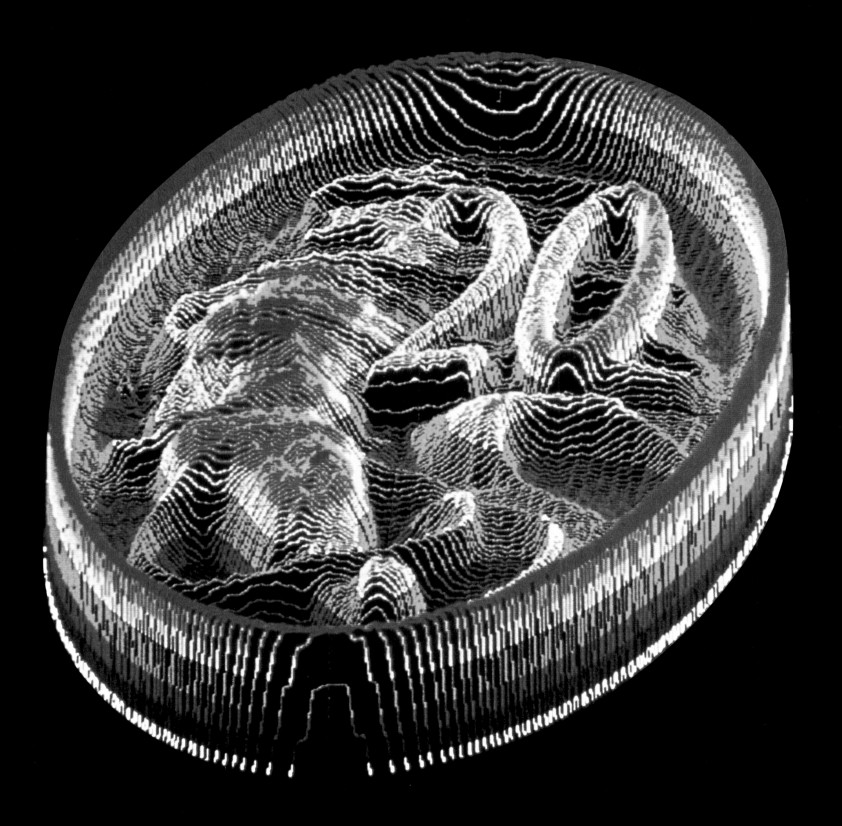

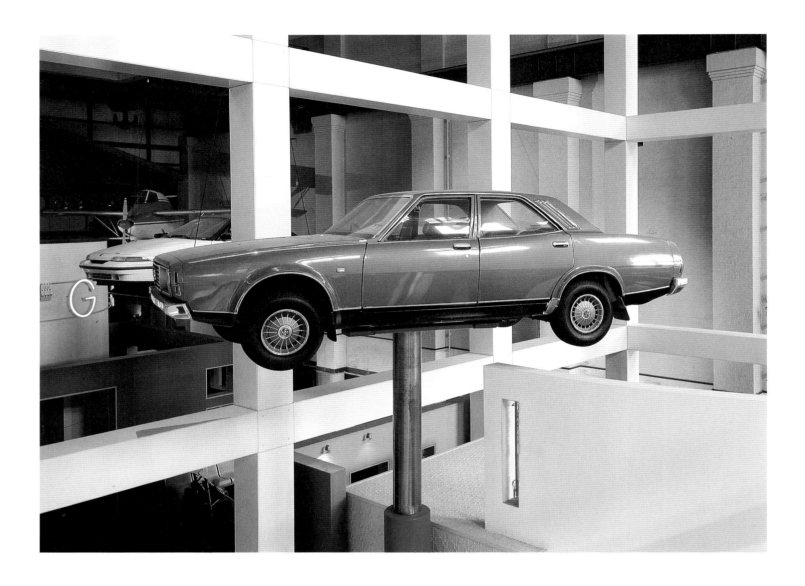

25. *Leyland Australia P76 Super Saloon on display in the museum's* Success and innovation *exhibition; height 155.2 x width 187.9 x length 480 cm. Purchased 1992.* Photograph by Penelope Clay

World oil prices began a round of increases just as small Japanese cars became more easily available thanks to a reduction in import tariffs by the Australian government. Although the P76 design was one of the most innovative in years the car missed its mark. Circumstances prevailed against it. Customers were critical of its degree of quality control which failed, no doubt, because the company was not realising adequate revenue from its investment. In retrospect it does seem that the whole operation was under-capitalised – $11 million was just not enough and that might be the crucial lesson from the whole experience. After 17 000 units Leyland Australia ceased production. It was a debacle that sent the company out of business.

Today, the Powerhouse Museum's example is a handsome looking vehicle. Acquired from an original country dealer for Leylands who retained two – one for everyday use and ours for Sunday best! – our P76 looks like anything but the lemon everyone dismissed it as. It looks like a really smart car!

Smart, too, is the Ford Capri which the museum acquired in 1991. Ford Australia responded to my request and supplied the museum with an export version of this car which then seemed a certain success. It is a small, stylish and economic soft-top made for the American market and advertised there as 'a steel bikini'. Starting in the late 1980s, Ford Australia invested heavily in quality production methods and in training its workforce. (The benefits of that approach soon flowed on to the production of other models such as the all-Australian Falcon range.) Late changes in American legislation regarding safety and

26. *Ford Mercury Capri outside the museum's cafe in the Grace Bros Courtyard; height 150 x width 185 x length 425 cm. Gift of Ford Motor Company of Australia Ltd, 1991.*
Photograph by Jane Townsend

pollution put Ford Australia at a disadvantage but they went on to achieve excellent sales by 1991, taking the lead over their main rival, the Mazda Miata.

Unfortunately, this success was not sustained and sales slumped to the point where, at the beginning of 1994, Ford Australia announced that production of the Capri would be terminated. It will take some time to understand fully the reasons for this disappointment to become clear. Modifications to the design to take account of the unexpected changes in American legislation meant that Ford's marketing strategies were thrown seriously off schedule so that announcements, motor-show displays and the availability of the vehicle were not well co-ordinated. It is undoubtedly the case, also, that the early 1990s recession, which was by no means anticipated in the late 1980s, rendered a fun vehicle less attractive. Young Americans were forced to concentrate more on survival than leisure interests, just like their counterparts in so many other countries. Finally, it seems clear that in America, Ford's Lincoln division provided the wrong positioning for the little Australian car. Lincoln is associated with tradition and something of a stately

product line. Lincolns are mainly bought by conservative buyers of mature years, not the happy-go-lucky young.

The same recession also brought to a halt the development of another, most impressive Australian product, one devised for specifically Australian conditions and industry. This is the Automated Wool Harvesting System (AWHS), devised by Lance Lines, a South Australian grazier, and his team. Lines spent some fifteen years trying to solve the problems associated with the manual shearing of sheep, problems that affected both shearers and the animals. For humans, sheep-shearing is almost literally a back-breaking task. For the sheep, the process often leaves them with skin wounds and infections. The AWHS not only solved these problems but also improved the crop, or harvest of wool, in so far as the fleece resulting from robotic shearing was in better shape. It seems improbable that a computerised robotic arm can treat the skin of an animal with more sensitivity, delicacy and precision than a human being is capable of, but that is indeed the case. Provided, that is, that a sheep can be held still. Lance Lines attended to that problem by developing an electronic device to immobilise the sheep.

27. *Prototype robot arm for the Automated Wool Harvesting System (AWHS) devised by South Australian Lance Lines, to automate sheep shearing; height 198 x width 109 x depth 88 cm. Purchased 1995.* Photograph by Andrew Frolows

◄ **27.** *Detail*

The whole AWHS project was developed to the point where it was capable of shearing large numbers of sheep, apart from leaving the underbelly for manual shearing, and then providing ready classed and baled wool. The complete process attracted approval from all quarters, even including the unions which appreciated that the provision of a specially designed back support for the manual sheering of the sheep's underbelly was better for shearers even though it required fewer of them.

The AWHS system considerably reduced shearing costs. That was not enough to save it, to offset the effects of the recession where farmers destroyed their stock because they could not afford to feed them, let alone pay shearing costs and then try to sell wool on a market that had all but disappeared. Wool stocks became unsaleable. All this alone would have been enough to finish off Lance Lines' computerised robotic system, but there was yet more bad news. Development had been funded by Elders Pastoral to the tune of $6 million, but Elders then had their own problems and could not go on. The AWHS project was abandoned in 1992, a sad end to the smart, clever efforts of Lance Lines and so many dedicated people.

The AWHS project is available to be picked up again when times improve. The fact that the whole system is lodged at the Powerhouse Museum means that it will be readily accessible. It is so to speak *decanted* with the museum and we are only too keen to play whatever part is open to us to see AWHS revived. In the meantime, as the illustration shows, the robotic shearing arm makes a spectacular exhibit which is viewed every day by large numbers of visitors.

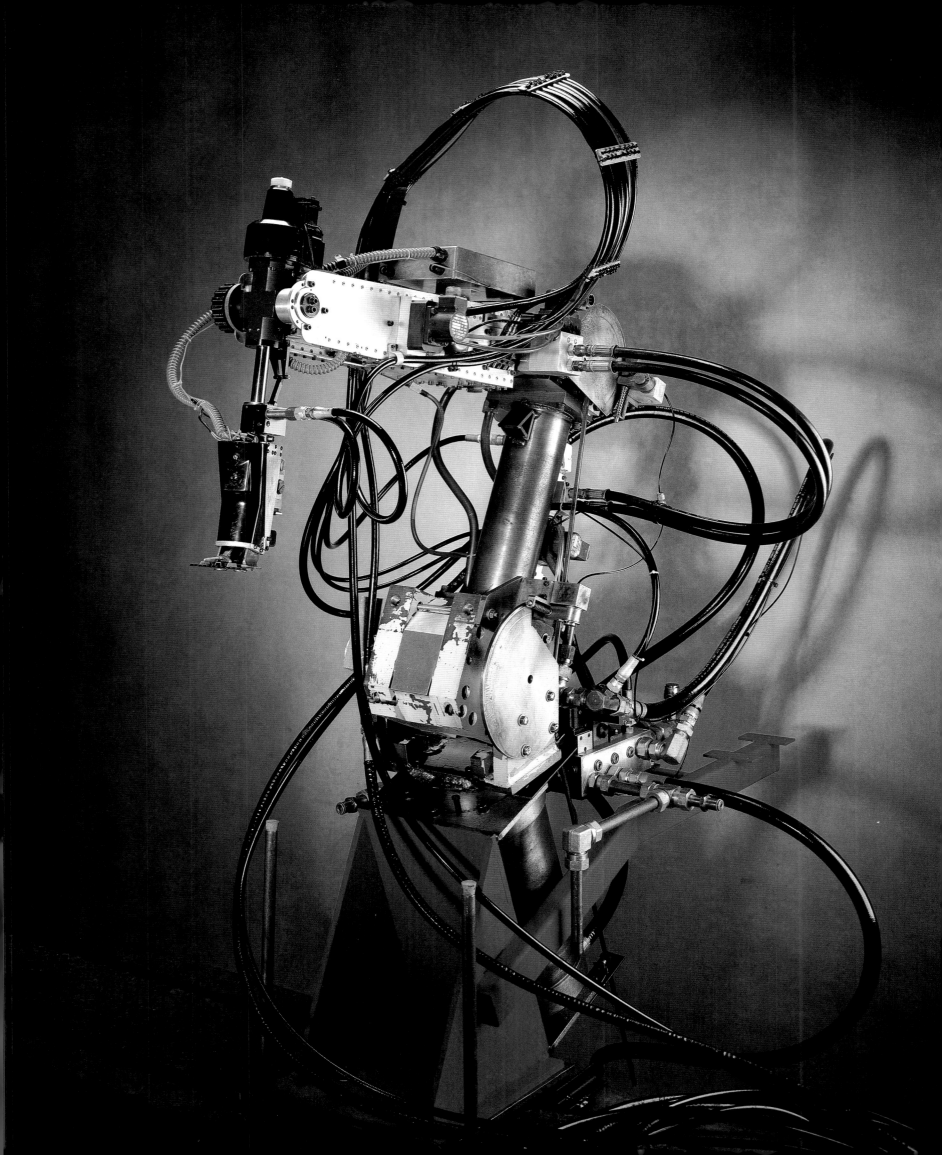

Innovations in Design

Innovations in Design

many objects are found in museums only because they are obsolete; preserved in museums they can be seen nowhere else. People generally are fascinated by the past. These two things lead to the common but erroneous assumption that museums are inherently concerned only with the past and the obsolete. Here is a series of objects from the Powerhouse collection which represent innovation in design; many of them are from the past but none of them is obsolete.

This is graphically true of the first of these examples, a great treasure by any criteria and an astonishing discovery. In 1991 a resident of Darlinghurst, an inner-city suburb of Sydney, telephoned the museum and asked us to look at a sideboard by E W Godwin. The prospect of it actually being a Godwin was remote. I was reminded of my years at the Tate Gallery in London, where hundreds of people asked curators to come and look at their Turner watercolours, Constable sketches, Blake prints, etc, etc. Needless to say, such curatorial visits were invariably futile and a real find as rare as a Pools win. The situation was somewhat similar at the National Gallery of Australia, where enquirers found it difficult to distinguish between an original painting by, say, Sidney Nolan, and a photographic reproduction, mounted and framed, in their possession. At least one caller believed she had the entire first Kelly series, a unique treasure in the national collection. So curators are used to shaking their heads sadly and delivering disappointing news. This was not necessary in the Darlinghurst apartment where the famous Godwin design of 1867 was instantly recognisable. And it was by no means obsolete. On the contrary, all its drawers were full of the vendor's personal effects. This internationally famous design, highly desirable to at least a hundred major museums across the world, was doing its humble domestic duty, like any other sideboard or chest of drawers in countless homes everywhere. The owner explained that she had bought it some decades previously because she liked it. Only later had she suspected its famous origin.

Godwin's sideboard is indeed a treasure. For two reasons – it is both a rarity and an innovation.

From the 1850s onwards, when trade with Japan was opening up for the first time in centuries, designers and artists in Europe became more and more knowledgeable about Japanese art and the most ambitious of them developed a taste for Japanese style. The adoption of

28. *Tea kettle with burner on stand designed by Christopher Dresser (1834–1904) in London. It was made by Hukin and Heath in Birmingham in 1878. It is electroplated silver with wooden mounts; height 27.5 x width 22.3 x depth 17 cm. On view in the* Style *exhibition, sponsored by the State Bank of New South Wales. Purchased 1991.* Photograph by Penelope Clay

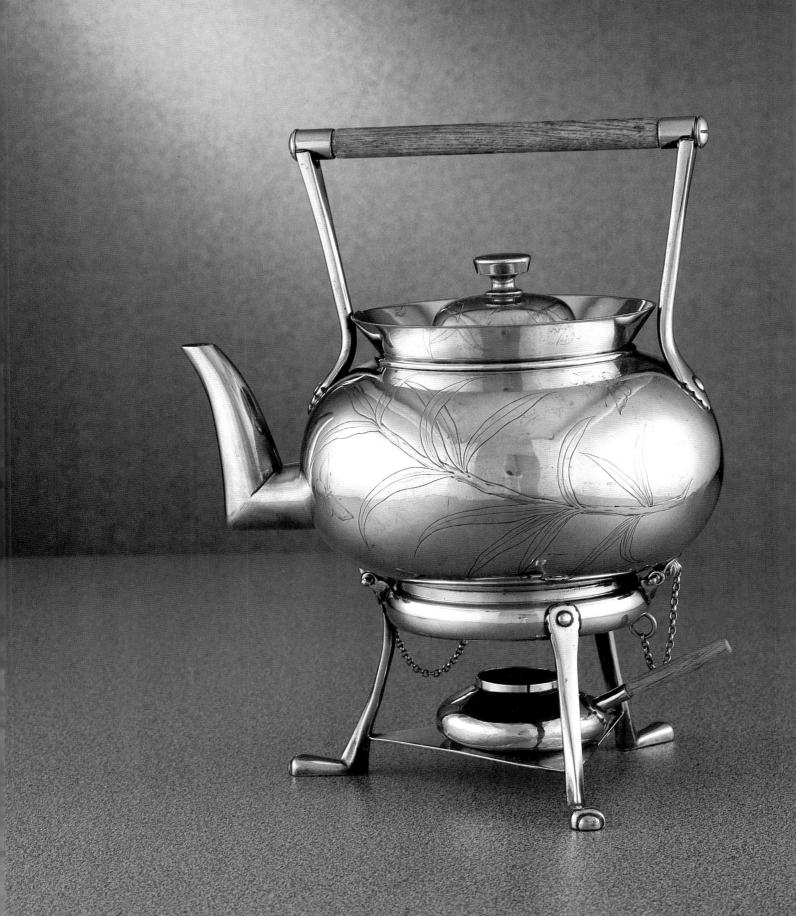

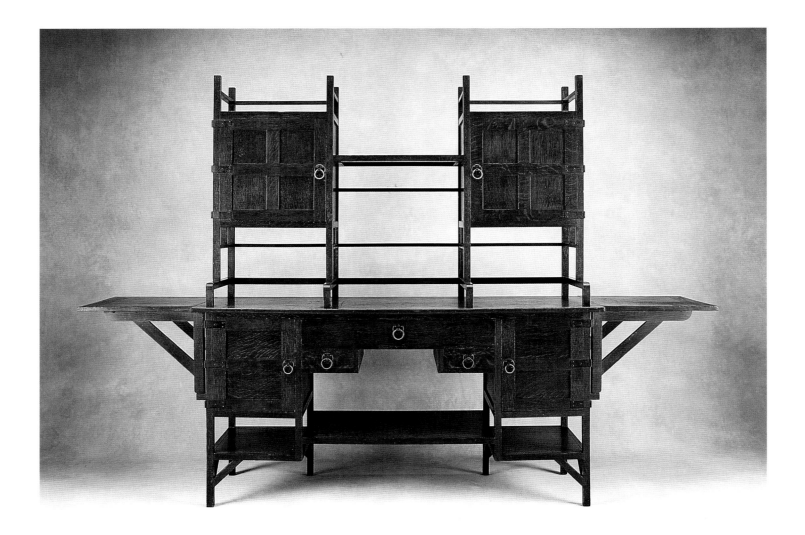

Japanese motives produced a style known as *Japanaiserie*, a parallel to *Chinoiserie*, which had been popular since the mid-eighteenth century. *Japanaiserie* indicates an enjoyable but superficial adoption of Japanese stylistic characteristics. For those advanced designers who took the taste for Japanese style further and deeper, to the point where they had fully absorbed the Japanese idiom, the term *Japonism* is used. E W Godwin (1833–1886) was such an artist. He so immersed himself in Japanese design principles that he was long past the decorative and surface quotations of Japanese mannerisms. The most notable feature of Japanese art and design was its sheer simplicity, in stark contrast to the lavishly over-designed and over-elaborate productions of the British Victorian age. Godwin's 1867 design for a sideboard was radical in its simplicity and purity. Structure and design, structure and

appearance were synonymous. Godwin could not have guessed the far-reaching consequences of this remarkable statement in functional design. He had introduced a direction which was to be taken up the world over to produce modernism, or what we think of as the modernist idiom, one that would carry force for at least a century. In many senses, it is still alive today.

So the innovatory power of Godwin's sideboard conception makes it a welcome inclusion in any collection of design. But there is another reason why examples of this design are undoubted treasures: they are exceedingly rare. There are less than a dozen of these sideboards extant anywhere. There are a few in Britain and at least one in the United States, and there is one attributed to Godwin in Munich. However, there are no less than two in Australia. One is in the collection of the National Gallery of Victoria

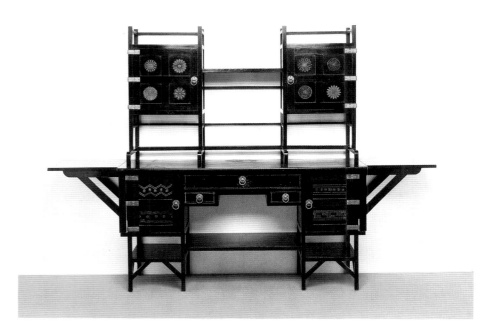

◄ **29.** *Sideboard designed in 1867 by E W Godwin (1833–1886), England. Made of oak, pine, brass and iron; height 180 x width 162 x depth 52 cm. Purchased 1991.*
Photograph by Andrew Frolows

in Melbourne and the other, of course, is at the Powerhouse Museum.

Another factor makes these two even more interesting. Of all the sideboards of this design known to exist, the two in Australia represent opposite extremes, or polarities. The Melbourne version is the most elaborate and ornate – though still without compromising the structural architecture of the piece. On the other hand, the Sydney version is quite the starkest, the most severe. So in Australia it is uniquely possible to appreciate the waveband, as it were, of Godwin's creativity. At least, as far as this remarkable sideboard design is concerned.

▲ **30.** *Sideboard designed by E W Godwin (1833–1886), England. Made by William Watt about 1877. Ebonised wood; height 184 x width 164 cm. Felton Bequest, 1977.*
Reproduced by permission of the National Gallery of Victoria, Melbourne

That said, there is an extra dimension of rarity in the Powerhouse's Godwin. In fact, it is quite unique. All the others are black. They were made in various woods, usually mahogany, which was then ebonised. (This merely means staining the wood black to suggest ebony.) The Powerhouse sideboard alone is in natural oak

29. *Detail*

and, indeed, until this wonderful piece of furniture turned up, nobody would have predicted an example of this design in anything other than ebonised wood. Of course,

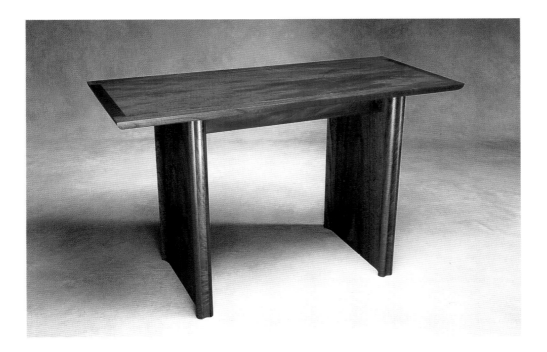

31. *Australian red cedar hall table designed and made by Grant Vaughan (born 1954) in New South Wales, 1993; height 70 x width 55 x length 120 cm. Purchased 1993.* Photograph by Jane Townsend

in black the design is more Japanese in effect. Why then would Godwin have sanctioned the oak version? Some have thought that oak is typical of the medieval, or rather, neo-Gothic style. And it is true that Godwin was a typical high Victorian in his ability to work in several different styles at once, even conflicting styles! He built neo-medieval castles and he also built functional, business-like warehouses in a no-nonsense, down-to-earth manner. He was probably content to approve one example of his famous design in oak simply because oak is so symbolic to the English. The Victorians were nothing if not nationalistic.

To describe comprehensively E W Godwin's influence on subsequent design history would require a book dedicated to that subject, even though Godwin himself, like so many pioneers, can have had little or no knowledge of all that was to come. He may even have found repugnant the very modernist style which his work anticipated. But the respect for clarity of structure and simplicity of statement as well as a high regard for function are enduring virtues. They characterise the work of a contemporary Australian craftsperson in wood, Grant Vaughan. The table in Australian red cedar which the Powerhouse Museum acquired in 1993, soon after Vaughan made it, is typical of his oeuvre. Its structure could not be more simple and straight-forward: two

uprights and one horizontal. This is post-and-lintel architecture which no doubt owes something to the fact that Grant Vaughan trained as an architect. Such structure is elemental and numinous. At a subconscious level it recalls Stonehenge. Like Godwin's sideboard it resonates with Japanese aesthetics and, elemental again, it is suggestive of a gateway.

Unlike the Godwin, Vaughan's table is more than a design, for it was crafted by the designer himself, presenting sensuous features, curves, edges, caressed into existence by Vaughan's own hand. Like the Godwin, Vaughan's table is elaborated with only the minimum of decoration, delicate strips of veneer. As the Godwin proclaims its substance of English oak, Vaughan's table proclaims its Australian red cedar, a timber that is now both scarce and exceedingly expensive. Grant Vaughan has received a number of official commissions in Australia and it is to be hoped that he will receive many more.

An English contemporary of E W Godwin's was Christopher Dresser (1834–1904), a most influential designer and design-theorist. Godwin and Dresser had much in common, not least a passion for Japanese design.

32. *Back of plate (detail)*

32. *Mortimer Menpes (1855–1938) painted the moonlit landscape scene on this porcelain plate in Japan in 1896 for his new London home; height 3.5 x diameter 24.7 cm. Purchased 1992.*
Photograph by Jane Townsend

Unlike most fellow enthusiasts, Dresser actually visited Japan, and this superb kettle, stand and burner of 1878 were made shortly after his immersion in Japanese culture for several months. The kettle group is at once elegant, visually appealing and highly functional. Indeed, it is made to a *functional aesthetic*. Its construction is frankly exposed as a prominent feature of the design. Even its rivets are boldly presented and used to punctuate the structure and catch the eye.

As a designer, Dresser brought to his profession a considerable expertise in a different discipline – botany. This was somewhat unusual, even taking account of the beliefs and attitudes of John Ruskin (1819–1900) whose theories of fidelity to nature and belief in organic structures and processes were a dominant force in nineteenth century English speaking cultures. Dresser's own level of distinction as a botanist, his knowledge of plant structures, occasionally informed his designs, though always in a discreet and sparing manner, never flamboyantly. Here, the sides of the kettle are decorated with a sensitive line engraving of plant forms.

Like Godwin's 1867 sideboard, the kettle group looks uncannily modern. We would not at first glance associate its sparse and economic lines with the suffocating plethora of ornamentation, the sheer ostentation, of typical high Victorian design.

*O*ne of the personalities of the period who, like Christopher Dresser, pursued his enthusiasm for Japanese style to the point of actually visiting Japan, was Mortimer Menpes. Menpes was an Australian, from Adelaide. In the 1880s he joined the circle of disciples around James McNeill Whistler, then the most famous and talked-about artist in London. Whistler is the outstanding example of the great Japonist who never went to Japan. Menpes, by contrast, not only visited Japan but, in 1896, he inveigled himself into a porcelain workshop in Tokyo and learned to fire pots and glaze them using authentic Japanese methods and processes. Unusually, he was sufficiently respected by Japanese craftspeople to be accepted as one of them. The porcelain plate owned by the Powerhouse Museum was produced under those circumstances and was part of a dinner service which Menpes produced in the Tokyo workshop. The nocturnal landscape depicted on it, in impressionistic brush-strokes,

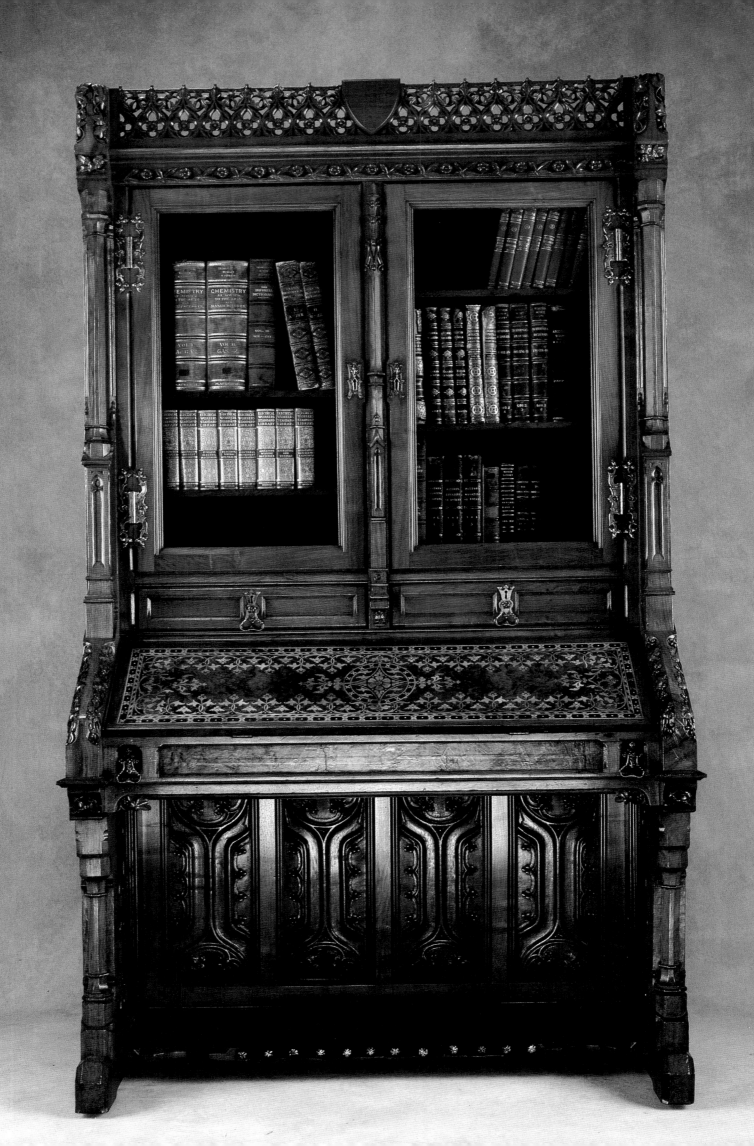

33. *Gothic-revival walnut secretaire/cabinet designed by John Dibblee Crace (1838–1919) in England, 1862; height 206.5 x width 120 x depth 58.5 cm. Purchased 1992.*
Photographs by Sue Stafford

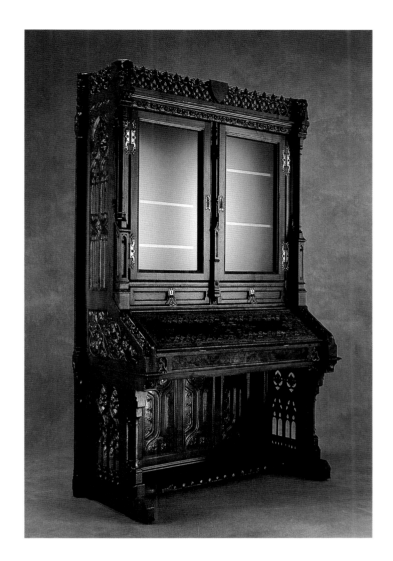

is undoubtedly Whistlerian, and none the worse for that. It is reminiscent of the American master's Thames scenes, moody and atmospheric. And like Whistler's Thames landscapes, Menpes' plate decoration is simple, minimalist and Japonist. The plate is so uncommon now as to be a rarity, and so it is all the more pleasing and fitting that it is a valued object in a design collection in a major museum in Australia, Menpes' native land and the country he revisited on his numerous travels.

The works by Godwin, Dresser and Mortimer Menpes, form part of a strong representation of British nineteenth century design, English arts and crafts, and art nouveau.

Notable in this context is a powerful exhibition secretaire/cabinet by the Crace firm of decorators (1768–1899), produced for international exhibition in London in 1862, and a group which includes works by William Morris (perhaps the most powerful influence on design in the nineteenth century), William de Morgan, Charles Rennie Mackintosh and others.

Much of the discussion above on design innovation has been about simplicity. The *G'day chair*, designed in 1988 by Brian Sayer and Christopher Connell, is not so much simple as laconic and very witty. For that reason alone it deserves a place in a museum as a rarity. In any of the visual arts, including design, humour is a scarce commodity. Cubist paintings have their in-jokes but they are generally too obscure or arcane for anybody except art initiates to see. There is humour of a leaden kind in surrealism but it is seldom without a tedious hint of menace. Pop art was very

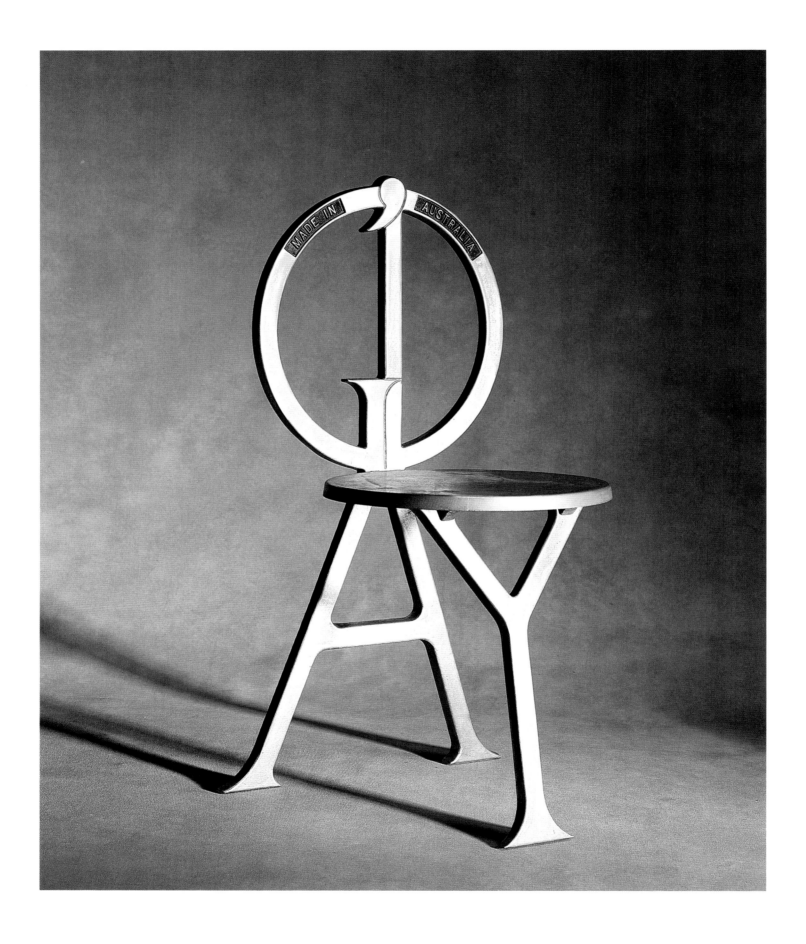

60

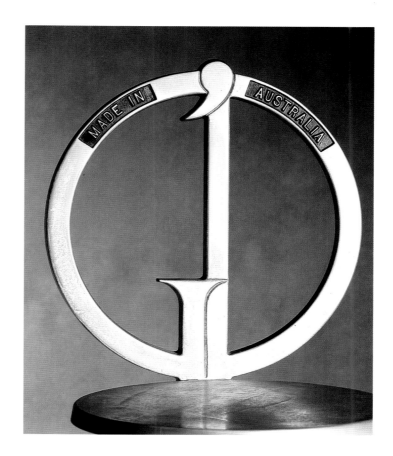

◄ **34.** G'day chair, *designed by Brian Sayer and Christopher Connell, of the G'day Chair Company, Sydney, 1988. Made from recycled aluminium; height 87 x width 40 x depth 38 cm. Purchased 1988.* Photograph by Penelope Clay

34. G'day chair *(detail)*.

funny but has been dated by more politically correct attitudes. Oddly enough, the *G'day chair* is like a cubist sculpture: it is planar and it works on puns as so much of Picasso, or Braque, or Leger did. Giving concrete form to a letter of the alphabet was a cubist innovation. But the *G'day chair* is all Australian. That laconic humour is Australian. In case you don't get the joke from the illustration, the chair is made in recycled aluminium in three sections: the back consists of the letters G and D above, with an apostrophe, and the letter A below. The front leg is a Y. You can take the *G'day chair* anywhere. It makes an excellent gift. Its humour is transportable and so is its light structure which folds neatly into a cardboard carton.

I have likened the *G'day chair* to a sculpture. Its minimal, skeletal structure makes it a perfect sculptor's armature. Australian designer Jenny Bannister treated it in exactly that way to produce a work for the AIDS Trust of Australia to auction at their second annual G'Day Gala auction held in 1989. The Powerhouse Museum was the successful bidder for Jenny Bannister's creation. To the structure of the chair she added a seat of black imitation fur, a black fluffy fringe and a large silvered metal brassiere surmounted by a red leather bow, matching the one below on the front leg. All three feet are decorated with puffs of black fur suggestive of a poodle. At the back

of the chair she hung a long white ponytail. Fully in keeping with the wit of the original chair, Bannister gave her work a punning title: *Chair coquette.*

While many of the objects selected for inclusion in this book could be described under a number of different headings, this is particularly true of musical instruments. In this late period of the twentieth century, there is a strong tradition in Australia of instrument design and making. The process of making instruments combines craft with science and the resulting objects, as well as being functional (on which they must be finally judged) are eminently suitable for display. The spectacle of an orchestra is visual and musical instruments are endlessly appealing to the eye. They are sculptures designed to function with the human body. Legs go around cellos, arms cradle violins, hands feel into the bells of horns, the reeds of clarinets and oboes go into mouths and tubas are embraced by the whole body. An orchestra is a symphony of colours – the savoury russets and browns of the strings, the strident flashes of gold and silver from the brass.

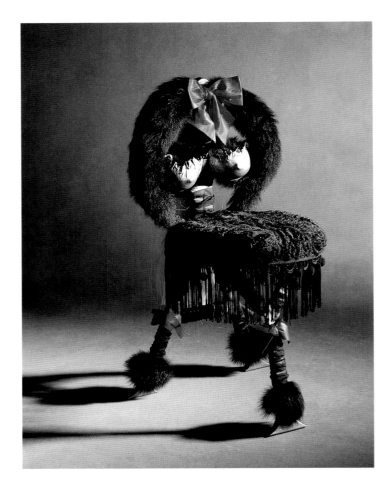

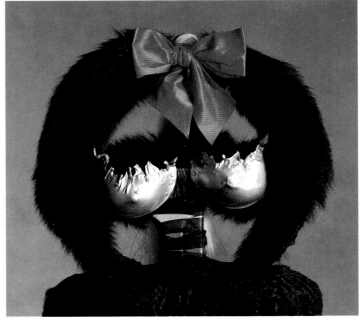

35. *Jenny Bannister (born 1954) decorated this* G'day chair, *and called it* Chair coquette, *Sydney, 1989; height 87 x width 47 x depth 43.5 cm. Purchased 1989.* Photograph by Penelope Clay

35. *Detail*

The oboe in rich, warm, brown mulga with gold-plated keys which the Powerhouse Museum commissioned in 1993 is a particularly beautiful instrument. If it were not the marvellous playing instrument that it is, its visual appeal alone would qualify it for this book's chapter on display. But this oboe also represents a number of technical innovations. It is the work of instrument-maker Tom Sparkes. Sparkes began his career as an oboe player and found himself able to carry out repairs to the instruments of fellow performers. Little by little, his repairing took over from his playing. As the logic of the situation ran its course, he began to make instruments. Today, working out of his Hornsby workshop in the northern suburbs of Sydney, Sparkes has assumed a leadership role in oboe-making that is of world-wide significance. His first innovation, of significance within Australia, at least, was his choice of an Australian hardwood, mulga. He found supplies of mature mulga in the form of props in disused gold mines, the perfect environment, dry and of even temperature, for the ideal ageing of the wood.

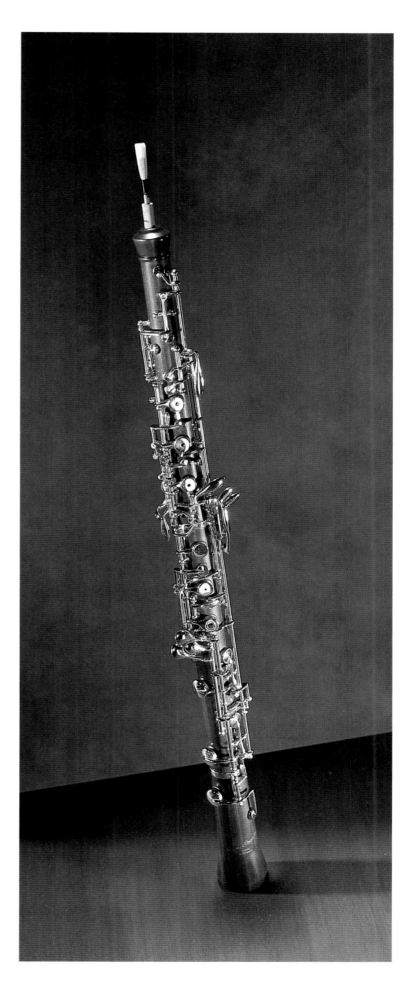

36. *Oboe, designed and made of brown mulga wood, with gold-plated keys, commissioned from Tom Sparkes of Sydney, by the museum; length 66 x diameter 8 cm. Purchased 1993.*

Photograph by Andrew Frolows

The finished appearance of Sparkes' oboes is a warm rich brown, a pleasant change from the previously ubiquitous black oboes made from the conventional granadilla wood from Africa. The russet colour of Sparkes' oboes is further enhanced by their gold-plated keys. The 'engineering' of the keys is yet another Sparkes innovation. They are strongly and elaborately balanced on long rods instead of pivot screws which make the pads and adjustments last much longer since they are not under such uneven pressure as in the conventional instrument.

Perhaps the most historically significant innovation for which Sparkes is responsible is his improvement of the pitch or intonation of the 'lowest' two keys – those furthest away from the reed, or lips of the oboist. Throughout the history of the oboe, these have always played flat. Performers have always had to gloss over this historic failing of the instrument, or they have vainly tried to 'lip' the notes up. Sparkes solved the problem quite simply by redesigning the join between the middle and the lowest sections of his oboes and, flouting conventional wisdom, added in a carefully measured step. Thus, for the first time in history, oboes play in tune!

Designed for Display

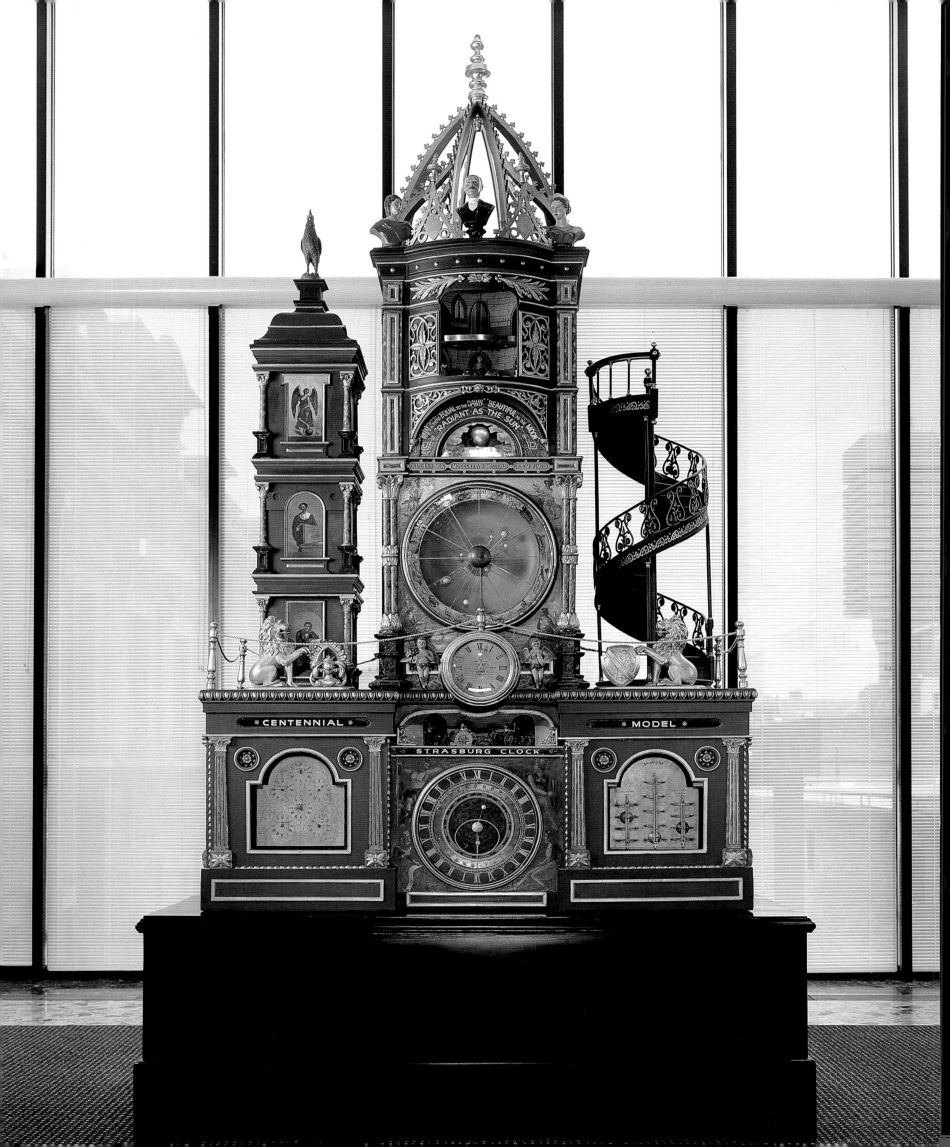

Designed for Display

*t*here are many objects in the Powerhouse collection which have an ostensible function, such as telling the time or containing a quantity of liquid or supporting a seated person, but whose real function is the same as that of the paintings and sculptures in an art gallery. This is to be gazed at, to be the object of visual delectation. Many such objects, particularly in modern times, that is, in the age of museums, have been intended from the outset, by those who produce them, for public exhibition.

It is hard to know what purpose Richard Bartholomew Smith (1862–1942) intended for his large model of the cathedral clock in Strasbourg when he approached the New South Wales government in 1889 to persuade them to buy it. It really could go nowhere else but into a museum. In that sense, even when it was completely new, it was a museum piece. At all events, the government must have thought so when they gave Smith his seven hundred pounds and placed his clock straightaway into the Technological, Industrial and Sanitary Museum (the ancestor of the Powerhouse Museum) where it gave a needed fillip to visitor numbers. Indeed, the clock may well have saved the institution, since before its arrival attendances were so poor that the museum faced closure. Even today, the Powerhouse's record for the largest visitor numbers of any museum in Australia is enhanced by the

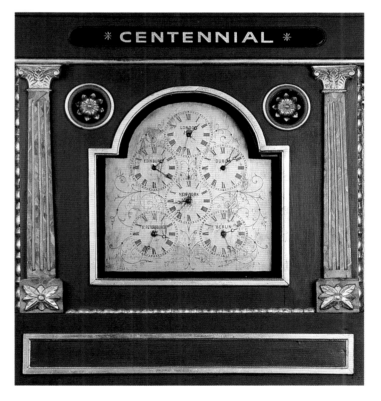

37. *The 'Strasburg' clock was built in Sydney by Richard B Smith (1862–1942) and ornamented and painted by James Cunningham (1841–1905) in 1887–1889; height 366 x width 185 x depth 91.5 cm. Purchased 1890.*

Photograph of entire clock by Penelope Clay; details by Andrew Frolows

performance of the Strasburg Clock, which is still a drawcard. It continues to demonstrate the same comforting teleological message of its medieval predecessor, namely, that the universe is an orderly mechanism with an all-powerful deity to keep the springs wound up.

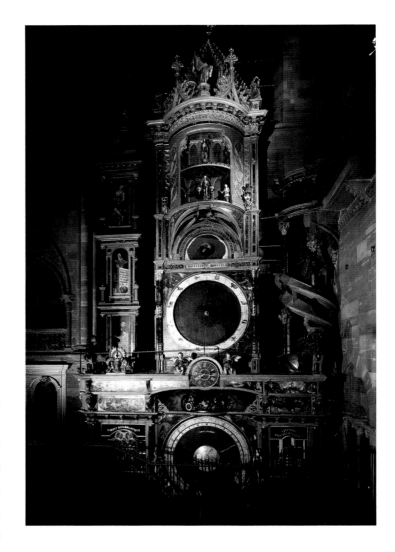

38. *The giant clock in Strasbourg Cathedral which provided the inspiration for Richard Smith's model.*

Reproduced with permission from Edira. Photograph by René Ansel, France

The continuing popularity of the Strasburg Clock model is a paradox that can only be explained by its rarity, its oddness. It is a true curiosity. Every hour, some seventy or eighty people will sit on seats provided to meet this demand and watch a large and rather gaudily painted clock go through its paces. On the hour they will see a procession of tiny dolls, representing the apostles of Jesus Christ, pass and bow in front of an enthroned doll representing their Lord. As the one representing St Peter takes his turn, a crude figure of a cockerel, perched on a flanking tower, crows thrice after the manner described in St Mark's Gospel in the New Testament, indicating St Peter's denial of Christ. In his turn, Judas Iscariot comes along carrying his bag of silver. In a separate small alcove another event takes place as the four ages of man adjust their positions according to the time of day. And there are many other functions visible to continuingly enthusiastic audiences, most of whom return home for the evening to watch television. Or they might play or work on their personal computer. Yet no modern gimmickry lessens the fascination people feel for this home-made astronomical clock.

The clock was made by Richard Smith, an eccentric Sydneysider, when he was in his mid-twenties, to mark the centenary of European settlement in Australia. It was a copy, or rather a version, of the famous astronomical clock in the cathedral of Strasbourg. He seems to have worked from photographs or printed illustrations because there is no evidence that he actually went to Strasbourg. (Smith's apparently idiosyncratic spelling of Strasburg reflects a common nineteenth century spelling.) Smith's effort can best be described as a scale model, because the original is six times bigger, with a truly architectural height of eighteen metres. (It, too, is immensely popular. Every day tourists, for a special fee, are jostled and packed, to a level of life-threatening discomfort, into the north transept of the cathedral, to face the giant clock on the east wall and listen to a prerecorded tape in several languages.)

One of the specially interesting aspects of Smith's clock is that it falls quite definitely into one of Australia's major cultural traditions, that is, improvisation. Although Richard Smith fancied himself as a great craftsman and technician, he was really an inspired bodger. He made this clock from scrap materials in his backyard workshop. The case is roughly constructed from packing case wood

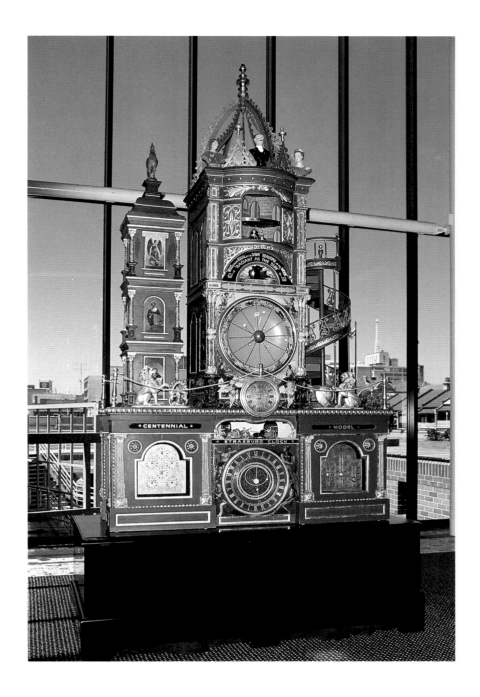

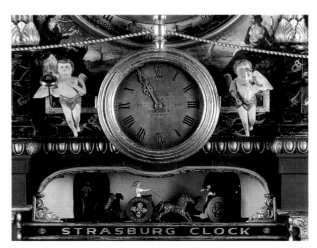

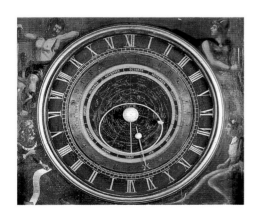

37. *'Strasburg' clock and details.*

Photograph of entire clock by Penelope Clay;
details by Andrew Frolows

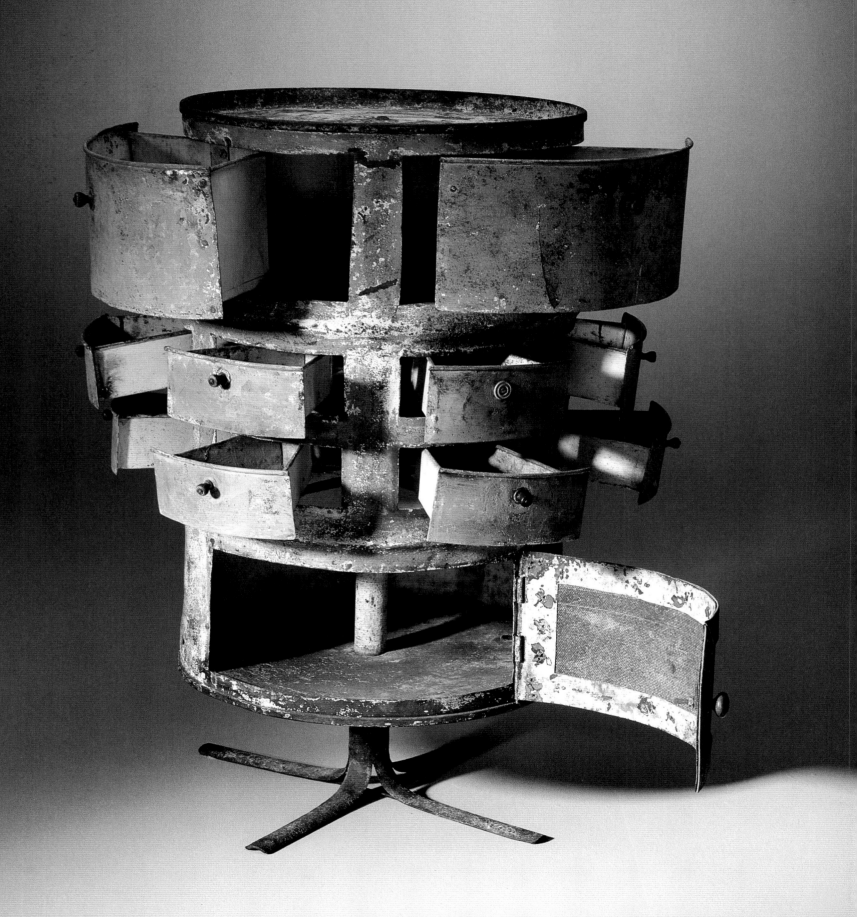

39. *Australian 'bush pantry', home-made in about 1925 from a galvanized iron 44-gallon drum; height 87.5 (111.5 on stand) x diameter 65 cm. Purchased 1992 from the McAlpine Collection.*
Photograph by Penelope Clay

although it is richly ornamented and painted by Smith's collaborator James Cunningham. For the mechanism, Smith appears to have used whatever bits of metal were to hand. This does not lessen the fascination of his creation one jot. Neither does the fact that the clock seldom worked or, to say the least, was erratic in its performance. In the early days of its life as a museum exhibit, Richard Smith was the only person who could make it work, a fact that caused regular friction with the museum management.

A century after he created it and managed to sell it to the New South Wales government, Smith's clock has received dedicated care and attention from skilled modern experts so today, with a minimum of maintenance, it continues to delight and entertain museum visitors who seem to attach far more significance to its mechanised and somewhat naive theatrics than they do to the endless supply of sophisticated but bland entertainment available to them on the TV at home.

Although Richard Smith's Strasburg Clock model was made in the middle of a large city, namely Sydney, it has much in common with bush furniture. It has a connection with all those artefacts made in far-flung places with little or no access to shopping emporia. People mixed and used whatever materials were available, manufactured or natural, to make functional objects, such as furniture, or sometimes fun objects such as toys.

*S*ome settlement objects are so unconventional or so unselfconsciously creative as to appear surrealist. Today, taken out of their original depression or settlement contexts, they have a ready appeal as exhibition pieces. A dresser or chest of drawers in the Powerhouse collection may look like a sculpture by Salvador Dali. Made for purely utilitarian purposes by some not-so-naive denizen of the outback, is this construction from a large oil drum. This extraordinary object was acquired from the McAlpine Collection of bush toys and furniture which was shown in virtual entirety at the Powerhouse in 1990. Other examples of the same genre include a food safe resembling a piece of neo-gothic, ecclesiastical architecture (acquired in 1993 in a conscious effort to boost the collection's neo-gothic holdings), another in the form of a robust piece of federation architecture, and a decorous commode made from boxes originally containing tins of kerosene, (see photo pages 22–23). Outback users of recycled materials received encouragement and instruction from printed matter funded by oil companies, showing how to transform kero tins and packing cases into furniture. The results are eminently exhibitable.

Such objects have a strong claim to representation in an Australian museum collection because they are a central or essential aspect of Australian culture and history. They are curiosities indeed, but also more than that. With the end of

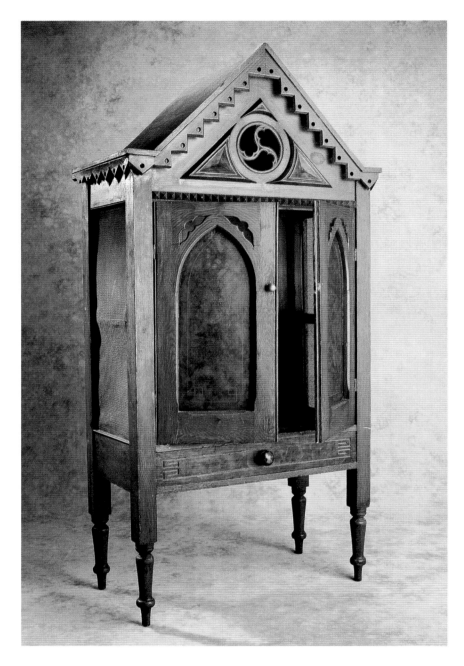

40. *Australian gothic-revival food cupboard made of packing-case pine with perforated zinc side panels. Its gabled roof is painted with 'trompe l'oeil' bookcases; height 191 x width 96 x depth 45 cm. Purchased 1993.*

Photographs by Sue Stafford

the twentieth century in sight, these supposedly naive or Depression objects have much to teach contemporary society. They are ideal models in any concept of conservation or recycling. They were made by people who took little in the way of resources and recycled everything they could. Yet Depression artefacts, settlement or bush objects – in this context all these names are inter-changeable – though utilitarian, were made with wit, with style, with imagination and, when all is said and done, with real affection.

Whatever their qualities such bucolic objects were not, of course, designed expressly for display. But Australia has long boasted a strong tradition of excellent and sophisticated furniture making and the museum is always keen to acquire objects representing that proud aspect of our national heritage. A good example is the Tasmanian muskwood table, acquired in 1992, which occupies a prominent position in the Powerhouse Museum's rich collection of colonial Australian furniture. This is because it was made for a most important exhibition, none other than the very first international expo, the Great Exhibition in the Crystal Palace in Hyde Park, London, in 1851. It was presented in the Van Diemen's Land (as Tasmania was then called) section of the exhibition. The small island

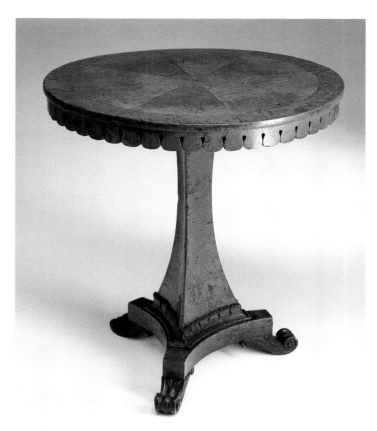

41. *Occasional table from Tasmania, exhibited for the beauty of its material – muskwood veneers on a red cedar carcass – at the Great Exhibition of 1851 in London; height 72 x width 64 x depth 64 cm. Purchased 1993.* Photograph by Jane Townsend

colony showed off its primary resources such as timbers, furs and so forth, but a number of manufactured products were also displayed to indicate ways in which the world might employ Tasmanian materials. The muskwood table is small and modest (and therefore easily shipped) but it reveals the impressive qualities of its wood, its honeyed colour and its fine grain.

The term *fine arts*, even though it has held currency for a very long time, is somewhat deficient. In most people's minds, it connotes only paintings and sculpture. *Applied arts* is a decidedly obsolete term, for many craftspeople produce works of expressive power and creativity equal to anything produced by a painter. The Powerhouse Museum has no mandate to collect fine art as such but it does have a strong brief to collect craftwork. Very often, there is no meaningful distinction. A major work by John Perceval is a case in point. It was acquired in 1991 as a superb example of innovation in ceramics.

John Perceval (born 1923) is without doubt one of the most important artists in twentieth century Australia. He was a key figure in the Melbourne group of expressionists, of whom Sidney Nolan and Arthur Boyd were among the most prominent. Boyd himself was born into a dynasty of craftspeople and Boyd and Perceval, with others, set up a pottery close to Arthur Boyd's father's existing pottery, at Murrumbeena, near Melbourne, in 1944. Murrumbeena

soon consolidated its reputation as a colony of artists and intellectuals, attracting a wide range of luminaries who have since figured prominently in histories of Australian arts and crafts.

Perceval's imagery, both in painting and in ceramics, followed similar themes. For about five years from 1957, Perceval produced a series of representational ceramic pieces on the theme of angels, which have become famous partly for their potency as images, as ceramic sculptures, and partly for his experimental techniques. The culmination of this development was a powerful sculptured group called *Romulus and Remus with wolf mother*, which Perceval made in 1961. The colour of this astonishingly innovative work is supplied by the *sang-de-boeuf*-type glaze with which Perceval had been experimenting for years, inspired by Chinese traditions. The infant figures, naked, of Romulus and Remus are undoubtedly a continuation of his angel series. Like his

42. *Artist and potter John Perceval (born 1923) made* Romulus and Remus with wolf mother *of earthenware with* sang-de-boeuf-*type glaze, at Murrumbeena, Victoria, in 1961; height 31 x width 52 x depth 25 cm. Purchased 1991.* Photograph by Penelope Clay

43. *One of two large terracotta* Palaceware *jardinières, thrown by Mark Heidenreich (born 1958), decorated by Stephen Bowers (born 1952), in Sydney, 1989; height 257 x diameter 88 cm. Purchased with funds donated by Philip Davenport, 1991.*
Photographs by Penelope Clay

angels, they are little devils. They are like demanding parasites sheltered by the powerful, resilient, protective wolf mother.

Perceval's *Romulus and Remus with wolf mother* is a powerful statement whose full significance has yet to be appreciated. Many of Perceval's contemporaries, such as Sidney Nolan, drew on antique myths and legends in a way that has become more apparent through time. Melbourne has often been referred to as the 'Athens of the South' and there has been much conscious identification with Mediterranean culture among the very active artist groups of that city. So it is not at all surprising that Perceval should have resorted to such an archetypical image as Romulus and Remus. His highly individual approach to the theme expresses not only strength but also pain. The pain no doubt flowed from the artist's own somewhat tortured existence, but in addition it is almost certainly a reflection of the horrors of international conflict.

In recent times, Australian crafts have continued to manifest a connection with classical and Mediterranean cultures. The title of two large urns, or jardinières, was originally 'Etruscan'. The makers, Australian potters, Mark Heidenreich and Stephen Bowers, later changed this to *Palaceware* jardinières. After agreeing on their overall approach, Heidenreich made them and Bowers carried out the decoration. The whole process was executed at the Pump & Crank Pottery, Taren Point, Sydney, in 1989 and the works were acquired by the Powerhouse Museum in 1991. In the museum, the jardinières are displayed to serve an architectural function; they stand as sentinels on either side of the entrance to a decorative arts exhibition. This is exactly as Heidenrich and Bowers intended; the very scale of the jardinières is architectural. With its pedestal, each one is more than two and a half metres high. It was a real technical feat to get them both to match exactly in scale. Throwing or coiling pots is more of an organic process than a precise one and each pot is made up of five discrete components, which were then assembled or stacked. The final effect is powerfully classical, yet the decoration employs Australian

44. *Stoneware jar made by Errol Barnes (born 1941) and decorated by Joe Furlonger (born 1952) in Queensland, 1991; height 89 x diameter 72cm. Purchased 1991.*
Photograph by Penelope Clay

floral motifs, albeit with an 'Etruscan effect'.

The decoration by Joe Furlonger of a large stoneware vase thrown by Errol Barnes is another strong example of the links between Australia's ceramic tradition and the Mediterranean. On a biscuit-coloured base, Furlonger's swirling figures, line-drawn, pick up references from Picasso and, through him, from Picasso's own sources, the long tradition of decorated Greek urns.

Inspiration from a similar region of the Mediterranean, but from an earlier period, can be seen in the splendid glass creations by Brian Hirst, one of several excellent glass artists in Australia. *Votive bowl* of 1992 is a large powerful vessel, chunky, thick and heavy, standing on three inverted cones which act as legs. Hirst's colours are dark, rich and lustrous. This bowl has a strong presence and speaks of a lost age of mystery and myth.

Glass workers and ceramicists have much in common. Both crafts use very high temperatures and both produce similar objects: bowls, dishes, vases and goblets. Both crafts are deeply traditional. Ceramics in particular owes much to oriental countries, Japan, Korea and China in particular. Perhaps because Australasia is on the Pacific rim, New Zealand and Australian potters have been highly responsive to oriental traditions.

Chester Nealie (born 1942) began his career as a potter when he was directly inspired by the visit to his native New Zealand of two leading Japanese ceramic artists. Nealie went on to give life and contemporary relevance to the ancient oriental technique of prolonged high-temperature wood firing. With his friends, Nealie rediscovered the anagama kiln, which is made to a length of several metres, with different zones for firing. The potter literally crawls

45. *Brian Hirst (born 1956) made this blown and cast glass* Votive bowl *in Sydney in 1992; height 28.3 x diameter 30 cm. Purchased 1992.* Photograph by Lisa Sharkey

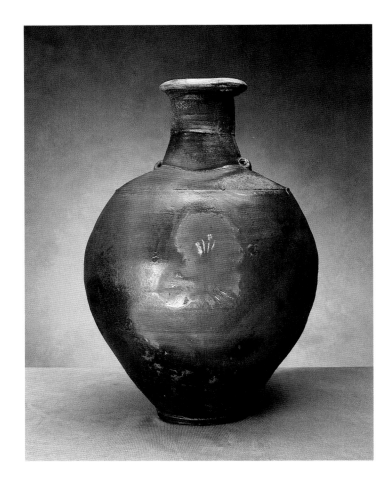

46. *Large stoneware, wood-fired vase by Chester Nealie (born 1942) in NSW, 1992; height 70 x diameter 45 cm. Purchased 1993.*
Photograph by Jane Townsend

inside and along the kiln to stack pots ready to fire. An essential part of the creative process is to anticipate some of the apparently chance or random effects of flame and ash on the surface of the pots. Nealie's pots are thick and chunky; they are a rich record of the process that brought them into being: a mixture of coiling and throwing, followed by the traditional firing technique. The result is powerful, with strong overtones of the middle ages. There is no sense of over-refinement.

Col Levy is another Australian potter inspired by oriental traditions, yet refinement is one of the first words that come to mind when describing his work. Levy worked for a time in pottery studios in Japan, absorbing the tradition at first hand. The spherical form of this porcelain vase is complemented by a deep copper-red glaze which invites the eye to pass smoothly over and around the form. The spherical body is almost mathematical but not quite – the white-lipped opening at the top is delicately organic, revealing the dynamic quality that is essential in all wheel-thrown pots.

The craftspeople so far mentioned all have well-established reputations. Their works are in a number of major public collections as well as private ones. They have been the subjects of numerous articles in specialist journals, catalogues and books. Museums and art galleries seldom go out talent spotting. Although curators keep an

eye on schools of art and design and attend end-of-term exhibitions of student works, generally it is only when young talents have proved themselves and established a track record that their work attracts the attention of a major public museum. Generally but not always. Occasionally the museum will acquire the work of a newly emerging craftsperson if it looks sufficiently interesting. A recent case in point is the ceramic work of Anders Ousback. His first exhibition in Sydney, at the Rex Irwin Gallery in February 1994, was a complete sell-out. Undoubtedly benefiting from a strong Australian tradition of ceramics and with an obvious debt to potters he admires, such as Gwyn Hanssen Pigott, Ousback has produced fine porcelain bowls and vases which, placed together, invite the calm contemplation that might be evoked by a still-life by Giorgio Morandi. The bowls and beakers by Ousback are subtle and delicate, combining a simple solid geometry with a sense of the organic. Ousback has changed careers. He was widely known in Australia as a restaurateur of distinction, so perhaps it is not surprising that he has now focused his attention

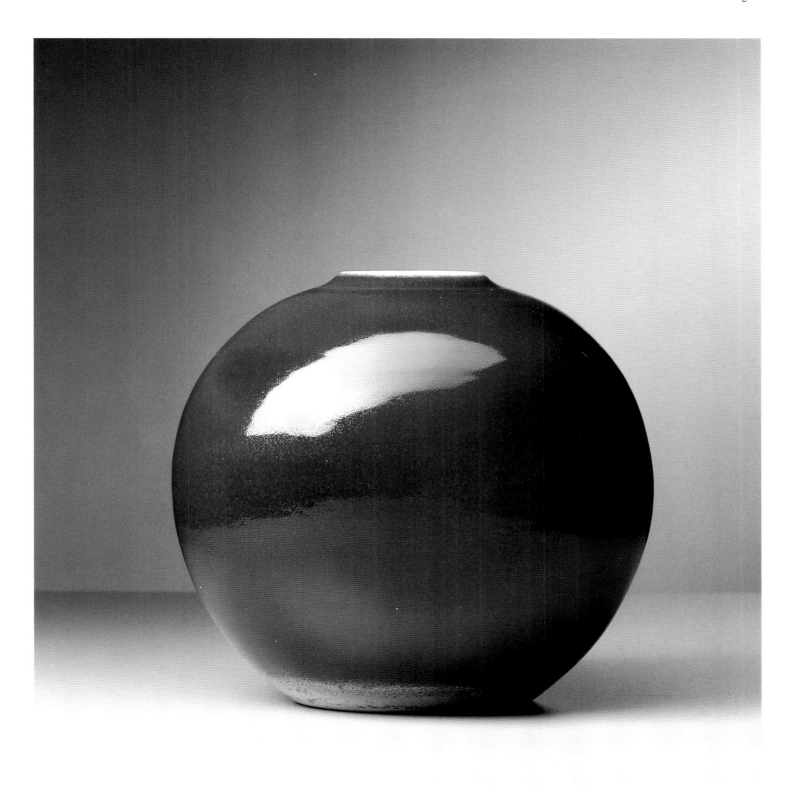

47. *Porcelain vase with copper red glaze by Col Levy (born 1933), NSW, 1985;*
height 34.7 x diameter 37.5 cm. Purchased 1986. Photograph by Andrew Frolows

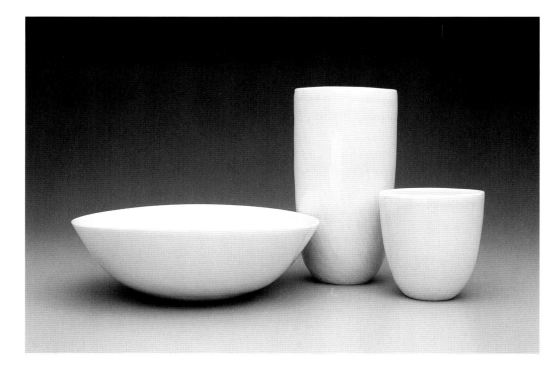

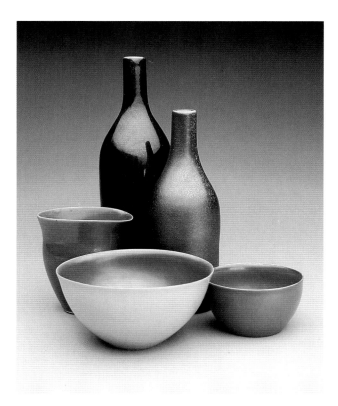

away from food and on to the vessels that contain it.

All the ceramic and glass works just discussed are capable of functioning as containers but they are really objects of contemplation. They are mostly vulnerable and fragile; they would be impossible to replace and they need to be looked after carefully. It is appropriate for them to be in the museum's collection, taking their turn on display or in storage but always accessible to specialist or keen enquirers.

Just as those vessels can hold water, so the *Lysaght couch* by South Australian Bruce Howard is fully capable of being sat on. Yet it is pre-eminently an exhibition piece. The museum acquired it in 1991, the year after Howard made it. It is a prominent work in a whole series of extraordinary pieces of furniture that would best be described as works of art on a theme of furniture. Through his whole oeuvre, Howard investigates and celebrates his interest in quintessentially Australian materials as well as international historic styles. This allows him to finish off an object with flourishes of whimsy.

The *Lysaght couch* derives its title from the name of the division of Broken Hill Proprietary Company Ltd (BHP) which produces corrugated galvanised steel, the material which is practically ubiquitous in Australian roofs and of which this large object is made. More than two and a half metres long the *Lysaght couch* would fit awkwardly into a

domestic space, but the powerful scrolls that make up its arms/legs – quite Napoleonic in their effect – easily dominate the more generous spaces of an exhibition gallery. Exhibition designers find that they have to give Howard's work plenty of room to breathe. It cannot be crowded with other objects and it needs to be seen from a distance, while it also needs to be seen close up so that important details are not missed. For example, at each end of the top Howard has supplied a finial consisting of a brass tap with a bull's head spout. The bull's horns are there to hang a notional bucket on! This latter piece of whimsy is a reference to one of Howard's fond sources for this work, a workman's couch comfortably positioned on a cottage verandah. Another humorous touch is the brass bath plug at the centre of the lower part of the seat. Its attendant plug chains are a faint but discernible parody of classical swags. Thus Howard makes art that plays off provincial bush pragmatism and homeliness against grandiose historical and rhetorical styles. The *Lysaght couch* is not altogether comfortable to relax on at home but is stimulating and impressive in that great modern public forum, the museum!

50. Lysaght couch *by Bruce Howard (born 1945) made in Adelaide in 1990 of corrugated Lysaght Mini-Orb galvanised steel over mild steel frame with brass trimmings. The title refers to Lysaght's Works Pty Ltd (now part of BHP) who were the makers of the first rolled corrugated steel in Australia, in Newcastle, in 1921; height 76 x width 256 x length 62 cm. Purchased 1991.*
Photograph by Penelope Clay

a young Sydney designer who has made an international name for exhibition piece furniture is Marc Newson. His *Lockheed lounge* of 1989 and his *Event horizon table* of 1992 are remarkable examples which the museum has recently acquired. Like Bruce Howard, Newson also draws inspiration from the past as well as from modern technology, but his metaphors are more high tech or even science fictional. The *Lockheed lounge* is a play on the traditional shape of a chaise longue, or Madame Recamier chair, but its glossy, reflective aluminium body is made up of riveted sections resembling a modern aircraft fuselage. Hence the title borrowed from the American aircraft company. The *Lockheed lounge* is made in a limited edition, hand built to Newson's design by his associate Eckhard Reissig. Each example is made to order and so is naturally

very expensive. It is therefore a collector's item and museum object. The *Event horizon table* is even more futuristic, suggesting not so much aviation technology as space travel or the exploration of other worlds.

'I've always been fascinated by space travel. My dream would be to do a space ship interior,' Newson is quoted as saying in a February 1994 issue of *Blueprint*, a leading London design magazine. The issue features a lengthy article on the Australian designer and a full-length photograph on its large-format front cover. Newson's POD bar in Tokyo is indeed like the interior of a spacecraft as is his Skoda boutique in Berlin.

Tom Sparkes' oboe, a beautiful looking instrument, was discussed in the preceding chapter because of its innovative approach to instrument design. A saxophone in

51. Lockheed lounge *was designed by Marc Newson (born 1963) in 1985–1986, and made in Sydney by Eckhard Reissig (born 1945) of fibreglass and aluminium 1990; height 90 x width 60 x length 180 cm. Purchased 1991.*
Photographs by Sue Stafford

52. Event horizon table, *made of aluminium with painted red enamel interior, designed by Marc Newson (born 1963) and made in France in 1991–1992; height 82 x width 94 x length 180 cm. Purchased 1993.*
Photograph by Sue Stafford

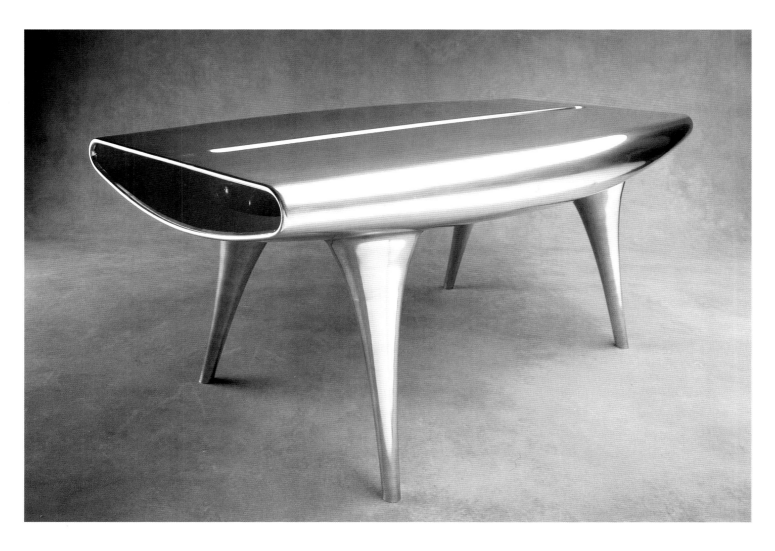

53. *Gold-plated alto saxophone made by Australian J E Becker in 1926 at the Conn factory in Indiana, USA, at the end of his training as a brass instrument maker; height 15.5 x length 64 cm. Purchased 1989.*
Photograph by Sue Stafford

the museum's large collection of more than six hundred musical instruments is remarkable less for its sound, which is fine, and more for its finish, its extraordinarily striking visual appeal. Made of brass, its gold-plated surface is exquisitely engraved with graphic designs, which, under scrutiny, manifest humour and wit. In among lyrical and linear designs is an image of Uncle Sam shaking hands with a kangaroo. The significance of this vignette is that the saxophone was made in 1926 by a South Australian, J E Becker while he was working for an American company, C G Conn Ltd, of Indiana. With this saxophone,

Becker completed his apprenticeship. In the truest, medieval sense of the word, this was his masterpiece. The instrument has been played by Don Burrows in a performance in the museum. The audience was enthralled by the sound that Burrows was able to produce on it, but, as he said to his listeners, the musician himself was deeply impressed by Becker's decorative embellishments. The great jazz player enthused, and enthused his audience, about the mother-of-pearl keys and the octave key shaped like a snake 'with emerald eyes'.

'The car is a landscape as if viewed from an aeroplane –

54. *BMW Art Car painted by Michael Jagamara Nelson for BMW, as exhibited at the Powerhouse Museum.* Reproduced with permission from BMW AG. Photograph by Andrew Frolows

I have included water, the kangaroo and the possum.' These were the words used by Michael Jagamara Nelson to describe his contribution to the BMW car company's *Art Car* collection exhibited at the Powerhouse Museum in 1989. Jagamara Nelson is a member of the Warlpiri tribe from Central Australia's Western Desert. His usual technique of painting uses acrylic paints applied in the dot style associated with Papunya.

Nobody knew if acrylics would survive when painted on the metal of a car body, so a piece of a car was flown to Papunya for the artist to use as a test. The test proved successful and Jagamara could have used his acrylics, but at a late stage he decided to go with the automotive paint that BMW provided. The test door remained as a work of art in itself and the company graciously donated it to the Powerhouse since the museum had recommended Jagamara to BMW in the first place.

Aboriginal works of art were produced, until recently, to play an integral role in tribal ritual. Of late, Aboriginal paintings, with their traditional messages intact (even if edited for western eyes) have hung in art galleries in the European manner and sold as commodities. Either way, Aboriginal paintings were meant for display. All that changed was the nature of the audience, the venue and the time scale. Ritually, painting apart from rock paintings may have been more ephemeral. European-style canvas paintings are portable – though what could be more moveable than body-painting? It is never still! Michael Jagamara Nelson carried out his car commission on the notion that his message could be painted on any surface, no matter where. In doing so, he also pointed to a new realisation about the role of the motor car in ever-evolving Aboriginal culture. There is no doubt that the car has been a positive force in renewing ceremonial contact between dispersed tribal groups and, ironically, the car has played its part in the recent reinforcement of traditional ritual relationships. Since 1989, the Jagamara car has travelled the world, carrying its potent message into the heartlands of western high-culture. In the meantime, the museum's acrylic-painted door has gone on show, making its own contribution to landscape themes, revealing more about the land and denying the common belief that Aboriginal culture is inherently static. On the contrary, it is a small but powerful demonstration that Aboriginal culture, while it maintains its own integrity, is a developing and evolving culture.

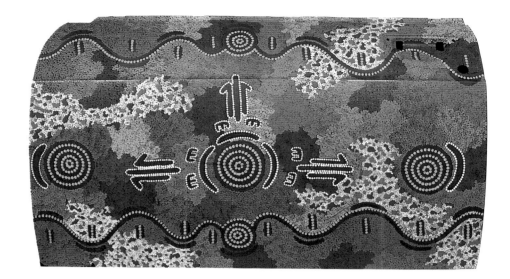

ʌ **55.** *Painting, acrylic, 1989,
on a BMW car door panel, by
Michael Jagamara Nelson,
from Papunya in the Northern
Territory, Australia; height
62 x width 99 x depth 16 cm.
Gift of BMW AG, 1992.*
Photograph by Andrew Frolows

*BMW Art Cars on display in the museum
in 1989. In the foreground is the car painted
by Michael Jagamara Nelson.*
Photograph by Andrew Frolows

56. *The Powerhouse Museum Garden Restaurant painted by Ken Done (born 1940) in 1994. Paint, gift of Chroma Acrylics, 1994. Design and painting, gift of Ken Done, 1994.* Photographs by Penelope Clay

The BMW Art Car collection also contains a car painted by the Australian artist Ken Done. Done is of particular interest to the Powerhouse Museum. With his wife Judy, he is a principal of Done Art and Design, an extremely successful Sydney-based company which markets its Australian products overseas, particularly in Asia and Japan. Done's trade mark is a colour scheme of vivid primaries, printed on T-shirts, scarves, dresses, and almost every type of garment, as well as other fabrics. His patterns and shapes come from nature, mediated by his paintings, because Done is a seriously committed artist. Much of his pictorial vocabulary comes from beach scenes and views of Sydney Harbour, on the shores of which he and his wife have their house. To many Australian eyes, his paintings are too bright, too hedonistic for a fine art world that puts a higher premium on pain and agony. I have witnessed the reception of Done's work overseas, where it is

regarded as distinctly Australian and is seen as capturing an Australian life-style. Although Done's reputation as a painter and designer is big in Japan (where he is also very successful as a graphic artist), the Australian art world has awarded him scant recognition. He is regarded as derivative in an art world where artists win points for their quotations, although these are usually delivered with a knowing irony or even a twist of derision. Done's references to other artists, notably Matisse, Bonnard, Hockney, are presented with affection, or with that other Done trade mark, a smile!

The Powerhouse Museum would be stretching its brief to acquire paintings by Done, but it was well within its scope to commission him to paint the restaurant in 1994. So the restaurant is now a gigantic artwork in which visitors can dine together enjoyably. The theme which the artist chose was a garden, resembling his own, but here set up in contrast to the industrial environment of Ultimo, the district which the museum shares with the ABC, Fairfax Press, a commercial television station and the University of Technology, Sydney. The Garden Restaurant by Ken Done is the largest painted public commission given to any artist in Australian history. The Board of Trustees was naturally prepared to meet the cost, but Ken Done, having accepted the job, declined payment. He even organised a sponsor to provide the paint free to the Museum. This was the paint manufacturer, Chroma Acrylics, a notably successful Sydney company; their exports to the USA are so voluminous that they have now built a factory in Pennsylvania.

*O*ne of the most remarkable objects made purely for display, and recently acquired, is Peter Tully's *New Age business suit*, made in Sydney in 1989. Tully (1947–1992) was a remarkable designer, who was one of the main inspirations behind Sydney's Gay and Lesbian Mardi Gras, which he directed from 1982 to 1986. Originally trained as a jeweller using precious metals, Tully systematically undermined elitist and over-precious attitudes to costume and jewellery by introducing cheap and gaudy materials in day-glow colours and plastics. Simultaneously, he brought in overtones of exotic and tribal ritual decoration – all with an unstressed wit and

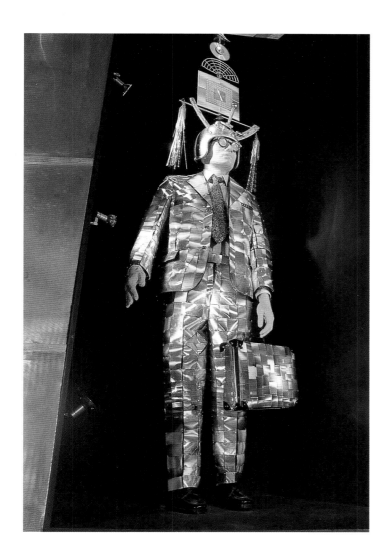

57. New Age business suit *designed by Peter Tully (1947–1992), and made from a range of materials including holograms, in Sydney, 1989. Purchased 1990.* Photograph by Andrew Frolows

Opposite, photograph by Sue Stafford

good humour. His work was confronting but never aggressive. In this work, which the Powerhouse commissioned for an exhibition of contemporary Australian fashion, Tully takes on that enduring symbol of conformity, the business suit, and transforms it with a dazzling surface of small holograms. The briefcase, symbol of hard work and respectability, is given the same surface treatment. The head gear is both exotic and futuristic. Surmounted by a compact disc, it nevertheless looks like a radio receiving station.

Tully's oeuvre has contributed immeasurably to the progress of gay liberation and to the reduction of hostile confrontation surrounding Sydney's Mardi Gras movement. Tully's achievements flowed from his humour, his flair for the extravagant, the sheer panache of his designs. His talents were of such a magnitude that his work transcends causes and groups. He was a foremost designer of his generation.

58. *Set of bowl forms,* Violet macchia set with teal lip wraps, *designed by Dale Chihuly (born 1941), and made by his team in the Chihuly Studio in Seattle, Washington, USA, in 1990; height 40.5 x width 86.5 x length 94 cm. Purchased 1993.*

Reproduced with permission from Dale Chihuly. Photograph by Roger Schreiber

59. *Bowl,* Deep cobalt macchia with yellow lip wrap, *designed by Dale Chihuly (born 1941), and made by his team in the Chihuly Studio in Seattle, Washington, USA, in 1992; height 43 x width 58.5 x length 63.5 cm. Purchased 1993.*

Reproduced with permission from Dale Chihuly. Photograph by Claire Garoutte

The Marriage of Arts and Sciences

The Marriage of Arts and Sciences

What an amazing time it was when the British started to colonise Australia in the late eighteenth century. It was a period of revolution in science and technology and in Britain this was not centred in fashionable London but up in the English midlands. As already discussed, that was where James Watt and Matthew Boulton produced their steam engine in 1784 for use in Whitbread's London brewery. In north Staffordshire, close to the same date, Josiah Wedgwood (1730–1795) perfected his famous *Jasperware*. That was in 1775.

Josiah Wedgwood is regarded as the greatest English potter of his century. Born into a family of potters who had been in the industry for generations, Josiah opened his own business in 1759. What marked his progress towards ever-increasing success was a process of ceaseless experimentation. He was tireless in developing new ceramic bodies and new qualities in colours and textures. His business acumen was unrivalled and he developed a thriving export trade to Europe and America. He understood the principles of marketing and gave them his direct, personal attention.

60. *Jasperware vase*, Venus in her chariot, *with relief decoration designed by Henry Webber (1754–1826), made by Josiah Wedgwood & Sons, about 1790; height 62 x width 17.5 cm. Gift of the Powerhouse Members Organisation, 1990.*
Photograph by Andrew Frolows

In the 1770s, Wedgwood recognised a major shift in English taste towards neo-classicism. This was manifest in the country houses and town houses of the Adam brothers as well as the architecture of Sir William Chambers, who designed Somerset House on the Strand, London. Wedgwood decided that he needed to search for a ceramic material that would fit in with the delicate, airy style that was now pervasive. In the early 1770s, he made more than 3000 trials until he could reliably produce the clear blue stoneware body that he named *Jasperware* after the gemstone of the same name. Jasperware quickly became synonymous with the name Wedgwood. Illustrated is a superb example purchased for the museum from its Australian owner by the Powerhouse Members Organisation in 1990. Their generous and supportive gesture was all the more important because this magnificent vase would otherwise most probably have been sold overseas. It is 62 centimetres high, a most handsome treasure. The whole design evokes the antique world; the white applied jasperware reliefs create the sense of a lost age of innocence and pleasure with its fabulous creatures, such as the gryphons that squat proudly on guard at the four corners of the base. Above them, the base is finished with rams' heads, their horns suggesting ionic capitals. Set in this frame, a goddess carries her cornucopia, symbol of optimism, luxury and fertility. On

61. *Twin-barrelled vacuum pump or air pump used for scientific experiments and demonstrations. It was made in England about 1800; height 35 x width 26.5 x length 48.5 cm. Purchased 1986.*
Photograph by Geoff Friend

the main body of the vase her chariot awaits, pulled by flying swans, attended by putti and poised on a pure white cloud. It is not accidental that this aesthetic of innocence and innate goodness was coeval with European settlement in Australia. Despite the fact that Australia was seized opportunistically as a dumping ground for convicts, European migration, even that forced on convicts, was coloured by a strong vein of idealism. In Europe, the Pacific was seen through rose-tinted spectacles as a remote survivor of a lost age of goodness and innocence. Australia, whatever the true state of affairs, was perceived as a distant land of opportunity and plenty. Accordingly, early

administrative styles in the colony were relatively enlightened. They were rational; convicts could win their freedom and get a fresh start.

No better illustration exists of the fascination felt by British midlanders for new principles of science than the epic-scale paintings of that great eighteenth century midland artist, Joseph Wright of Derby (1734–1797). Wedgwood and Wright were almost exact contemporaries and knew one another. They worked for the same sort of clients – indeed, Wedgwood *was* Wright's client and bought his paintings. In the eighteenth century, reasonably well-to-do families would gather together in private houses to listen to hearth-side lectures given by visiting experts. Wright's two greatest paintings are both dedicated to the theme of improvement and learning through peripatetic science demonstrations. *A lecture on*

62. *Painting,* Experiment on a bird in an air pump *(1768) by Joseph Wright of Derby (1734–1797); height 184.2 x width 243.8cm.*

Reproduced by courtesy of the Trustees, The National Gallery, London

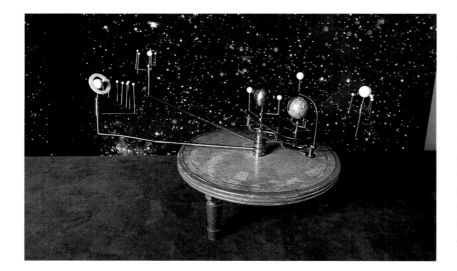

63. *Orreries like this English one from about 1800 were used in the eighteenth and early nineteenth centuries to show how the earth and other planets moved around the sun. The sun is represented by the brass sphere and the earth by the little coloured globe. The small white balls are the moons revolving around each planet; height 22.5 x maximum diameter 47 cm. Acquired 1894.*

Photograph by Andrew Frolows

64. *Plate from the magnificent dessert service known as the* Service des Arts Industriels *(industrial arts service), made at the Sèvres Royal Porcelain Factory, France 1830; height 3.2 x width 24 cm. Purchased 1993. (detail opposite).* Photographs by Sue Stafford

an orrery (1766) is the title of one in Derby Art Gallery, while illustrated here is *Experiment on a bird in an air pump* (1768) from London's National Gallery. On view in the Powerhouse Museum is an example of the eighteenth century air pump that the sage in Wright's painting is demonstrating with such lethal effect. The subject of the lecture is the nature of a vacuum and how to achieve it. The guinea pig in this case is a bird, the imminent demise of which, for lack of air, causes alarm to the daughters of the house.

George Stubbs, another English artist (famous for horses) from the same period, collaborated with Wedgwood in experiments designed to produce pictorial imagery in enamel on a ceramic base. A big advantage of such pictures is that, unlike oil paintings, they usually do not age and do not discolour. A similar desire to retain brilliance of hue marked the efforts of the Sèvres Royal Porcelain Manufactory in early nineteenth century France. In 1993, the museum was able to bid successfully at a Christie's auction in London for a plate, one of only 51 pieces known to have survived, from a famous 173 piece dessert service produced at Sèvres in 1830. This was the *Service des Arts Industriels*. The theme of the illustrations

was that of industrial arts, or, as some might say, applied arts. This service was deliberately planned to be prestigious and was finally presented by King Louis-Philippe in 1836 to Prince von Metternich, the Austrian Chancellor. The particular industrial art which is the subject of the Powerhouse plate is textile dyeing in a workshop at the Jouy factory near Versailles. This was not a copy from some pre-existing painting or illustration but rather an original composition drawn from life. The workers are immersed in their tasks, which are accurately portrayed. A man adjusts a large spool of white material while, in front of him, another prepares indigo dye. Nearby, two workers are absorbed in dyeing pink fabric. The colours are naturalistic in the extreme, with a soft light entering the workshop through an open door and clear sky and feathery green trees beyond. It is an ambitious little painting with roughish wooden architecture suggestive of a renaissance nativity. The artist was Jean-Charles Develly. He was using newly improved pigments developed at Sèvres and applying them to the factory's new hard-paste porcelain. The wide border of the plate is elaborately patterned and gilded, a superb example of a late

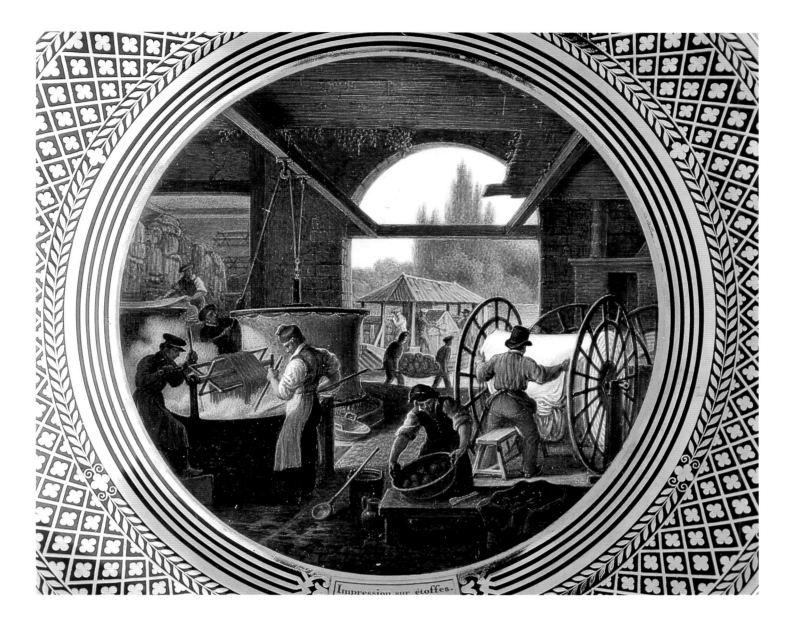

Impression sur étoffes.

Empire style, the style inspired by Napoleon, his achievements and triumphs. It also shows notable gothic revival influences. The Powerhouse Museum is indeed fortunate to have secured this plate, a true rarity and a treasure. At the London auction, bidding was hotly competitive, the French government setting the pace to attempt to ensure that some of this rare material could be repatriated to France, and indeed, to the ceramics museum at Sèvres.

*t*he Powerhouse Museum is deservedly becoming a famous name. Nonetheless, from a legal point of view, it is not our correct name and cannot be so until the New South Wales Parliament passes an Act repealing the 1945 Act under which the museum operates.

By statute our correct name is the *Museum of Applied Arts and Sciences*. It has always seemed to me that, given this charter, nothing could be more central to the museum's scope than its highly distinguished collection of musical instruments and musical memorabilia, documents etc, for music combines art, craft and science.

Most musical instruments are works of almost mystical craftsmanship. Violins, for example, are a product of theory, experience, and a hands-on familiarity with rare woods. One of the many violins in the museum's collection is an instrument by Antonio Gragnani (active 1740–1794), who worked at Livorno on the north-west Mediterranean coast of Italy. Gragnani is not considered by violinists to be the very best of violin craftsmen but none disputes the full

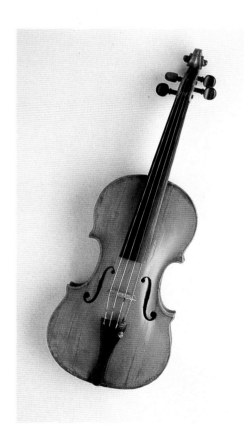

◄ **65.** *Violin made by Antonio Gragnani (active 1740–1794), in Livorno, Italy, in 1788; height 8.5 x width 61 x length 20.5 cm. E A & V I Crome collection, 1969.* Photograph by Jane Townsend

➤ **66.** *A E Smith (1880–1978) of Sydney made this violin, a copy of a Stradivarius, in 1951; height 78 x width 25.8 x depth 12 cm. E A & V I Crome collection, 1975.* Photograph by Andrew Frolows

sound his instruments are capable of producing. This instrument is exactly the same age as European settlement in Australia – it was made in 1788 and has survived its two centuries of existence well. It was played in concert in December 1993 by the accomplished violinist Dene Olding, a stylish performer who charmed his audience in the museum with insights and observations about this and other instruments. He pointed out that if not played for any length of time, a violin, so to speak 'goes to sleep'. It then needs to be played frequently for a few weeks so that the wood from which it is made can wake up or come to life. The Gragnani had slept for years but Olding nevertheless produced a rich romantic sound with it. Dene Olding's own violin is Australian, made by A E Smith (1880–1978), of Sydney, Australia's greatest violin maker. Several great

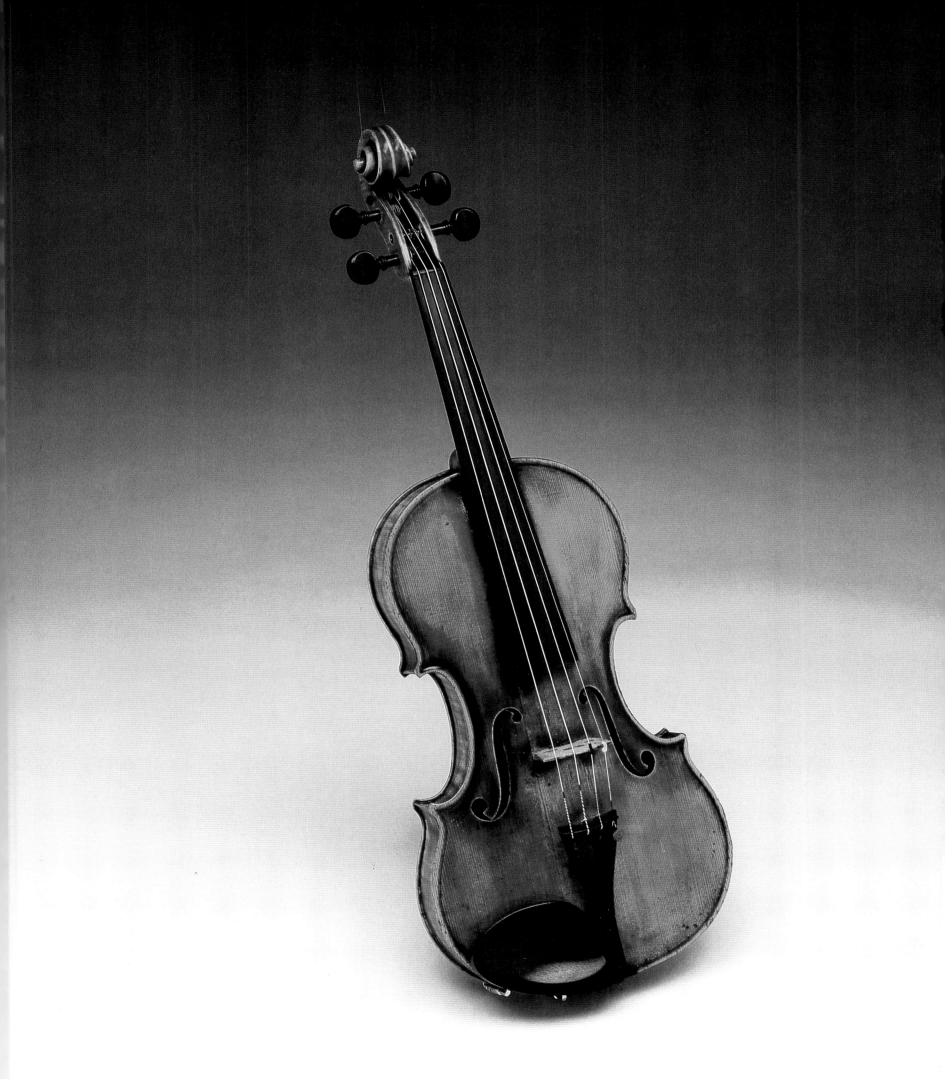

67. *Virginal, 1629, built in Bologna, the oldest keyboard instrument in a public collection in Australia; height 20 x width 150 x depth 48.5 cm. Purchased 1985.*

Photograph of virginal: Powerhouse Museum; details by Andrew Frolows

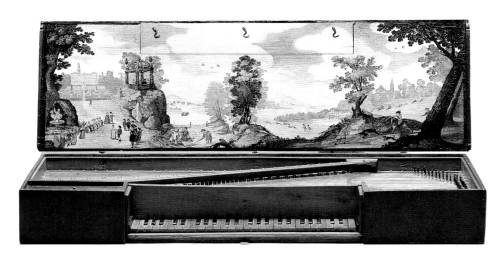

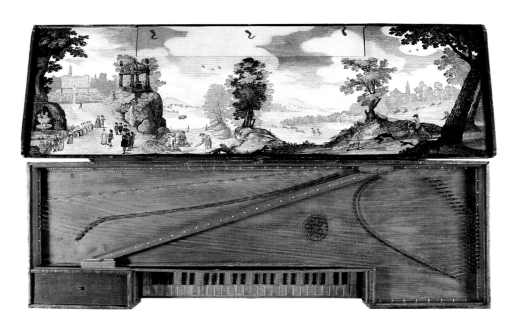

violinists of the twentieth century have owned Smith violins, including Isaac Stern, Yehudi Menuhin and David Oistrakh. Illustrated is a magnificent Smith violin of 1931, a copy of a Stradivarius.

The music collection has a number of particular strengths. There is, for example, an extremely distinguished collection of bows. Recently we were given an excellent collection – really three collections – of flutes. But perhaps the strongest suit is in keyboard instruments. The earliest

of these is an Italian virginal of 1629, made in Bologna. This is the oldest keyboard instrument in a public collection in Australia. It is still playable and produces an impressive deep, rich, sonorous sound. Impressive too is the superb painting on the lid of the virginal.

This is an Italianate landscape with architecture and figures. Appropriately, music is a theme of the painting. Below the formal, geometric garden of a country house, a group of women perform on their instruments in front of an informal audience. A seated woman plays a bass viol (a size up from the viola da gamba of 1700 which we have in the collection); next to her is a woodwind player on a cornett, an ancestor of the oboe: next, a woman plays the hurdy-gurdy (we have two in the collection); then a harpist and finally a singer. It is a delightful scene, worthy of a place in the most distinguished of art galleries. The harpsichord of 1873 by Jacob Kirckman is also in

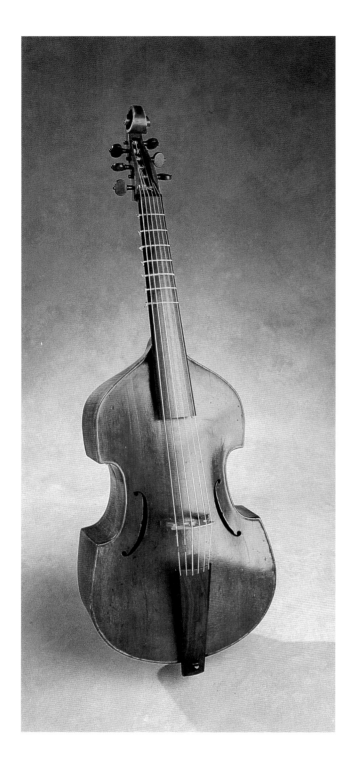

➤ **68.** *Harpsichord made by Jacob Kirckman (1710–1792) in London in 1763; height 91 x width 157 x depth 227 cm. Purchased 1964. (detail above)* Photograph by Jane Townsend

◄ **69.** *Bass viola da gamba, southern Germany, about 1700; height 125.7 x width 40.9 x depth 25 cm. Purchased with funds donated by Mr and Mrs R O Albert, 1991.* Photograph by Andrew Frolows

excellent playing order. This is a marvellous instrument with a full, deep sound. The attractive dark brown mahogany of this instrument gives it a strong visual appeal, always an advantage in a museum. Simply as an example of the craft of cabinetry, it is a major museum piece, with its delicate bands of veneer and inlays of satinwood. It is always on a display stand when not being played. Kirckman was the greatest of English harpsichord makers. The firm which he founded lasted until 1896 after which, and following a series of takeovers, it was absorbed into the famous Chappell and Co. The museum has a large, ornate Chappell grand piano of 1915 on which world-famous virtuoso Roger Woodward gave an electrifying performance of Debussy in December 1993. His performance was art of the highest order and his audience, including myself, knew that they had been privileged with an experience of rare beauty and astonishing expression.

Listening to music in the museum is a different experience from listening, say, at the opera house or another concert hall. Played in a concert hall, the

70. *In the foreground is a Queen Victoria commemorative model Chappell grand piano and stool, made in London, 1915–1916; height 120 x width 154 x length 265 cm. Purchased 1987. To the right is a Lyon and Healy Style 23, concert grand pedal harp, Chicago, 1987–1988; height 188 x width 100 x depth 54.8 cm. Purchased 1988 with assistance from Continental Airlines.*
Photograph by Penelope Clay

instrument seems to matter less. People simply take it for granted that instruments will be good and leave it at that. Second, to state the obvious, all music in a concert hall is inevitably heard in the context of other music. By contrast, at the Powerhouse, music is experienced in a variety of contexts – superb porcelain, for example, or perhaps furniture of the period to which this or that piece of music belongs. Or why not in the context of science or technology as represented by objects, machines contemporary with the composer or the instrument? Recently, when Don Burrows enthralled us with his performance on our 1926 saxophone (illustrated in chapter 4), he was standing next to a 1928 Chrysler chassis and engine block. That seemed highly appropriate – all in period. The jazz maestro spoke charmingly to the audience about the merits and qualities of the instruments he was playing, just as Dene Olding spoke about violins. Such discourse would be rare, and not particularly wanted, in a conventional concert hall. It can be seen that the museum's policy is to introduce professional players, virtuosi, to our instruments, and where possible to persuade them to play them. And it is always intriguing to speculate about which musicians in the past might have been familiar with instruments now in the collection. For instance, Mozart was in London for several months the year after the Kirckman harpsichord, described above, was made. It is

INVERNESS.
W.B.GRIFFIN.
ARCHITECT.

not too fanciful to imagine that the eight-year-old prodigy played on this excellent instrument or even composed on it.

*S*o many things in the Powerhouse collection unite art or design with technological processes. Almost all ceramics, for example, could be discussed under this heading. I cannot resist the temptation, however, to include one item that was the fruit of a real or literal marriage. This is a presentational drawing using ink and body colour on cloth of a house called *Inverness* in a Sydney suburb. The drawing, which the museum acquired in 1993, is by Marion Mahony Griffin and shows the front or street view of an attractive house designed by her husband, Walter Burley Griffin. (The museum has separately acquired a set of plans for the house.) Their marriage was a true partnership in the fullest sense. Her special competence was drawing and she drew out most of the designs in their architectural practice.

A Chicago architect, Griffin won the competition to design Australia's new capital in 1912 and stayed with the project until 1921. In Melbourne, he was the architect of Newman College, and in Sydney his lasting memorial is

71. Walter Burley Griffin was the architect of this house, Inverness, in Killara, NSW. This painting of the house, in ink and body colour on fabric, is by Marion Mahony Griffin; height 51.5 x width 59.5 cm. Gift of Ewen J Cameron, 1995. Photograph by Sue Stafford

the suburb of Castlecrag. The *Inverness* house had been largely forgotten or wrongly attributed but the coloured drawing, when it came into the public domain, proved its true origin. Confusion is understandable, for the house does not conform to Griffin's Australian mode, which, strangely, is small-scale, dark and neo-medieval. *Inverness*, by contrast, is spreading and expansive, a generous house recalling Griffin's Prairie house style around Chicago. If that sounds like Frank Lloyd Wright, it *is* like him. Wright and the Griffins were associated and that association, like the whole of Walter Burley Griffin's career, is receiving new attention and reassessment. The Powerhouse Museum is playing a central role in this process and will mount a major exhibition of the work of Walter Burley Griffin and Marion Mahony Griffin in 1996, including architecture and design in America, Australia and India.

In so many ways, the Powerhouse is a highly unusual museum. In its collection there is a Christmas tree which is assembled each year and displayed through December

*> **72.** The ionised Christmas tree, made in Australia in 1988, has electronically controlled, ionisable gas-filled glass decorations. It is Australia's – and probably the world's – first electronic Christmas tree. At certain stations around the tree, a visitor's touch makes the decorations glow and the tree sing with ethereal, 'floating' choral voices; height 400 x diameter 500 cm. Designed and made by the Studio of Arts and Sciences and Neonics. Purchased with funds donated by James Hardie Industries Limited, 1989.* Photograph by Penelope Clay

*< **73.** Lace flower designed and made of optical fibre by the museum's lace specialist, Rosemary Shepherd, 1993, for the* Telecom Laserlink *exhibition. The foundation of the flower is a sixteenth century lacemaking stitch. Underneath the lace is a revolving colour wheel, lit from below, which causes the lace to glow and change colour; height 30 x width 15 cm.* Photograph by Sue Stafford

and January. This is no ordinary Christmas tree. It is truly Powerhouse in style. It is interactive. It sings! It was built for the museum by a team of high-tech geniuses called *The Studio of Arts and Sciences* and it was fully funded by a generous sponsor, James Hardie Industries. Its trunk and branches are made of plastic piping, and if that sounds prosaic, the rest is poetry, a symphony of neon lights that switch on and off with a dazzling array of colours. Instead of ordinary baubles, the tree is hung with plasma balls, those astonishing spheres of bottled lightning that might have been invented for the Powerhouse. What is plasma? According to Dr Jesse Shore, head of science at the museum, 'Plasma is an ionised gas. If you introduce energy into a substance, perhaps by raising its temperature, one or more electrons will separate from an atom or molecule resulting in a positively charged ion. A whole lot of these separated but stable charged particles make up a plasma.

'Light and other types of electromagnetic radiation can be given off at various stages of the excitation process. Lightning is a plasma of ionised atoms and molecules of air.

Auroras are light-emitting plasmas which occur as charged extraterrestrial (ET – call home and charge it) particles collide with our upper atmosphere and ionise the oxygen and nitrogen molecules present there. The nitrogen gives off the characteristic green colours of the aurora. The sun and other stars are plasmas of mostly ionised hydrogen and helium atoms. Glowing gas clouds in the galaxy are plasmas. And plasmas occur on neon signs and fluorescent lights.'

The Powerhouse ionised Christmas tree was designed for display – like all Christmas trees. It would have been an excellent subject for chapter 4. Like so many objects in this book it can be considered from several points of view. About its visual attractiveness there can be no doubt – it is, in its way, the most spectacular exhibit in the whole museum. It sums up so much that the Powerhouse stands for. It is certainly fun! It is highly sophisticated and there is much to learn from it for those who want to do so. Perhaps as much as any object in the collection, perhaps more than most, it represents a union, a marriage of art and science.

The Power of Movement

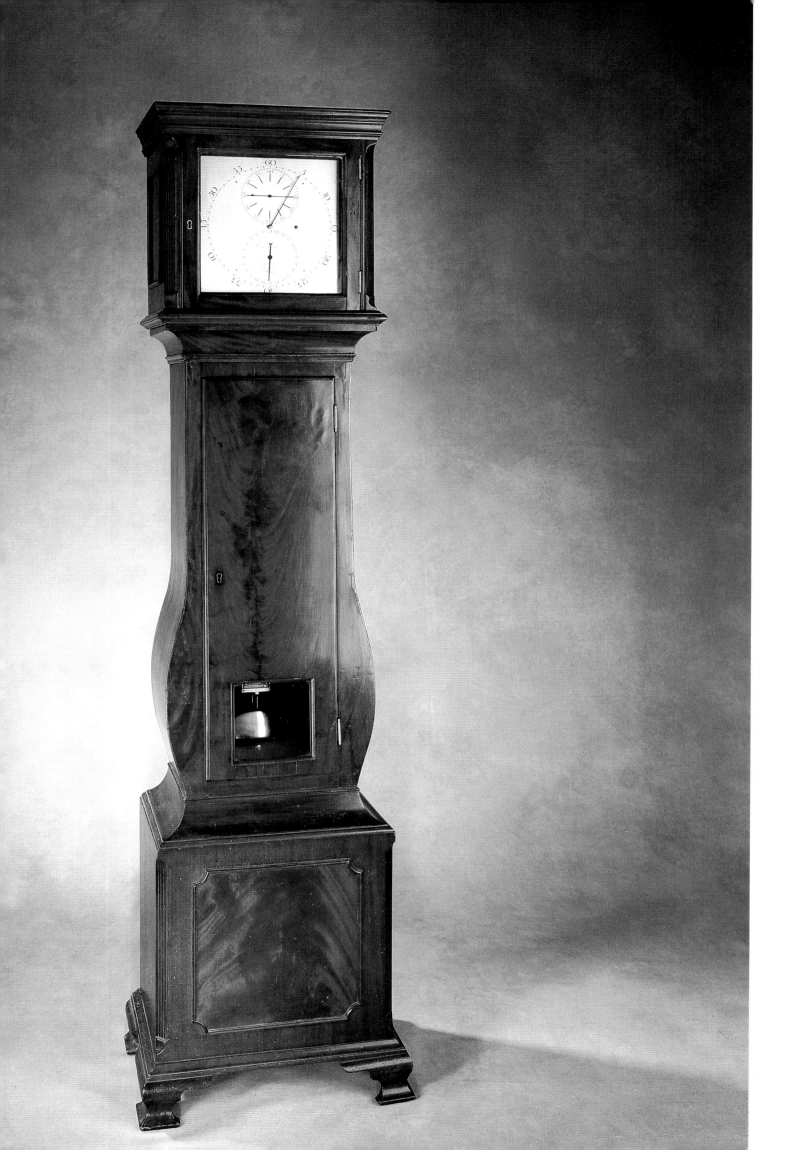

The Power of Movement

*t*he land mass of Australia is very large, more than twice the size of Europe. The Australian population has always been small and dispersed. Today the population is largely concentrated in a few major cities widely spaced around the coastline. Connections between these cities themselves and with other population centres across the globe has never been easy. Not if you compare connections between, say, Paris and Brussels, Munich and Rome, Chicago and Toronto. So it is easy to understand that Australians show an abiding interest in transport and communications.

In the earliest days of European settlement, no-one had more than the haziest idea of the extent of the country. Nor did they know what shape it was. The person who set out in earnest to find the answers to these questions was a young British naval officer, Matthew Flinders. His essential equipment for this quest included accurate clocks, which were necessary to establish longitude. After a period of almost two centuries, one of the clocks which was used by Flinders has been brought back to Australia by the Powerhouse Museum, which bid successfully for it at a Sotheby's auction in London.

74. *Regulator clock made by Thomas Earnshaw (1749–1829) in England in 1791, and used by Matthew Flinders in his circumnavigation of Australia in 1801–1803; height 180.5 x width 48 x depth 32 cm. Purchased 1994.* Photograph by Andrew Frolows

This long case clock is a national treasure for Australia. Correctly described, it is a regulator clock. Its mechanism was so accurate that it was used to set other clocks. It was made in 1791 in Britain by Thomas Earnshaw, to be used as a navigational instrument by explorers charting unknown parts of the globe. It was used in the late years of the eighteenth century by George Vancouver in his exploration of the west coast of Canada. Then, in the years 1801–1803, Matthew Flinders took it on board the *Investigator* for his circumnavigation of Australia.

As the Earnshaw is a pendulum clock, many have wondered how it could have functioned aboard a tossing and pitching ship's deck. The answer is that it didn't! On board ship, it was carefully packed and boxed.

75. *Model of the* Investigator, *the ship on which Matthew Flinders sailed around the coast of Australia in the first ever circumnavigation of the continent. Scale about 1:100; height 51 x width 20 x length 68 cm. Made by Roland Michel Laroche on commission for the museum, 1980.*

Photograph: Powerhouse Museum

Periodically, Flinders had it rowed ashore and set up to regulate his chronometers.

A chronometer is a small clock mounted in a swivelled cradle to mitigate the severity of the ship's movement and with a mechanism designed to function accurately in environments characterised by extreme changes of temperature. Although chronometers were as exact as it was possible to be in such circumstances, it was necessary to check them periodically against a regulator. This process took several days.

Ashore, Flinders erected a tent observatory from which to check the position of the stars and the sun, and this together with an accurate reading of time, enabled him, like any good navigator of his day, to achieve a precise fix of his position. That is how Flinders was able to chart the coastline of Australia so precisely and accurately.

The museum also owns the last of Flinders' chronometers, the only one to have survived his historic survey in working order. Like the regulator clock, this chronometer also was made by Thomas Earnshaw, who was, in fact, better known as a maker of chronometers than other clocks.

The fact that Matthew Flinders, using these instruments, was able to establish the exact coastlines of the Australian island continent is of immeasurable significance, historically and politically. It was Matthew Flinders himself who coined the name *Australia*, derived

76. *Marine chronometer made by Thomas Earnshaw (1749–1829) in England in 1800; height 15.5 x width 21.2 x depth 21.2 cm. Purchased 1957.* Photograph by Andrew Frolows

from *Terra Australis* (Latin for 'land of the south'), a term used for centuries to indicate a great southern continent. Flinders proposed *Australia* rather than *New Holland* or *New South Wales*, names invented by the Dutch and the British, for those parts of the continent which they respectively discovered.

So, thanks to Flinders, settlers in Australia knew the full extent, the size and shape, the distant limits of their vast continent. Now they knew what they had to travel across and around by land transport, and by sea. Eventually they

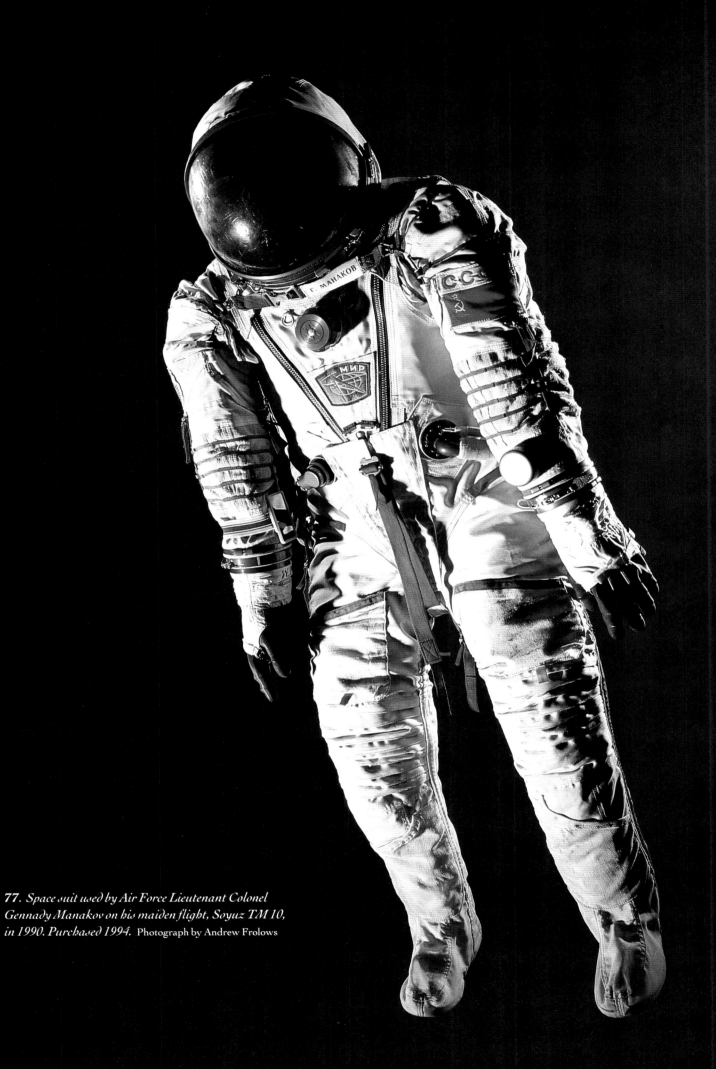

77. Space suit used by Air Force Lieutenant Colonel Gennady Manakov on his maiden flight, Soyuz TM 10, in 1990. Purchased 1994. Photograph by Andrew Frolows

would enthusiastically attack distances by air transport. Further ahead, they would study and understand its features, its weather patterns, using data recorded in space.

*t*he Powerhouse's coverage of transport extends across land, sea and air. It also goes beyond this Earth into space. Our permanent exhibition devoted to space exploration is the most popular and most visited section of all. The exhibition outlines world space activities and highlights American efforts, as well as those of the former Soviet Union and China, a combination which was extremely unusual for a while given the somewhat uncertain relationships between those countries. The

77. Space suit (detail) used by Air Force Lieutenant Colonel Gennady Manakov on his maiden flight, Soyuz TM 10, in 1990. Purchased 1994. Photograph by Andrew Frolows

friction that may exist between governments seems to be absent among individual players in the space game. The Powerhouse exhibition was launched in October 1988 by two astronauts and one cosmonaut. From America came Commander Vance Brand and the Australian born Paul Scully-Power (the latter a frequent visitor to the Powerhouse Museum). From the USSR came Nikolai Rukavishnikov. These three were conspicuous friends, members of an elite and exclusive international club. Much of the material in our exhibition is on loan from

78. *Flight suit used by civilian flight engineer Oleg Makarov in a 1978 Soyuz mission. Purchased 1994.*
Photograph by Andrew Frolows

various international scientific and space agencies and therefore the museum recognises the need to acquire material for the permanent collection. That need is being addressed as we shall shortly see.

Unfortunately there is little to show in the exhibition of Australia's own significant history of involvement in space exploration and the development of space technology. What little material remains from that history is in the hands of government agencies and private individuals who are understandably not keen to relinquish it. The museum has, however, received generous cooperation from all sections of the Australian space community in the production of the book, *Space Australia*, written by the museum's own expert, curator Kerrie Dougherty, whose knowledge of space matters is encyclopedic, and her co-author Matthew James. This book was the ideal medium in which to explore Australia's poorly known involvement in space exploration and to speculate about opportunities for Australia in the future.

In recent years, Australia has benefited at little cost from the technological gains in, say communications, remote sensing etc etc from the investment by friendly nations. This may not continue. It is not that historic alliances may change, although anything is possible. It is simply that so many countries are strapped for cash and may well invoke the 'user pays' principle – a principle in which most Australian governments, state and federal, have loudly proclaimed their belief. Of course, between friendly nations, high tech information is frequently swapped or traded in kind, but unless Australia participates in the development of space technology in one form or another, the country will have nothing to trade. That could make life difficult for a population so distant from other centres.

One country that has been notably strapped for dollars in recent years is Russia. As a result, the Russians are always looking for something to sell, and, in my experience, they assume that their material has a higher monetary value than the rest of the world tends to place on it. Australian museums and galleries have been offered a number of opportunities to show Russian things in the last few years: icons, silverware, van Gogh paintings etc. Generally speaking, museum directors and their exhibition organisers have found Russian charges prohibitive or their offerings unattractive for other

reasons, such as being of inadequate quality or not sufficiently interesting. And Russian negotiators are characteristically inflexible. The Powerhouse Museum has turned down two recent Russian exhibition proposals after evaluating them carefully. (We also knocked back a large force of MIG fighter jets offered by an ailing eastern bloc country a few years ago.)

But in space exploration and the development of associated equipment and technology Russia does have much to offer. The Soviet Union was one of the two great leader nations in the exploration of space, often producing different and alternative solutions from those of the Americans. In this case, the Russian tendency to dramatically overvalue their material was avoided because they took the sensible option of selling it through auction at

Sotheby's in New York. That was in December 1993. The Powerhouse Museum was the successful bidder for two items which we acquired at very reasonable prices. These were a space suit and a flight suit both of which had been worn on missions into space.

The space suit was worn by Air Force Lieutenant Colonel Gennady Manakov on his maiden flight, Soyuz TM 10, launched on 1 August 1990. Cosmonaut Manakov, with his co-crew member Strekalov, docked with the MIR space station for four months, returning to the planet Earth on 10 December. Manakov's space suit is a

79. *Model made by Lawrence Hargrave (1850–1915) in 1887 to explore the concept of flight, was based on bird-wing motion; width 215.4 x length 168.5 cm. Gift of Lawrence Hargrave, 1891.*
Photograph by Jane Townsend

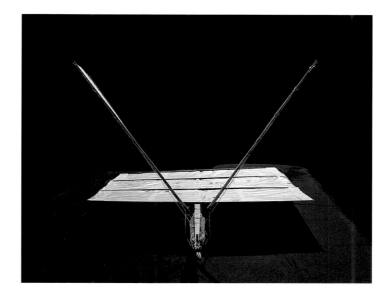

fascinating costume and I found it difficult to decide whether or not to discuss it in the following chapter next to a suit of armour or even, on colour grounds, next to a dress by Courrèges!

The Powerhouse Museum is one of the few places where you can compare many of the different ways we cover our bodies for various purposes such as protection, and where you can speculate about the complex messages encoded in our forms of costume and clothing.

You may think that a space suit was designed for anything but display yet various badges, logos and seals are attached to it. Unlike most other forms of costumes, however, it is equipped with umbilical interfaces for electrical, air and coolant lines. And with a pressure valve on the chest.

What is the difference between a space suit and a flight suit? The sort of space suit described above is for take-offs, landings and other critical manoevres, for example, docking. Now let the man who wore this flight suit, civilian flight engineer Oleg Makarov, describe what it is for: 'The flying suit is the working wear of the cosmonaut when he is in orbit and out of his space suit. Usually it is made out of wool, as the temperature standard of 18–22°C means relatively cool air and, besides, due to the forced ventilation, cosmonauts are apprehensive of catching cold.' Makarov thoughtfully provided this information in a typed and signed document which he supplied with the suit. He wore the suit in a Soyuz mission of 1978 which supplied the long-duration crew on Space Station Soyuz 6 with mail, books, newspapers and equipment for their experiments.

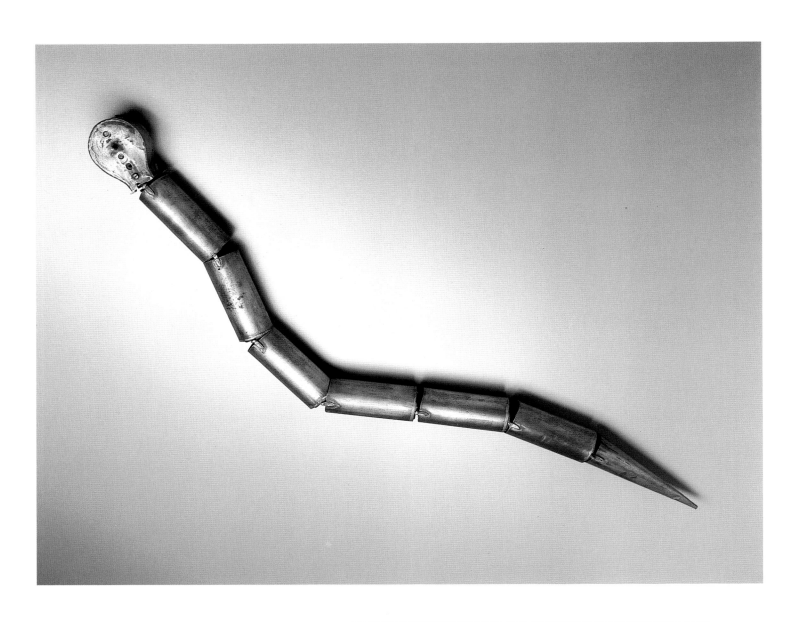

80. *Models made by Lawrence Hargrave (1850–1915) in 1884 to explore trochoidal motion; above: height 4 x width 5 x length 66 cm; right: height 17.5 x width 38.5 x depth 22 cm. Gift of Deutsches Museum, Munich, 1961.*
Photograph by Jane Townsend

81. *A copy of Lawrence Hargrave's box kite which lifted him up 4.8 metres in 1894 at Stanwell Park, south of Sydney. Its design helped make powered flight possible.*
Photograph by Penelope Clay

*C*oming down closer to Earth, but still on the theme of mobility, it is timely to mention that great Australian pioneer of flight, Lawrence Hargrave. He barely got off the ground, himself, but his heroic efforts prepared the way for others. Indeed, we could discuss his achievements equally well in chapter 8, along with all the other heroes of aviation. The museum possesses a hoard of Hargrave material – an archive, in fact – and the time is near when the Powerhouse will fulfil the role of a centre for Hargrave studies that many expect of it. It is good to be able to report that all our Hargrave material is now in good order, a state of affairs that has taken considerable time to achieve. The effort to do so has been part of our collection assessment program which, over four to five years, has tackled a backlog going back more than a hundred years to 1880.

Hargrave attempted to solve the problem of flight, as so many had done before him, by studying the motion of birds' wings. He then made machines that reproduced this 'trochoidal' motion if powered in some way, for instance via a crank handle. He also looked at 'serpentine' motion as a means of propulsion. It means side-to-side motion, literally snaking along. As for motive power, Hargrave addressed that problem also and experimented with steam power and petrol engines. Although the name of Hargrave is famous, we do not yet have a very clear idea of the products of his restless and fertile mind. But the day is not too far away when enthusiasts and students will have a better opportunity to come to grips with a man whose schemes, proposals, projects and designs bear something of a resemblance to those of Leonardo da Vinci.

From schemes that were up in the air, or were meant to be, to a flying machine that really works (more of aviation in chapter 8). The Transavia PL12 Airtruk of 1965 is an ugly bird but it is Australian and we should be proud of it. Transavia is a division of the Australian construction giant Transfield. They have now renamed their Airtruk as the slightly more glamorous Skyfarmer. The design is ingeniously practical; its twin tail booms allow cargo to be loaded into the body from the rear and, in the case of crop dusting, or liming, the material can be jettisoned from the rear without fouling the tail. It really is like an airborne ute!

82. *1965 Transavia PL12 Airtruk is the prototype of the Transavia production aircraft; height 279.4 x width 1197.6 x length 635 cm. Gift of Transfield NSW Pty Ltd, 1988.* Photograph by Penelope Clay

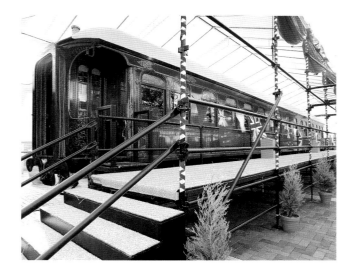

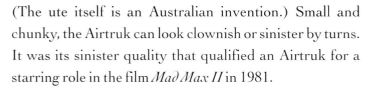

(The ute itself is an Australian invention.) Small and chunky, the Airtruk can look clownish or sinister by turns. It was its sinister quality that qualified an Airtruk for a starring role in the film *Mad Max II* in 1981.

The Transavia Airtruk is a work horse. The pilot has good visibility but the vehicle was not designed for pilot comfort to any marked degree. Probably the most comfortable ride in history, across Australia, was in the railway carriage of the governor-general made in 1901. Artisans and craftspeople of the New South Wales state railways pulled out all the stops to make this handsome vehicle fit for a queen. Over the next several decades it was used by many royal travelling parties but it was not until the 1950s that it transported a reigning monarch. That was during the tour of Queen Elizabeth II and the Duke of Edinburgh in 1954 which was the first occasion when any monarch had visited Australia, originally colonised by the British, as we know, 166 years earlier.

The spacious interiors of the carriage consist of a dining room, an observation room which is really like a lounge room, three bedrooms with bathrooms, and the kitchen and staff quarters. Interior decorative features are elaborate, with fine wood panelling and many metal fixtures finished in gold plate. The carriage came to the museum as a gift from State Rail in 1993 complete with silver, crystal and plate as well as all bedding and so on. It

83. *Railway carriage built in 1901 by the NSW Department of Railways workshops for the Earl of Hopetoun, Australia's first governor-general; height 271.8 x width 285.8 x length 2260.6 cm. Gift of State Rail Authority, 1995.* Photograph by Jane Townsend

Pages 130–131. *View of the Boiler House gallery showing the Sydney Terminal departure board. Gift of State Rail Authority of NSW, 1982; and top right the Beechcraft Queen Air – the first air ambulance to be operated in New South Wales by the NSW Air Ambulance Service. Gift of the NSW Air Ambulance Service via the Aviation Historical Society of Australia, NSW Branch, 1985.* Photograph by Andrew Frolows

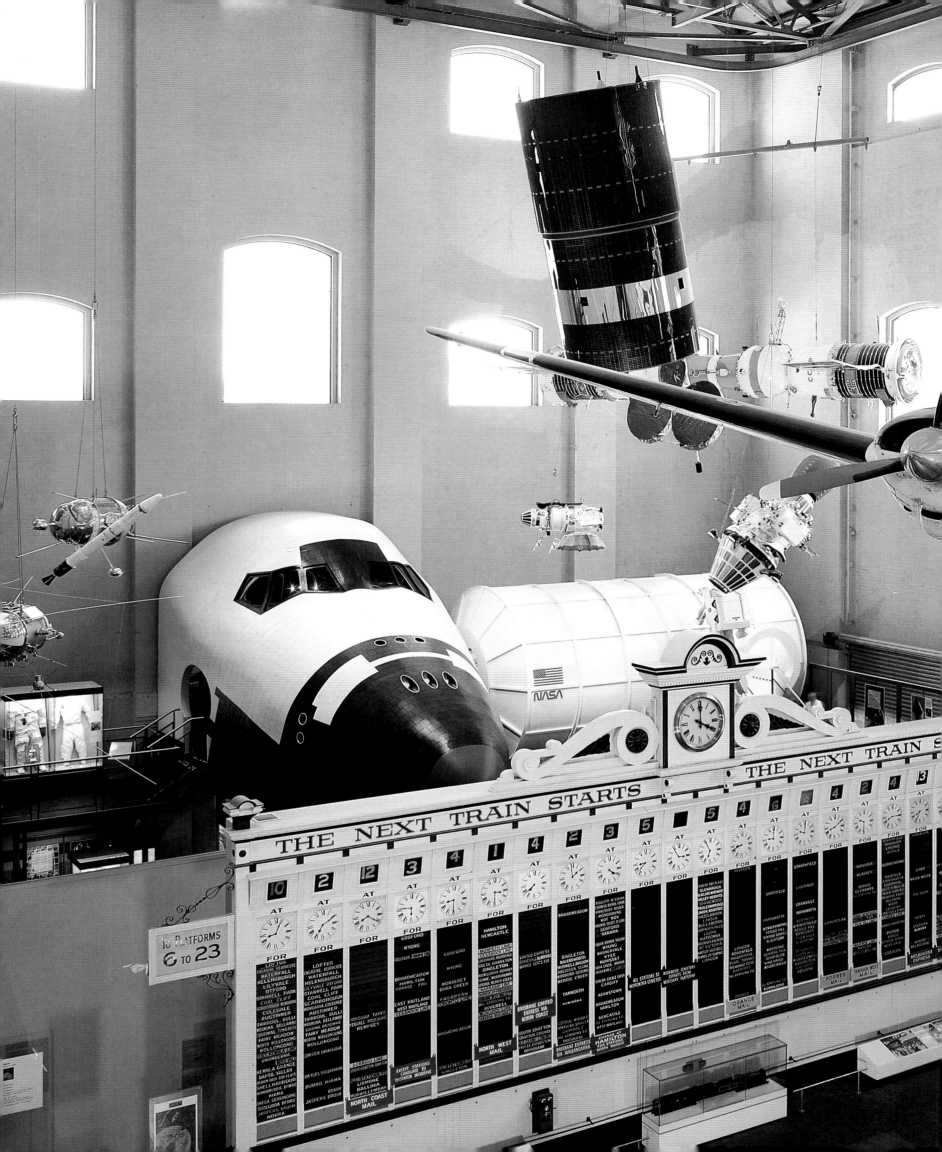

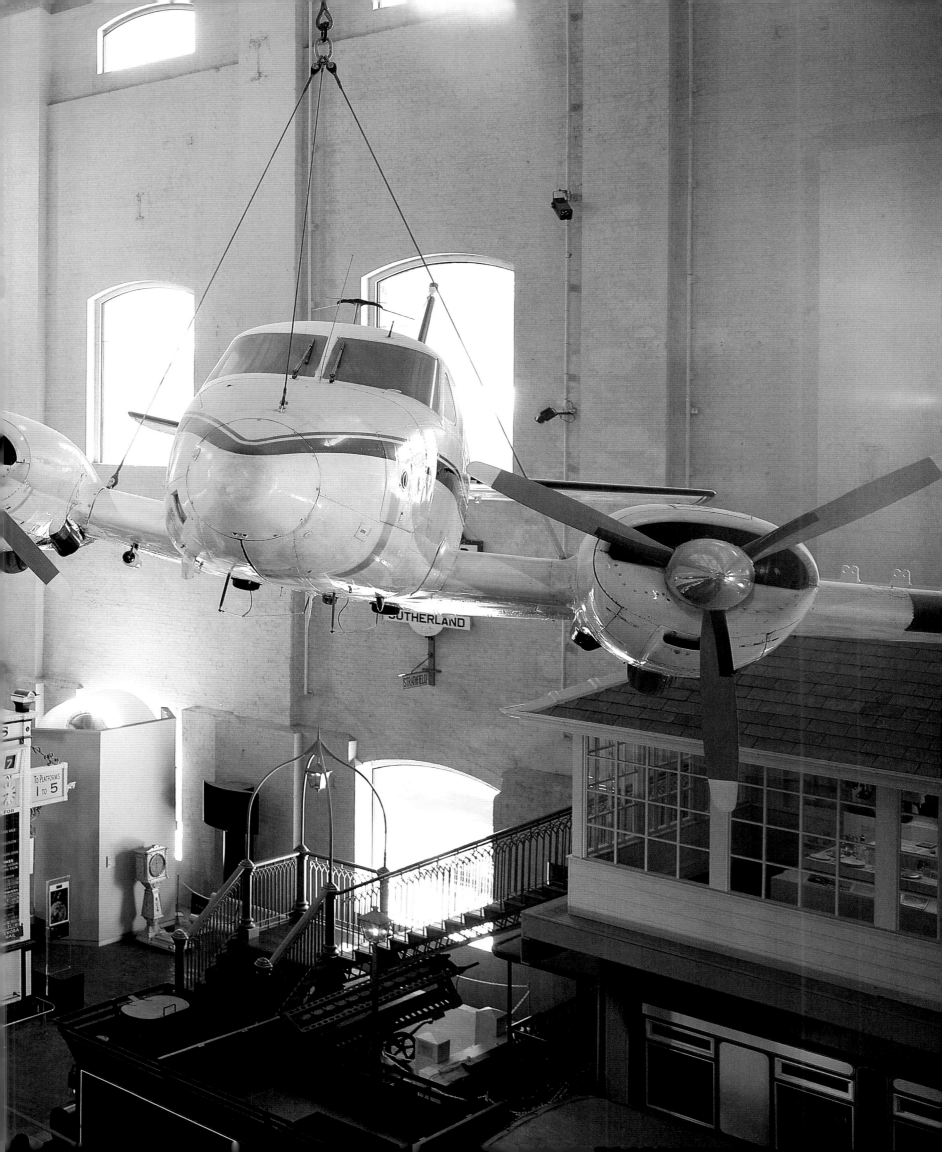

is a monument to a past age of late colonial style when Royal visits were occasions of intense excitement and when the British Empire was so vast with so many colonies that people did not expect its titular head to be able to get around them all in several generations.

*m*ass rail travel has been in decline for decades. An easy way to appreciate this fact which causes so much gloom to rail and steam buffs is to look at the large departure board, one of the most striking sights in the Powerhouse Museum. More than six metres in height, this information board was gazed at searchingly by departing passengers at Sydney Terminal Station, the main rail terminal, for seventy-six years, from 1906, when it was installed, having been carried across from the nearby Redfern rail workshops where it was made. During three-quarters of a century, the spot below the famous clock above the board was a meeting point for Sydneysiders, their families, friends and lovers. It has thus played an important role in the texture of Sydney society and for that reason alone merits its place of honour in Sydney's largest museum. Its arrival and departure times are set to represent a typical Sunday in 1937, about halfway through

ʌ **84.** *The sedan chair, an eighteenth century mode of transport, England; height 170 x width 66 x depth 84 cm. Purchased 1946.*
Photograph: Powerhouse Museum

≺ **85.** *Departure board (detail), built in 1906 for use in the Sydney Terminal Station, where it was used until 1982; height 620 x width 1220 x depth 360 cm. Gift of State Rail Authority of NSW, 1982.*
Photograph: Powerhouse Museum

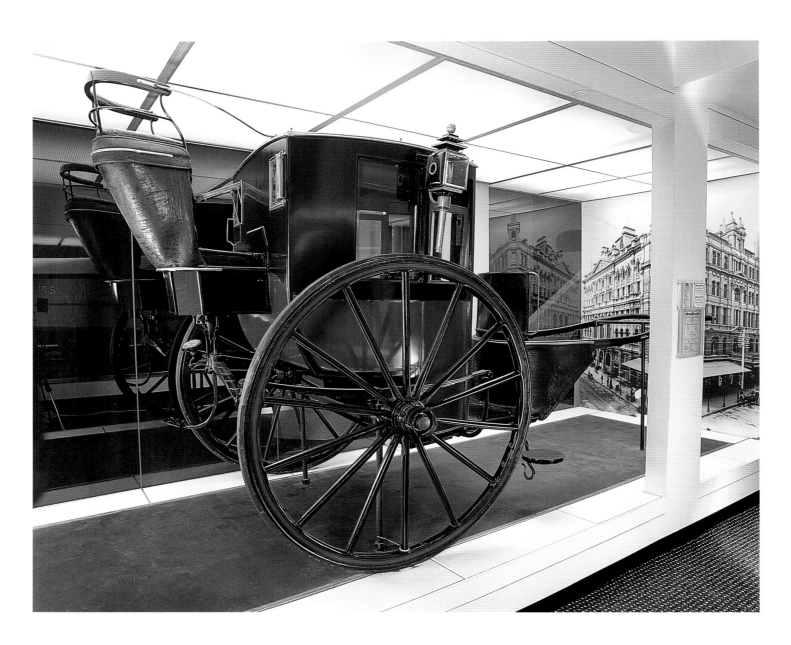

86. *Sydney hansom cab, built in the 1880s to carry one or two passengers; height 224 x width 110 x length 428.6 cm. Purchased 1937.* Photograph by Sue Stafford

its history. It was a busy time when a large number of country services were available. Some of the routes and itineraries listed on its panels are now history, just like the board itself.

Turning to personal transport, a major theme in the history of Australia, we begin with a sedan chair, not much used, if at all, in the colony. Sedan chairs go back centuries but their peak of popularity in Europe was in the mid-eighteenth century, when hundreds were to be seen in the streets of London, both privately owned and for hire. The attraction of the single seater sedan chair was probably

more than simply the alternative it offered to the physical act of walking. It provided protection from the filthy mire that was the street surface in the eighteenth century, a mix of mud and horse droppings or worse, if that was possible, which it probably was. The sedan chair, or rather the two hefty men who carried it, also provided security against jostling or mugging.

Much later on but still in a bygone age comes the hansom cab. The one in the collection was sold to the museum in 1937 for six pounds. It was the last one on the road in Sydney, an obsolete mode of transport by that time and its acquisition by the museum was the final recognition of the end of an era that in reality had been over years before. Its owner, Mr J Connor of Redfern, drove the vehicle into the museum himself, foreshadowing Dick

87. *This 1928 Type 37A Bugatti racing car won the 1929 Grand Prix (Australia) on Phillip Island; height 140 x width 160 x length 590 cm. Purchased 1984.* Photograph by Roger Deckker

Smith's delivery of his helicopter as described in chapter 8. Mr Connor had been driving hansom cabs since their heyday in 1890, when 250 would leave from Redfern station in a single hour. The cabman sat high up at the rear of the cab looking forward across its roof. Two small windows in the upper rear wall of the cab allowed him to communicate with his passengers who otherwise enjoyed considerable privacy. Thus it was that hansom cabs were good-naturedly thought of as slightly risque. The Depression of the 1890s reduced interest in hansom cab travel. Then came bicycles, cable tramcars, and by 1910, motor taxis. But few if any successors were nearly so stylish and elegant as the hansom cab with its smooth coachwork, its high wheels and its dark, plush interior.

Compared with continental Europe, Australian culture has been reluctant to make the most of its weather. Why are there so few pavement cafes? Perhaps the reason is that Australian culture has for so long been closely linked with Britain, where weather conditions usually prohibit street cafe activity and where the pub reigns supreme.

Almost as odd as the dearth of pavement cafes in Australia is the very small population of open-topped cars, particularly given the fabled sporty nature of Australians. The comparative rarity in Australia of open-topped cars, what Americans call 'rag-tops' and what the French used to call 'coupés' because the top was cut off, helps to make them popular exhibits in a museum.

The undoubted jewel in the car collection is the 1928 Type 37A Grand Prix Bugatti racing car. This very car comfortably won the 1929 Australian Grand Prix on Phillip Island, Victoria, driven by its owner, Arthur J Terdich, who had brought it over from Europe. After that initial success, Terdich and his car had very little luck over the next few years. In the early days of motor racing,

88. *1926 Austin 7; height 165 x width 120 x length 268 cm. Purchased 1963.* Photograph by Andrew Frolows

Bugatti was the most famous and magical name. Bugattis dominated race meetings partly because they were one of the few makes designed from the outset as racers, not simply modified versions of vehicles designed for other purposes. Perhaps their mystique was also due to the combination of aesthetic and engineering qualities, credited to Ettore Bugatti, which contributed to the supremacy of Bugatti cars in race meetings throughout the 1920s.

The museum's Bugatti is very rare. Only seventy-eight Type 37As were ever made in the Bugatti factory at Molsheim, in Alsace, a half-hour drive west of Strasbourg. Today, survivors of these original seventy-eight are so expensive that there is a trade in replicating them. One

hundred and twenty-three Bugattis, of different types, make up the nucleus of the collection of the French National Automobile Museum at Mulhouse, also in Alsace. This is the most visited museum in France after the Louvre.

The Bugatti is a glamorous car, but the museum's little open-topped Austin 7, from the same period, is also pretty. Its chief claim to distinction is that it was imported whole in 1926 when it was new.

Mostly, car bodies were made in Australia to avoid the high import duties designed to protect the local car body industry. This car was probably bought by a wealthy individual as an ancillary vehicle or even for staff in service to use for errands. Its virtues were economy, a reasonable

≺ 89. Goggomobil Dart;
height 111.8 x width 144.8
x length 304.8 cm.
Purchased 1989.
Photograph by Andrew Frolows

turn of speed for its day – say forty miles an hour which is all you would want for short journeys in the city. It was considered easy to drive although by comparison with modern cars and in today's traffic, it reveals its somewhat nerve-racking limitations.

The Austin 7 was an economical car but the era to which it belonged was only the start of mass motoring. In the 1920s and '30s comparatively few people aspired to private transport more ambitious than motorcycles of which there are many in the collection.

In the 1950s, things were different. In Europe and Australia it was the beginning of an age of mass affluence, or so people persuaded themselves, when everyone could aspire to the good life. Everyone wanted what came to be known as a middle-class lifestyle: house and garden, telephone, and car outside if not in the garage. Not everyone could easily achieve this vision and European

⋏ 90. Bradbury & Co Ltd motorcycle and sidecar, England, 1915;
height 120 x width 150 x length 220 cm. Gift of Mr F Hodgson, 1953.
Photograph by John Day

car makers came to the rescue with tiny, inexpensive cars, mini-cars – some with only three wheels and many with fibreglass bodies. Open-top versions of these cheap forms of transport lent them a sporty air and drew attention away from their real reason for existence.

In Australia one such car had a distinct flair. That was the hybrid car, the Goggomobil Dart; the engine and chassis were made in Germany and the stylish body was designed and produced in Sydney by Bill Buckle. Its sleek lines enabled its young owners to imagine they were driving Alfa Romeos or Jaguars while gunning the tiny and

91. *1955 Holden FJ225 Special Sedan, one of 170 000 FJs produced by General Motors Holden; height 160 x width 160 x length 440 cm. Purchased 1985.*
Photograph by Sue Stafford

highly economical 300cc two-stroke engine. With its small purchase price, the Dart found its niche and became a cult vehicle. Seven hundred were sold in three years before a new 40 per cent sales tax was introduced in 1960. It was finally chased off the road by the zippy Morris Mini Minor which established comfortable superiority from 1961.

The Goggomobil Dart appealed to a niche market but the car that stands for the 1950s, decade of family affluence, is the FJ Holden. The Powerhouse collection would be seriously incomplete if it didn't have one. Appropriately, the museum's FJ Holden Special Sedan was produced in 1955, the middle of the decade. General Motors-Holden's, the Australian division of the American car company, introduced the FJ in 1953. It has since become representative of its epoch, an icon of family values, stability, enjoyment, the pleasure of visiting relatives, the freedom of the open road. Battlers continued their struggles but they were not visible through the windows of the FJ. Astonishingly, this icon was in production for no longer than three years, the same duration as the little Dart. There the similarity ends. GMH turned out some 170 000 FJs, a success that has given the car its unique place in Australian history.

On the Body

On the Body

*a*n enormous number of items in the Powerhouse Museum collection were designed to be worn on the human body. Sometimes for protection, sometimes as fancy costume, sometimes for pure decoration, sometimes as uniform or special dress to tell other people about the role of the wearer. For example, we have many bridal gowns which were designed to be worn on a single occasion to distinguish the bride at her wedding.

Dress design and high fashion is one of the strongest aspects of the collection. One of the world's greatest designers of the early twentieth century was Mariano Fortuny (1871–1949). His reputation, and our appreciation of his significance, seems to grow more and more as time goes on. A Spaniard, born in Granada, Fortuny lived out his career in Venice. His most famous innovation was the *Delphos* dress, designed in 1909. Its simple lines and finely pleated silk cling to the body in a manner reminiscent of Greek sculptures and reliefs, from about 400 BC onwards. These show gowns which adhere to the contours of the body as if wet. The museum's *Delphos* dress was purchased in 1984. In 1991, we acquired another of Fortuny's styles to complement it. This is a creation designed about 1910 and is medieval in inspiration. In his day, Fortuny's designs appealed to daring and avant-garde women who appreciated his desire to liberate them from the heavy and extravagant fashions of the late Victorian

and Edwardian eras. The continental or Parisian version of this style is known as *Belle Epoque*. An example in the collection is an evening dress of about 1900 from the House of Worth, Paris.

Fortuny based his style on the English arts and crafts movement which, with its emphasis on clarity and simplicity, led the world in design in fields such as architecture, interior and furniture design. He was also influenced by the art-nouveau movement which stressed

92. *Mariano Fortuny (1871–1949) evening gown,* Delphos, *made of finely pleated, vivid green satin-weave silk between 1910 and 1920. Purchased 1984.* Photograph by Geoff Friend

93. *Ball gown made by the House of Worth in Paris about 1900. Gift of Anne Schofield, 1983.* Photograph by Andrew Frolows

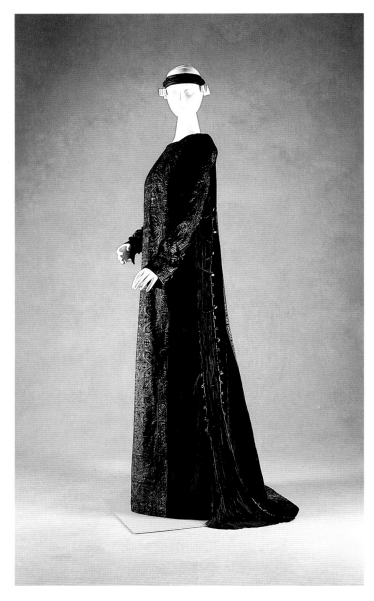

94. *Mariano Fortuny (1871–1949)* Medieval *gown, made of gold-stamped black silk velvet in Venice about 1920. Variations of the* Medieval *gown were produced from about 1910 to the 1940s. Purchased 1991.* Photograph by Andrew Frolows

the organic, the natural. The *Delphos* dress might have been worn, so to speak, by a tragic heroine in a painting by Burne-Jones, the English late Pre-Raphaelite artist whose reputation in Europe was unrivalled at the turn of the century.

Fortuny's *Medieval* dress might also have come from an earlier Pre-Raphaelite painting, perhaps by Millais, Rossetti, or Arthur Hughes. It is the costume of romantic medieval legend, worn by a Guinevere, or a Mariana by Millais out of Tennyson.

The museum is not without holdings from the real middle ages on which so much nineteenth century romance was based, but our medieval objects tend to be made of metal rather than textiles. Arms and armour, guns and swords are on display in many museums throughout the world. Such displays are invariably breathtaking. To walk through the armour galleries of the Wallace Collection in London is to experience an exhibition of surrealism *avant la lettre.* No surrealist artist of the 1920s or

'30s created anything quite so fantastic in the way of human imagery as we see in medieval plate armour from the late middle ages. Metal helmets in particular, with their bizarrely shaped visors, are highly imaginative and must have been terrifying to confront in battle or joust. Of course, Europe has plenty of examples. The Tower of London is almost too full of it all. The situation is quite different in Australia where a complete suit of armour is a rare sight. That is why the Powerhouse Museum is proud of its arms and armour collection. Nothing matches the *panache* of a full suit of armour or a dashing rapier! Somehow we ignore the fact that such things are

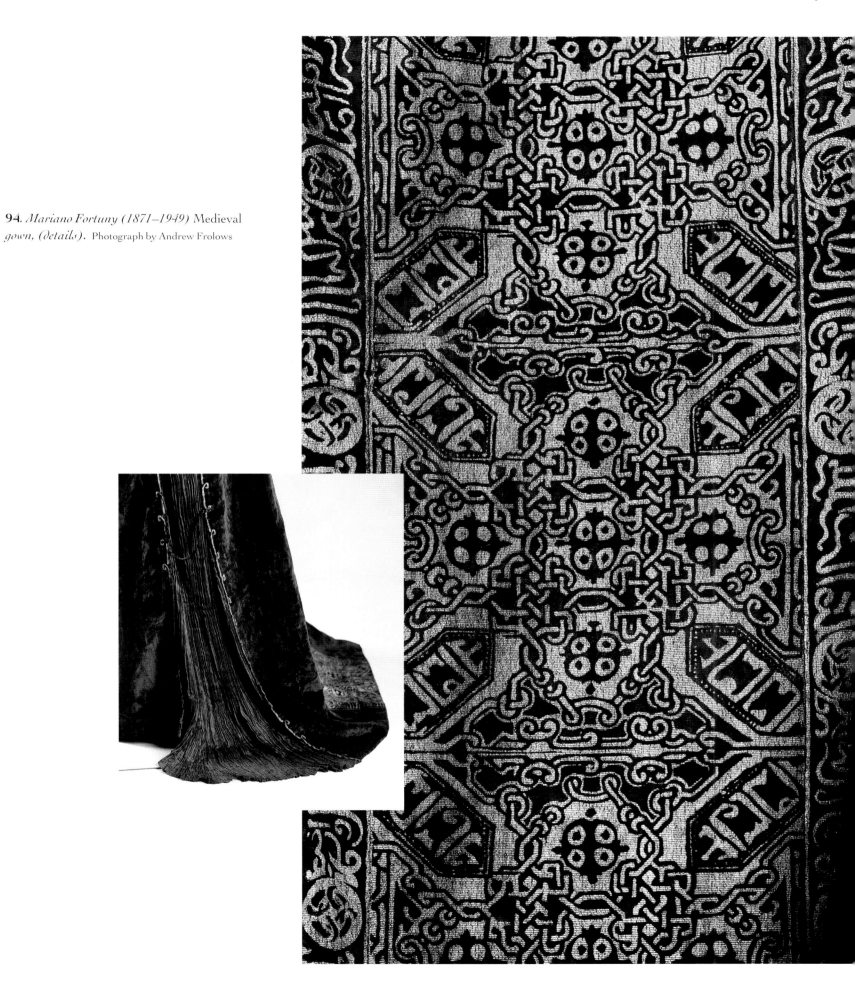

94. *Mariano Fortuny (1871–1949)* Medieval *gown, (details).* Photograph by Andrew Frolows

96. *Dress and coat by André Courrèges (born 1925), Paris,*
about 1965. Cap made by Frederick Waters, Sydney, about 1965.
Gift of The Fashion Group of Sydney Inc, 1983.
Photograph by Andrew Frolows

95. *Sixteenth century suit of armour with nineteenth century*
additions. Purchased 1960. Photograph by Andrew Frolows

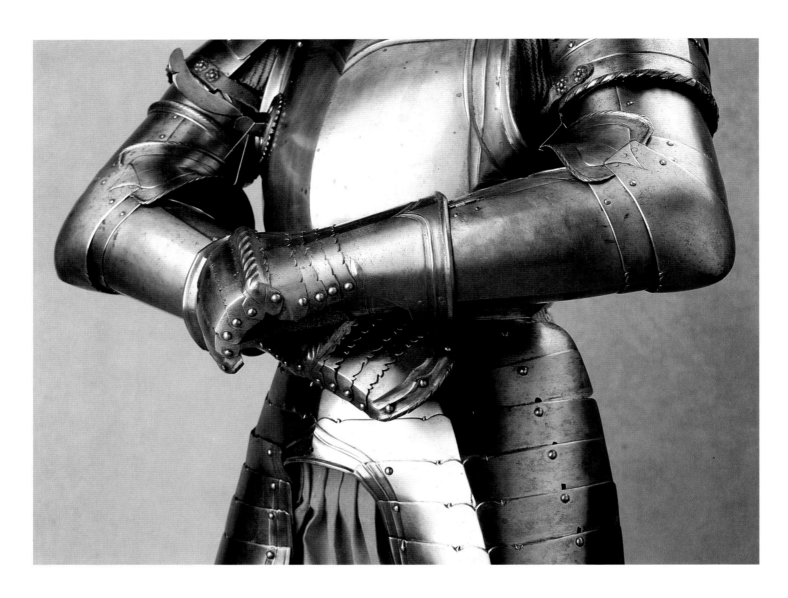

95. *Sixteenth century suit of armour (details)*
with nineteenth century additions. Purchased 1960.
Photographs by Andrew Frolows

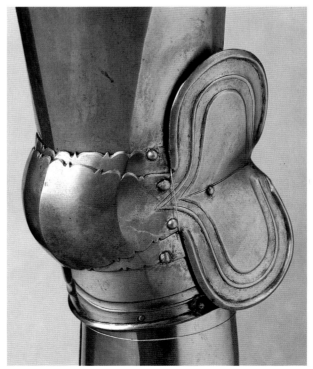

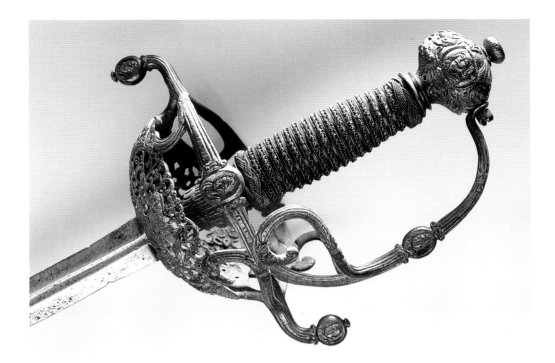

connected intimately with injury and death, and we feel free to enjoy the sense of sculptural style in objects made to be worn on the human body or held in the human hand. Of course, not all were purely for combat; many were also ceremonial.

Illustrated is a sword from the Powerhouse's large collection of edged weapons. It is English from the early seventeenth century, sufficiently elaborate to have been a stylish adjunct to costume or to have been worn ceremonially as court dress. The hilt and pommel are decorated with elaborate miniature portraits, a not uncommon practice. King Charles I and his Queen Henrietta Maria are clearly recognisable. Yet this sword was by no means merely decorative. It is a lethal weapon, and judging from the nicks and chips in the blade, just below the hilt, was used as such. The considerable length of the blade, 125 centimetres, and its slender width, the strength and rigidity of the metal, all add up to a serious weapon which would penetrate swiftly and deeply with a modicum of force.

This sword is at once serious and stylish. It is romantic, calling to mind dashing cavaliers in service of the king. It is exactly the kind of

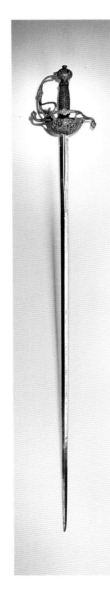

97. *Rapier made in England about 1640. The cup hilt is finely pierced and chiselled steel, with portrait busts on either side of King Charles I and Queen Henrietta Maria; length 124.5 cm. Purchased 1983.*

Photograph by Jane Townsend

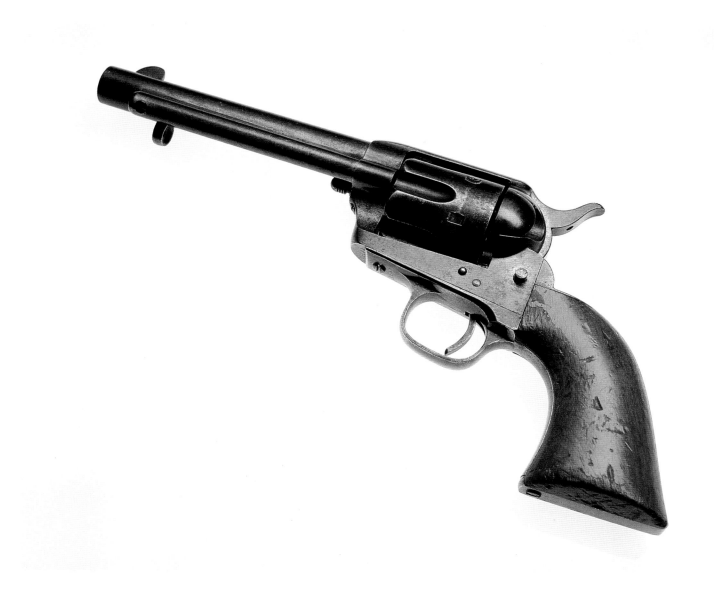

◄ **98**. *Solid frame, single action, .45 calibre Colt revolver, made in 1873; length 27.2 cm. Acquired in 1960.*
Photographs by Jane Townsend

sword, and from the same period, as those flourished by Alexandre Dumas' musketeers, on the other side of the English Channel.

*f*rom a later period and a different continent is the 1873 Colt revolver. This weapon is selected from the Powerhouse Museum's large collection of guns, many of which are far more rare and valuable. But the 1873 Colt is the evolved version of the six-shooter that won the West. Like the rapier, it was designed to be held in one hand, and in that sense it is an example of hand sculpture. Like the rapier before it, the Colt was worn by cavaliers, or at least, their successors, sometimes like a badge. The tradition of the Western frontier cowboy was inherited from seventeenth century cavaliers – even the hats look the same, give or take a plume of feathers. Like the rapier described above, the 1873 Colt is stylish but also serious. It is romantic but it is also efficient technology. For that reason alone, it belongs in a museum of technology and industry, which the Powerhouse – among other things – most certainly is. How many manufactured objects from the 1870s are still in production today? Despite the fact

that an immeasurable number of pistols have been invented and manufactured over the last hundred years or so, many of them displaying sophisticated and innovative technological departures, there is still a market today for the 1873 Colt revolver and it is still in production. As costume, it still figures in Western films, of which there is a resurgence in the 1990s.

If the Colt revolver is a run-of-the-mill example of an enduring design, the museum's full suit of Samurai armour, complete with harness is the opposite. This is a fine set of armour, very rare in its completeness. Like the Colt, it represents a bygone culture, legendary, dashing, and supposedly chivalrous. Samurai warriors wore armour like this, with small modifications, for more than a thousand years, until the Meiji period in the second half of the nineteenth century when their services were no longer required. Like Russian soldiers recently, they pathetically sold their weaponry to survive. Complementing this magnificent armour is a collection of Japanese swords and, separately, of tsuba or sword guards. These themselves are collectors items, and in their intricate geometry they represent a valuable aspect of Japanese tradition and craftsmanship.

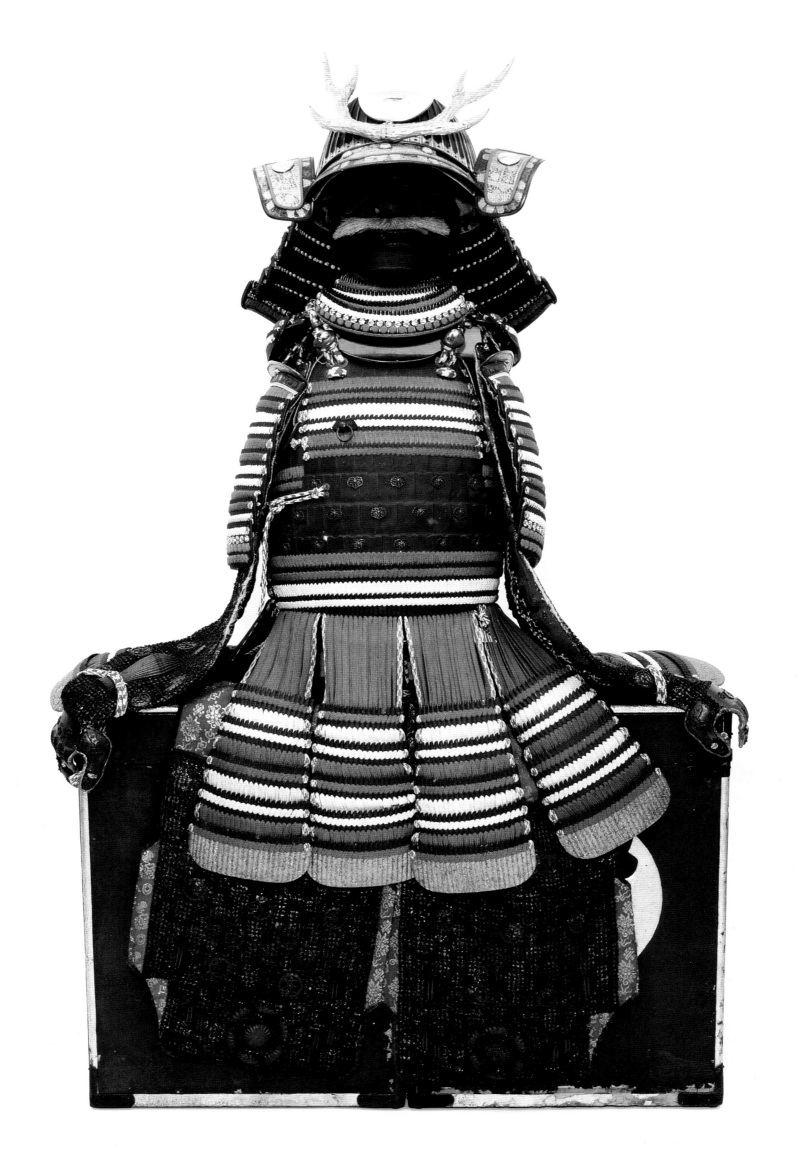

Japanese culture is not represented in the museum only by weapons and fighting equipment but also by several other things including a splendid collection of hair combs and kimonos. One of the latter is of particular interest in the context of an Australian museum collection. This is a *furisode*, a formal kimono in this case intended for a woman's twentieth birthday celebrations. Many young Japanese women have taken to wearing western-style dress for this sort of occasion, so one maker of kimonos, Atelier Moc, a 250-year-old company based in Kyoto, took an unusual step to attract customers back to traditional dress. They commissioned a design by an Adelaide firm, Jumbana Design, under their label, Balarinji Australia. This innovative company is run by Ros and John Moriarty. Inspired by John's rich Aboriginal heritage, the company began to adapt Aboriginal imagery for use in contemporary textiles. Their design for this kimono was executed under licence in Japan in 1992. It is made of exquisite cherry-red silk

100. Tsuba *(decorative Japanese metal sword guards)*, *nineteenth century; height 7.6 x width 7.2 x depth .3 cm; height 7.9 x width 7.3 x depth .4 cm. Gift of Mrs C R Thornett, 1966.* Photograph: Powerhouse Museum

◄ **99.** *Suit of Japanese Samurai armour, extremely rare in its completeness, made during the Edo period (1600–1868) and dates to about 1775. It includes banners, saddlery and storage boxes. Purchased 1948.* Photograph: Powerhouse Museum

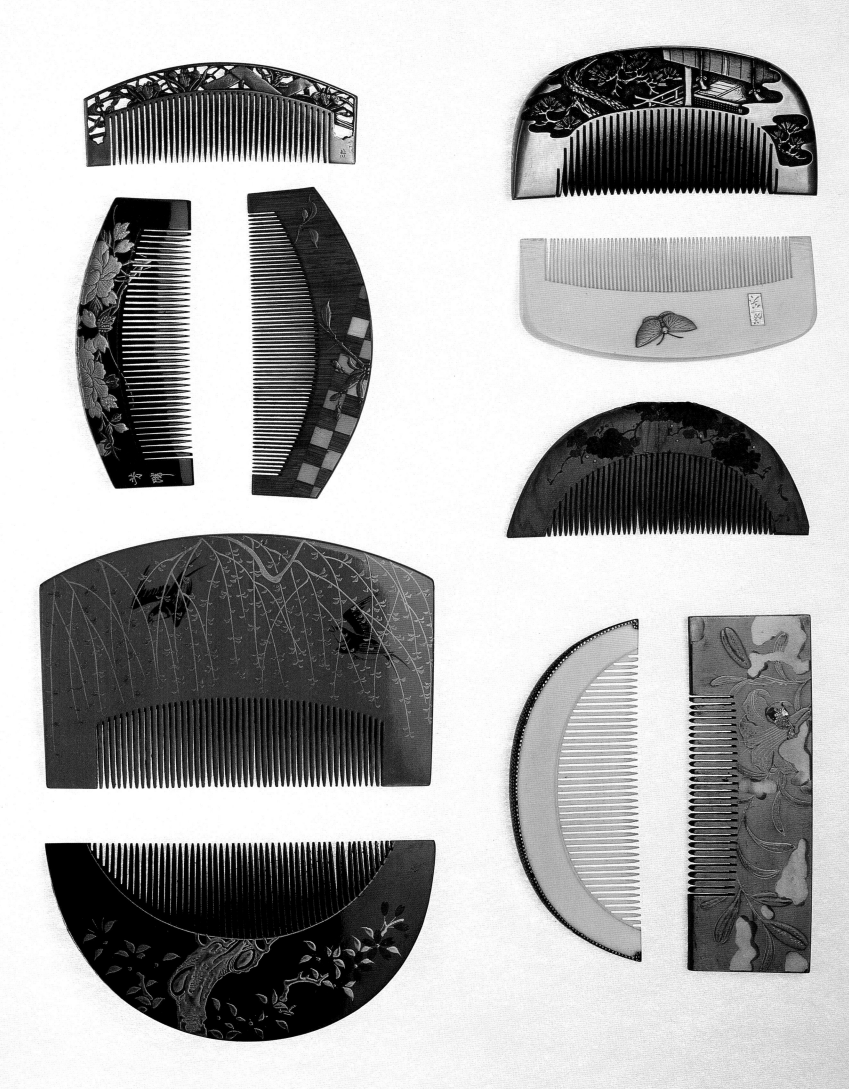

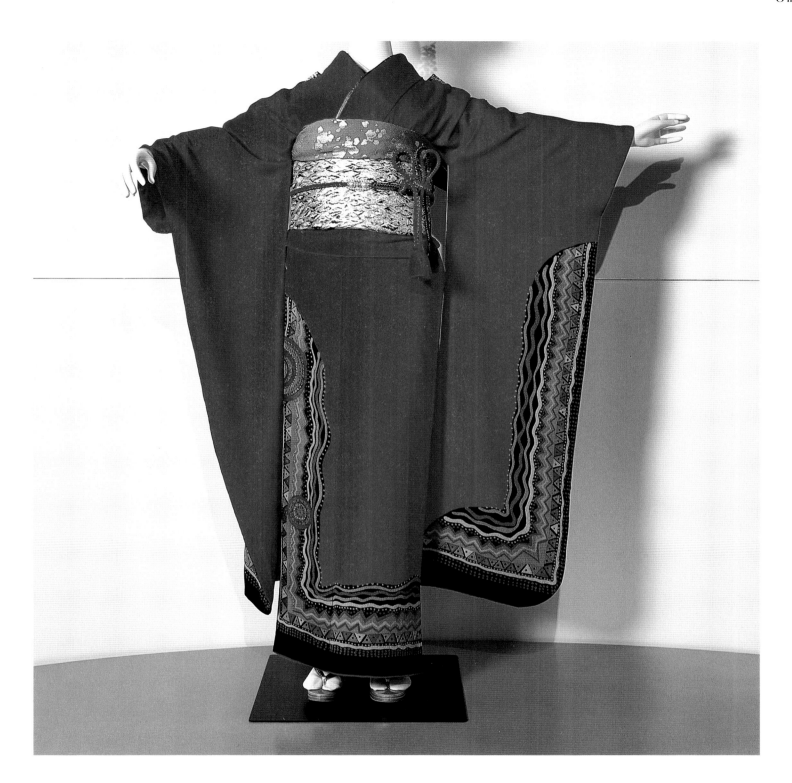

∧ **102**. *Traditional screenprinted and handpainted silk Japanese kimono made by Atelier Moc, Japan, features a design by Balarinji Australia based on Aboriginal imagery; width 141 x length 173 cm. Purchased 1993.* Photograph by Jane Townsend

≺ **101**. *Japanese combs, part of a large group that was collected in Japan in the early 1900s by Malcolm Henry, a teacher of English for the Japanese Government. They date from the nineteenth and early twentieth centuries. Purchased 1956.* Photograph by Geoff Friend

crepe, screen-printed with motifs adapted from traditional Aboriginal elements such as dots, triangles and wavy lines of ochre-colours. The commission clearly stimulated Balarinji to produce design of outstanding quality and ravishing beauty. Small wonder that they used this kimono to launch their designs in Japan. The kimono was a magnificent acquisition for the Powerhouse Museum in 1993, combining so many important elements in such a remarkable manner: contemporary Australian design, traditional Aboriginal motifs and traditional Japanese dress.

The collection also boasts some excellent Chinese robes. One purchased in 1989 has always intrigued me; it is an example of an informal robe worn by affluent Chinese

102. *Traditional screenprinted and handpainted silk Japanese kimono (details) made by Atelier Moc, Japan, features a design by Balarinji Australia based on Aboriginal imagery.* Photographs by Penelope Clay

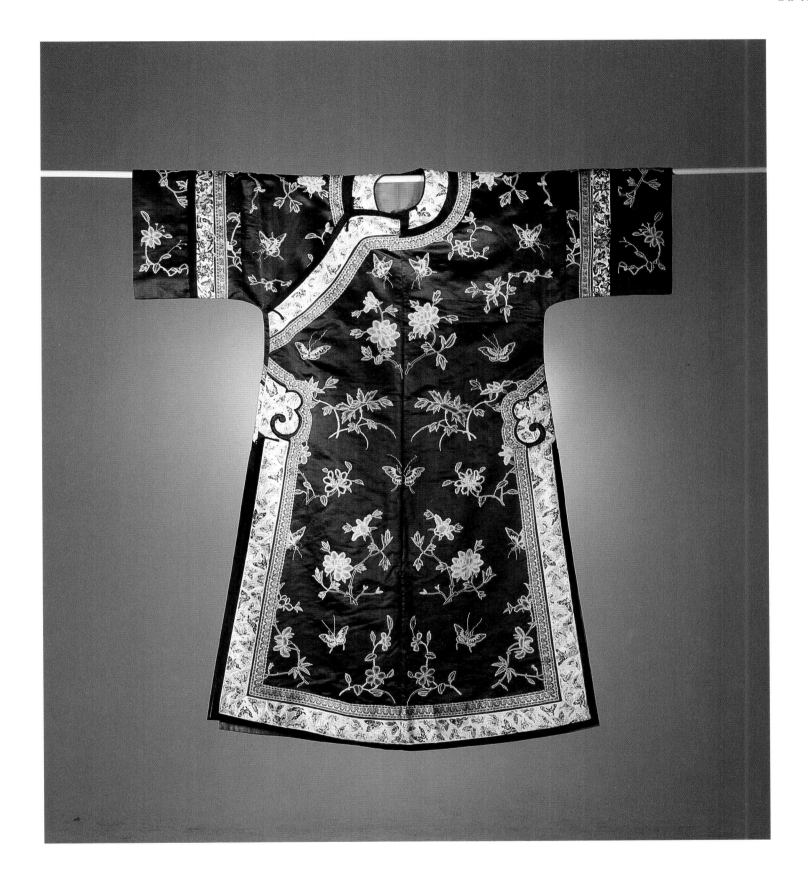

103. *Robes of this style were worn by well-to-do Manchu women in China in the Guangxu period of Manchu rule (1874–1907). This one is made of silk, and embroidered in 'Peking-knot' stitch with peonies, an emblem of spring, and butterflies, a symbol of happiness in marriage. Purchased with funds given by Mr and Mrs Preston Saywell, 1989.*

Photograph by Penelope Clay

103. *Embroidered butterfly in 'Peking-knot' stitch,*
a symbol of happiness in marriage (detail).
Photograph by Penelope Clay

➤ **104.** *Wooden bangles with painted,*
pokerwork decoration of Australian wildflowers
by Rolley Clarke, made 1987–1988, were
commissioned by Jenny Kee to complement
Flying Oz 200 *(pictured overleaf). Pictured*
here on background of printed silk charmeuse,
jacquard woven scarf designed by Jenny Kee;
height 4 x diameter 8 cm. Purchased 1990.
Photograph by Sue Stafford

women in the late nineteenth century. It is made of silk and decorated in a sensitive and delicate manner, embroidered with peonies and butterflies. What is fascinating is that it resembles patterns or products of the aesthetic movement in occidental countries, a movement with which this garment is precisely contemporaneous! Yet, as we all know, the aesthetic movement drew on Japan and China for inspiration and source material. The decorative pattern on this robe, its delicately toned colours, its gentle evocation of nature, its suggestion of spring, all call to mind a painting by, say, Albert Moore, of the same date. Here, sources, influences and results occur in parallel. It is a case of causes drawing level with effects!

*t*wo contemporary Australian designers also draw on nature in an assertive, fully committed way. These are Jenny Kee (born 1947) and Linda Jackson (born 1950). Already these two highly creative and expressive designers have proved to be an inspiration to the young stars of tomorrow as they emerge from art schools to try to register their identities in a crowded and competitive world. Thanks to Kee and Jackson, the newest generation of designers do not have to look to Paris for their models but now have the freedom to enjoy and express their Australian heritage, with its own colours, textures and values.

The Jenny Kee ensemble, illustrated, is typical of the work on which her reputation is based. The dress *Flying Oz 200* is a jigsaw puzzle of Australian motifs, including kangaroos, koalas, Sydney Opera House and much more. Like Ken Done, Jenny Kee has moved on from that generation of Australians who saw their country and its visual traditions in muted tones, greys and earth colours. Rather, she sees a kaleidoscope of saturated colours, reds, blues, maroons, wattle blossom yellows, all of boundless energy.

Linda Jackson's designs are so close to nature that the colours and textures of her creations almost disappear from view if placed against the bush setting that inspired them. They are like camouflage – not in a general way but in a manner so precise as to express deep respect for the Australian landscape, a true appreciation of pointed, curved, hanging, glaucous gum leaves and white stringy bark. As *the* museum for design in New South Wales, the Powerhouse Museum collects whole archives from designers, and we have acquired a large archive of the work of Linda Jackson. Both she and Jenny Kee could

105. *This printed silk charmeuse, jacquard woven scarf, with a design of stylised Australiana motifs, was designed by Jenny Kee between 1984–1988. Acquired in 1990.*
Photograph by Sue Stafford

106. *Handknitted dress,* Flying Oz 200 *1987–1988; handknitted jacket,* Kee Oz Kollage, *1988; printed silk charmeuse, jacquard woven scarf with a design of stylised Australiana motifs, designed by Jenny Kee (born 1947) in Sydney. Purchased 1990.* Photograph by Sue Stafford

have fitted within other chapters of this book, *Innovations in Design*, for example, and both are worthy of prominent inclusion in any anthology of Australian heroes.

The liberating effect of the careers of Kee and Jackson has been far-reaching and ubiquitous. The stunning costumes of *Strictly ballroom*, the highly successful Australian feature film of 1992, reflect a similar confidence in Australian attitudes and themes. The museum accepted all the film's costumes as a most generous gift from the M&A Film Corporation and immediately turned them into a popular exhibition which has toured Australia extensively since 1992. In keeping with the pantomime-like quality of the film, Angus Strathie's designs are the embodiment of caricature and fantasy.

Although there has been a strong vein of fantasy in Australian fashion design in recent years we do not have a monopoly on it. In the 1992 *Fashion of the year* selection the Powerhouse Museum featured the work of English milliner Philip Treacy. Illustrated is his *Featherbone dandelion* of that year.

The highly imaginative use of feathers, stripped and trimmed but left with arrowhead tips, makes an extravagant brim. The work exuded such power while on display in the museum that it entered the consciousness of

107. *Ensemble of a silk/cotton blend dress and coat,* Gumleaf, *designed by Linda Jackson (born 1950) in Sydney, 1989. Purchased 1990.* Photograph by Sue Stafford

◄ **108. 109.** ⅄ *Some of the sequinned and glittering costumes from the film* Strictly ballroom, *designed by Angus Strathie for M&A Film Corporation; made by Nola Lowe, Barrie Lowe, Tony Bonicci and Anthony Phillips. Gift of M&A Film Corporation, 1992.* Photograph by Jane Townsend

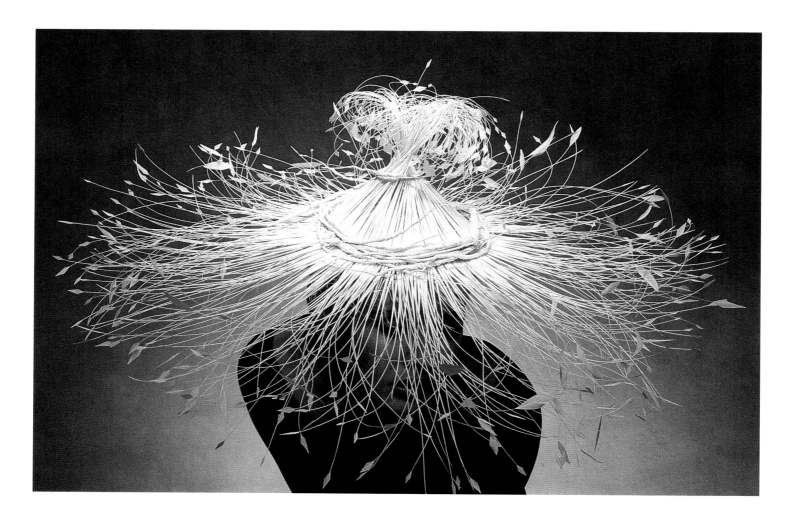

110. Featherbone dandelion *hat made of cockerel feathers by English designer Philip Treacy (born 1967), in 1992; height 57 x diameter 75 cm. Purchased 1992.* Photograph by Andrew Frolows

student designers as an irresistible model. The *Fashion of the year* event has become an important occasion in the museum's calendar, one that is shared with the newspaper the *Sydney Morning Herald*, which sponsors it.

Body ornaments such as bracelets and bangles are well represented in the collection. In colonial times, Australia was famous above all for gold. The gold rush years of the 1850s and 1860s changed the nature of Australian society and culture in a remarkable way, transforming major cities such as Melbourne and Sydney into financial centres. In Sydney in the 1850s, the first branch of the Royal Mint outside London was opened. It was a time of high ambition when staff of the Sydney Mint entered into international communications on economic matters. They became leading experts on the extraction of ores and other metallurgical processes. Not surprisingly, craft activities in

Australia at that time responded to the opportunities that gold provided. One maker of precious ornaments was Henry Steiner of Adelaide. In 1988, the museum acquired a spectacular 18 carat gold bangle made by Steiner about 1879. It was designed to impress! It was also designed to be romantic and carries the inscription: *Soyons toujours unis/par un divin amour* ('Let us always be united in a divine love').

a century or more later, jewellers are not so keen to impress by the sheer weight and value of precious metal. They might use it or they might use something inexpensive instead. Jewellery is a fertile field today where we find truly imaginative talents. This is as true internationally as it is within Australia. One of the interesting directions which artists have taken is towards a frank use of materials, precious or not, for their intrinsic appeal, their physical properties of colour and texture. These trends are exemplified in the work of Carlier

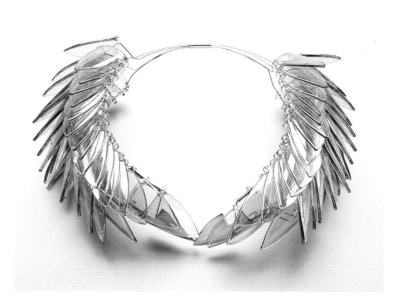

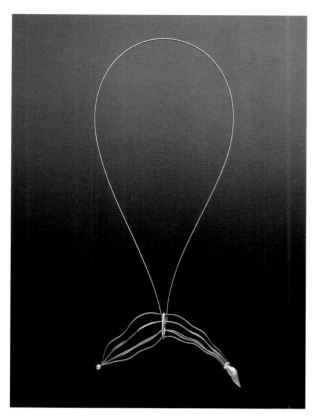

113. *Sterling silver, nicoros and stainless steel wire neckpiece by Carlier Makigawa (born 1952), Melbourne, 1991; width 4 x length 16.7 cm. Purchased 1992.*
Photograph by Sue Stafford

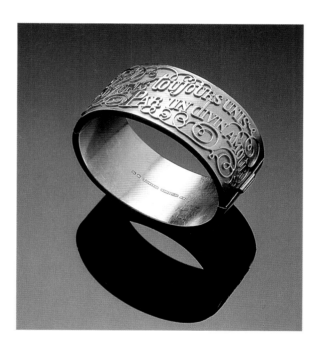

111. *(Top)* Blue neckpiece *by Giselle Courtney (born 1960), an Australian glass artist and jeweller, made of lampworked borosilicate glass with lustre, stainless steel wire and silverplated brass in 1990; height 9 x width 25 x depth 18 cm. Purchased 1995.*
Photograph by Jane Stafford

112. *Gold bangle made by Henry Steiner (1835–1914), Adelaide, about 1879. The translation of the inscription is, 'Let us always be united in a divine love'; height 3.15 x width 5.9 x length 6.8 cm. Purchased 1988.* Photograph by Penelope Clay

Makigawa, a highly respected jeweller in Melbourne. In 1992, the museum acquired a new piece of hers, a neckpiece in sterling silver, nicoros and stainless steel wire. The pendant is a wire frame, resembling a model of an aboriginal fish trap, or even a fish itself. It is a flowing form which is waisted or pinched in the middle, where it is joined to a stainless steel wire halter. The pendant is finished at one end with a tiny sphere and at the other with a flame-like form. This neckpiece is a miniature sculpture, a sculpture to wear on the body, and in that respect it is highly typical of the contemporary jewellery field.

Finally, in this look at things which people put on their bodies, we come down to shoes. It has been observed that the Powerhouse has a shoe collection bigger than that of Imelda Marcos! Out of our vast collection, just two will suffice. The first is a pair of women's boots that would justify their place in any collection for two

114. *Gold, stainless steel and anodized aluminium pendant by Johannes Kuhnen (born 1952), NSW, 1989; length 26.5 cm. Purchased 1989.*
Photograph by Sue Stafford

remarkable reasons. The first of these is that they represent a real turning point or innovation in shoe design. Their maker was Joseph Sparkes Hall, who is credited with the invention of the elastic-sided boot which he patented in England in 1837. A leading footwear expert, June Swann, of Northampton (where else!), England, accepted the Museum's invitation in 1993 to assess our shoe collection. While she was in Sydney, the private owner of the elastic-sided boots was asked to bring them in for an expert appraisal. June Swann confirmed that they are the only extant pair of Sparkes Hall patented elastic-sided boots in the world. For this distinction alone the museum would have been keen to acquire them. But there was a further, quite extraordinary fact. The owner's family history provided a provenance for these boots going back to none other than Queen Victoria! June Swann was able to recognise technical details that removed any doubt that this very pair of boots was indeed presented to his queen by Joseph Sparkes Hall. It so happens that this prototype pair uses thin coiled wire instead of the more effective rubber

elastic which he went on to use subsequently. Fortunately their Australian owner agreed to part with them and they entered the collection in 1994.

Provenance is part of the game! Museum visitors enjoy knowing who the previous owners of objects were. And in this case, who wore the shoes. A quite extraordinary pair of men's shoes in the collection represents their epoch just as strongly as Queen Victoria's do. This is a pair given to the museum by the well-known Sydney-based Australian artist Colin Lanceley. These shoes of 1967 belong to his London period; they are high off the ground, with stack heels and platform-soled, after the fashion of the sixties. Their uppers are embroidered with a cheerful pattern in yellow, green, purple, black and pink. Colin Lanceley purchased the shoes in Portobello Road, Notting Hill, the epicentre and nerve centre of swinging London! By comparison, Carnaby Street was sedate and rather grey, a place for lost tourists, not a place for artists.

115. *Elastic-sided boots, 1857, by Joseph Sparkes Hall, who presented them to Queen Victoria in the same year. Purchased 1994.*
Photograph by Jane Townsend

116. *Platform shoes, with uppers of woven Middle Eastern fabric, purchased in Portobello Road, London, in 1967, by the artist Colin Lanceley; height 13 x width 10 x length 28.5 cm. Gift of Colin Lanceley, 1986.*
Photograph by Andrew Frolows

Pages 168–169. *The Powerhouse Museum Garden Restaurant painted by Ken Done, 1994.*
Photograph by Jane Townsend

167

Australian Heroes

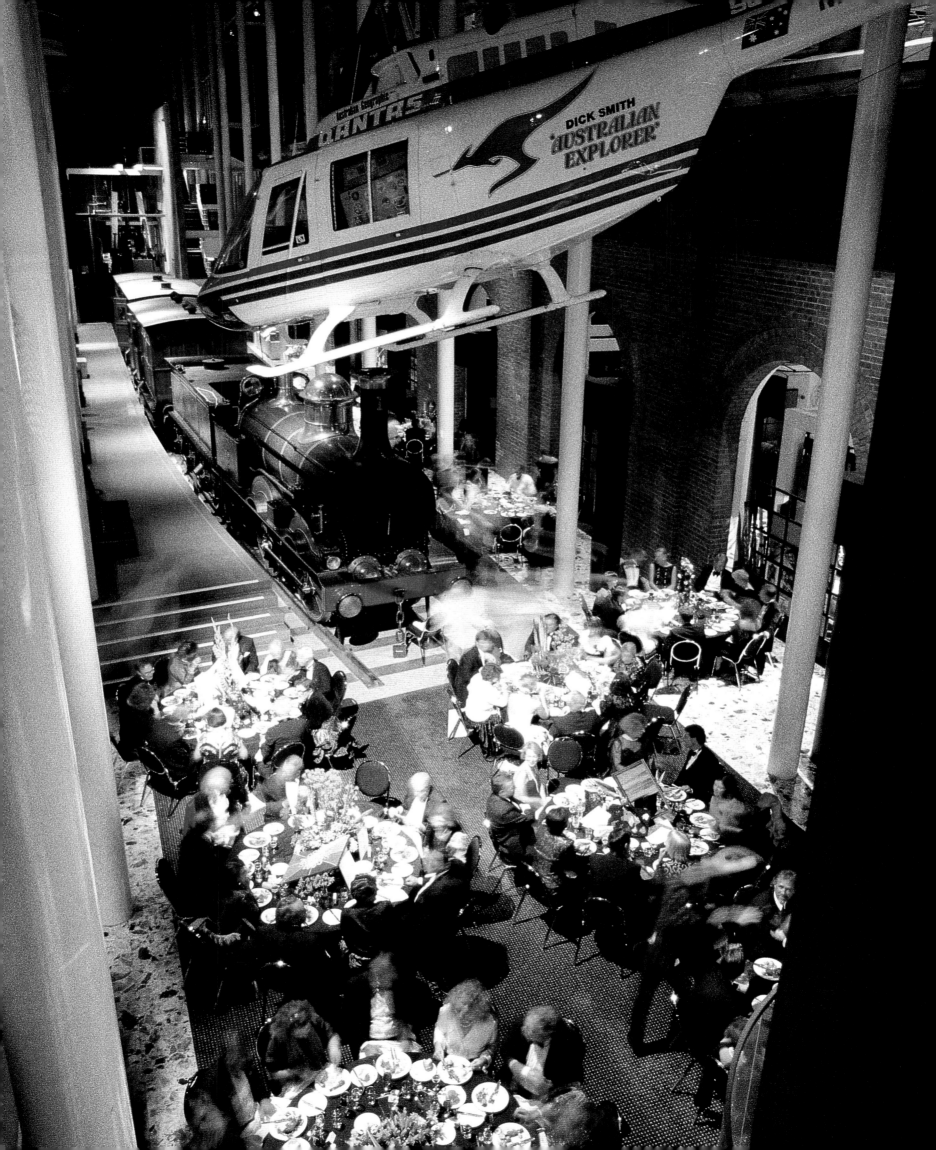

Australian Heroes

*a*ll cultures have their heroes, many of them military or political leaders. Australia has its heroes too but they are mostly great flyers, pioneers of aviation. And they were not all men! Lores Bonney's achievements in aviation equal those of men, but it took decades for Australia to give her the recognition she deserved. A more recent hero is New Zealand born Fred Hollows, the eye doctor whose care for Aborigines and similarly suffering people in other countries was nothing short of saintly.

The Powerhouse Museum is proud to commemorate the achievements of these outstanding Australians by collecting memorabilia associated with their adventures and displaying them together with explanatory material wherever possible. In some cases, the efforts of previous trustees, directors, curators and donors have made it possible to do more.

In the case of Captain P G Taylor, for example, we have his Catalina flying boat which is on perpetual display. It is one of the most awesome, dominating and spectacular sights in the museum.

In the case of Sir Charles Kingsford-Smith, we have a relic of the lost *Lady southern cross*. It is the starboard wheel

Powerhouse Museum annual Fundraising Ball, 1991; diners sit below the Bell JetRanger helicopter with which Dick Smith achieved many records.

and a piece of undercarriage. An object such as this falls into a long tradition of jealous guardianship of precious relics. We no longer believe in the magical properties of relics but they are still important in the context of a developing Australian cultural tradition, in which aviation has played such a vital role.

In the case of the still very much alive Dick Smith, we have much more than a fragment; the museum possesses the whole craft in which he set a list of world records, complete in its authentic livery and with its original fuel tanks and pilot's personal effects intact.

The *Bell 206B JetRanger III helicopter* is a fine, serviceable small helicopter, ideal for short trips. It was not designed for long, gruelling voyages of epic proportions. Yet that is exactly what Dick Smith, Australian businessman and intrepid explorer, took it on. Nothing less than a round-the-world trip. In 1983 Smith became the first person to have flown solo in a helicopter right around the world. He picked up his new helicopter from the Bell factory in Fort Worth, Texas, and began his record-breaking voyage from there, eventually returning to Fort Worth via, among innumerable other places, his native city, Sydney, Australia.

Smith equipped his craft with extra fuel tanks, increasing the helicopter's range from 400 nautical miles to 900, but even this was not enough for a Pacific crossing.

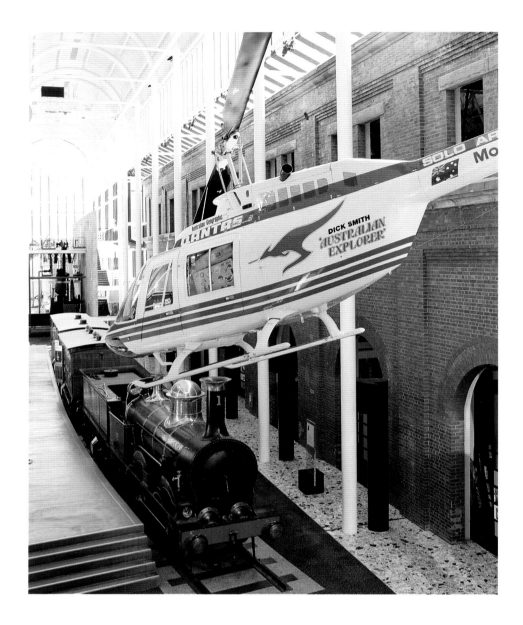

117. *This Bell 206B JetRanger III helicopter,* Australian explorer *VH-DIK (call sign Delta-India-Kilo), is the helicopter flown by Dick Smith in the first solo circumnavigation of the world; height 300 x width 250 x length 1500 cm. The helicopter was acquired along with log books and a variety of documentary material. Gift of Dick Smith, 1990.* Photograph by Jane Townsend

In order to cross the Pacific, Smith managed to persuade a Norwegian container ship to allow him to land and refuel on board at sea. This was an extraordinarily dangerous manoeuvre which required extremely accurate navigation, for the large bulk carrier had not agreed to stop nor to wait, only to carry Smith's fuel and give him permission to land. Bad weather, which Smith experienced, could easily have left him high and dry or, more accurately, low and wet! Storms forced him into many tight corners, sometimes sending him close to politically dangerous air space or causing him to land on physically dangerous beaches, risking getting his craft bogged in wet sand. At one point, possibly over Iceland, he was the target of a sniper and the aircraft still has a couple of bullet holes to show for it.

Smith was oblivious of this casual attack, due to the noise of his engine, but one bullet narrowly missed him and another entered a fuel tank, where it was eventually located.

In undertaking this heroic flight, Dick Smith placed himself consciously and directly in the line of great Australian aviators like Jim Mollison, Bert Hinkler, and Sir Charles Kingsford-Smith, whom he so much admired and for whom his own gruelling performance was an homage and a tribute.

Not long after Dick Smith took off from Fort Worth, he was astounded to find that a large group of Americans had set out to pay tribute to him, although their gesture was perhaps not so intended. H Ross Perot Jr decided that Americans must be the first to circumnavigate the globe in

118. *The twenty dollar note, designed by Gordon Andrews (born 1914), Sydney, features a portrait of Sir Charles Kingsford-Smith. Andrews designed Australia's first decimal currency notes. Gordon Andrews archives purchased 1989 and 1992.*
Photograph by Sue Stafford

a helicopter, but a much larger one, a float-equipped Bell LongRanger. His co-crew member was Jay Coburn, a veteran flier. These two were accompanied in turn by a crew of eleven in a four-engined Hercules transport. Its complement included divers in case the helicopter came down. It didn't, and it went on to complete its circum-navigation before Dick Smith completed his. But this is a museum story and that is why it is included in this book. Ross Perot's helicopter, *Spirit of Texas*, is now displayed in Washington's National Air and Space Museum – coincidentally a museum of the same size in exhibition area as the Powerhouse. *Spirit of Texas* achieved the first helicopter circumnavigation of the world – by no means solo – and looks well in its display space, but the labelling makes no mention of the Hercules transport and very little cogent mention of Dick Smith, whose initiative provoked the Americans, and whose detailed planning, including his flight plans, had impressed them.

What is the significance of Smith's achievement? In terms of technology, Smith demonstrated that it is possible to stretch the possibilities, the potential, of a machine through simple modifications but mainly through careful planning and the exercise of extraordinary courage. His little craft achieved many other records besides his solo flight around the world:

• first solo helicopter flight across the Atlantic ocean
• first solo helicopter flight across the Pacific ocean
• first helicopter flight to the North Pole
• first helicopter flight around Australia
• first helicopter flight across Australia.

In 1990 Dick Smith responded generously to my importunate requests and agreed to donate his Bell JetRanger craft to the collection. We were not surprised when he delivered it personally from his house in Terrey Hills, north of Sydney. With typical panache, on 16 August 1990, Smith flew his historic craft right into the museum's precinct and set it down in an open service area whence he helped staff to wheel it into the museum. It was with mixed feelings, including not a little sadness, that he left his craft behind. Since that time his adventures have continued and in 1993, for example, Dick Smith achieved the first

⋏ **120.** *1:12 scale model of Sir Charles Kingsford-Smith's aircraft, Lockheed Altair* Lady Southern Cross, *made 1988–1989 by the Powerhouse Museum model-maker, Iain Scott-Stevenson, 1989.*
Photograph by Andrew Frolows

≺ **119.** *Wheel and oleo section, the only part of Sir Charles Kingsford-Smith's (1897–1955) aircraft, Lockheed Altair* Lady Southern Cross, *to have been found after the plane crashed in 1955. Gift of the Civil Aviation Authority, Canberra, 1994.*
Photograph by Sue Stafford

hot-air balloon crossing of Australia.

Sir Charles Kingsford-Smith was one of Dick Smith's aviation heroes. Kingsford-Smith (1897–1935), after whom Sydney's international airport is named, is perhaps the greatest and best known of Australia's pioneer aviators. His exploits are legendary. He achieved the first air crossing of the Pacific, San Francisco to Brisbane in 1928, and the reverse direction in 1934, set several record times from England to Australia, was the first to cross the Tasman by air from Australia to New Zealand. He set many Australian records. He was a pioneer, and a far sighted one, of the aviation industry.

Like so many aviation pioneers, Kingsford-Smith died in his cockpit on one of his efforts to reduce the flying time between Britain and Australia. On 6 November 1935, he took off with co-pilot Tommy Pethybridge in a single-engined Lockheed Altair called the *Lady Southern Cross*. The plane disappeared in the Bay of Bengal, after passing over Rangoon, in the early hours of 8 November. Searches at the time revealed no trace of the machine, whose disappearance remains a mystery to this day. However, in May 1937, on the beach of tiny Aye Island in the Gulf of Martaban, off the coast of Burma, a piece of wreckage turned up. An English fisherman, Mr N M Andrews, discovered one of *Lady Southern Cross's* wheels still attached to a twisted and dented portion of the undercarriage. It has since been assumed that the Lockheed Altair struck trees on the ridge of this densely forested islet. The plane then dived into the sea below the cliffs of the island and sank out of sight. Sea currents gradually worked the still fully inflated starboard wheel free. Then the wheel floated upwards, dragging with it a still attached fragment of

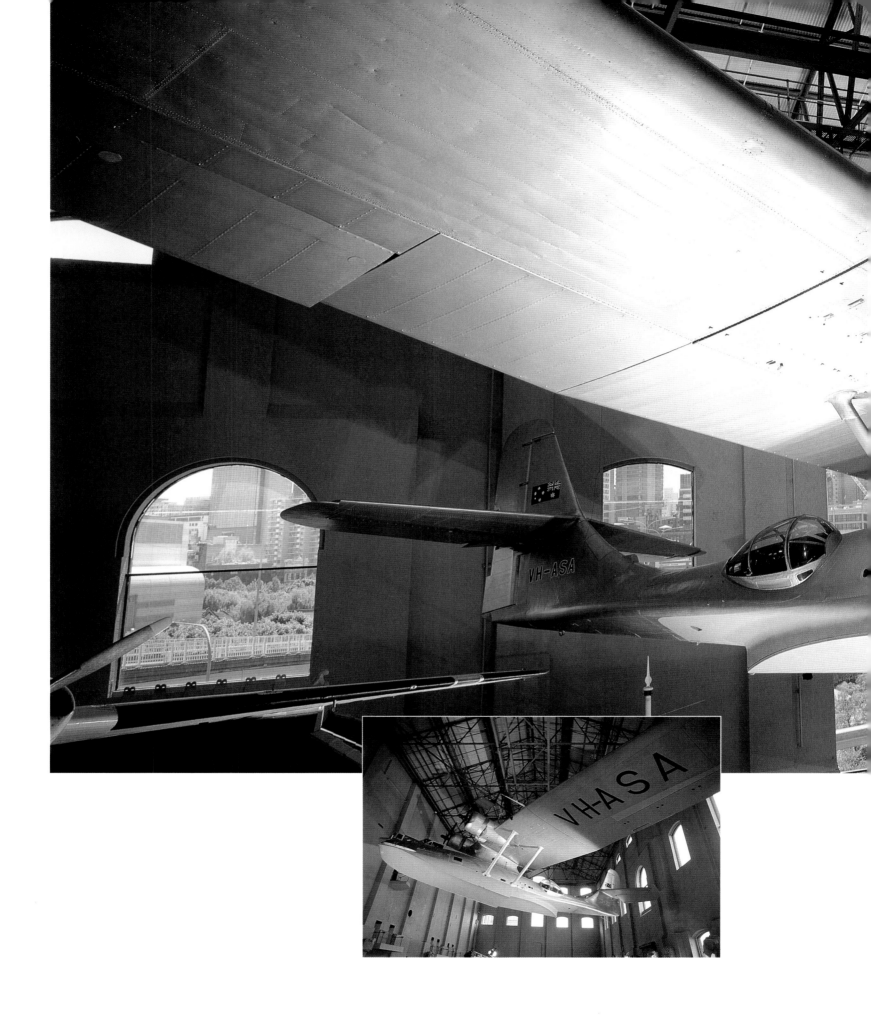

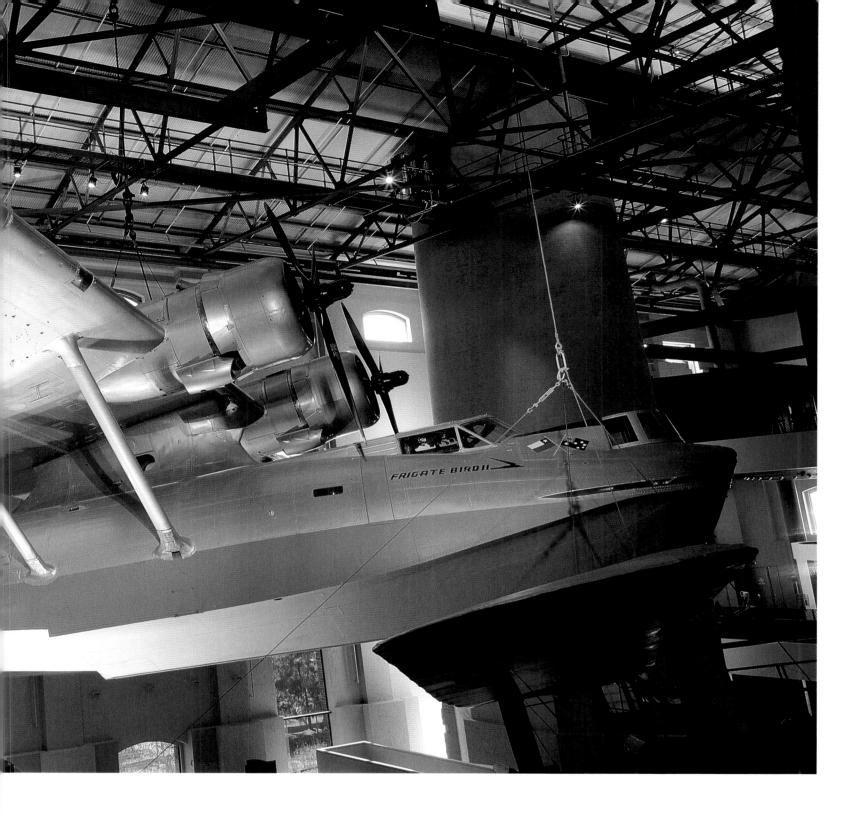

121. *The Powerhouse's PB2B-2 Catalina flying boat* Frigate bird II, *built 1944, has a wingspan of 31.7 metres and weighs 8.52 tonnes. It was restored by Hawker Pacific Pty Ltd in 1986. It is a spectacular sight in the* Transport *exhibition, sponsored by Toyota Motor Corporation Australia. Gift of Sir Patrick Gordon Taylor, 1962.*

Photographs by Penelope Clay (above) and Geoff Friend (left)

121. *The PB2B-2 Catalina flying boat* Frigate bird II *has a wingspan of 31.7 metres and weighs 8.52 tonnes (detail).*
Photograph by Penelope Clay

undercarriage, including the oleo gear or shock absorber. This poignant little assembly, all that is known of the *Lady Southern Cross*, eventually washed up on the beach for an English sportsman to find. Most of this explanation is conjectural but perhaps one day we may know something more. This fragment of wreckage from Kingsford-Smith's last adventure is rightfully treasured as a relic of the career of one of Australia's greatest heroes. It may well prove, eventually, an important piece of forensic evidence that throws light on the mystery of the death of Kingsford-Smith and his co-pilot, Tommy Pethybridge.

Frigate bird II, the Museum's Catalina flying boat, is at once one of the most spectacular and one of the most inescapably visible exhibits, floating aloft in the biggest of the galleries. With Loco No. 1 it is one of the two largest objects on exhibition. In fact, the Powerhouse Museum makes the claim that *Frigate bird II* is not only the largest suspended aeroplane in any museum in the world but it is also the largest suspended object of any description.

There are two principal reasons for the inclusion of *Frigate bird II* in the collection. The first is that it is one of the few remaining examples anywhere of this historically significant aircraft. There are perhaps a dozen museums around the world that possess a Catalina, yet in the great age of the flying boat, more Catalinas were produced than any other water borne aircraft. Designed in the early 1930s,

it was the most successful flying boat of all and almost 4,000 were produced, more than all other makes combined.

The Catalina was first commissioned from the Consolidated Aircraft Corporation in the USA as a military craft designed for reconnaissance patrols, but was considered obsolete by 1939 and the outbreak of World War II. Nevertheless, it went on to provide sterling war service. It was slow but safe; easy to hit but hard to destroy. Its functions expanded to include both rescue and attack.

In Australia, the RAAF flew 168 Catalinas and these aircraft and their crews significantly affected the course of the war against the Japanese forces in the Pacific. For this reason alone, Catalina flying boats have a strong Australian connection.

After the war, some Catalinas, stripped of their armaments, continued to work in non-military roles, joining the fleets of many of the world's airlines. The majority, however, were scrapped within a few years of the war's end.

The second reason for *Frigate bird II's* presence in the collection is that this particular Catalina accomplished a historic flight, piloted by one of Australia's long line of

aviation pioneers and heroes, Captain P G Taylor. The flying boat was assigned to Taylor by the Australian government for his record-breaking flight to South America in 1951. Captain Taylor and his crew flew from Sydney to Valparaiso, Chile, and back again, establishing the viability of a new air route. It was a hazardous pioneering flight, the most dangerous point being when the aircraft was trapped in buffeting seas off Easter Island. With all anchor lines snapped, Taylor tacked and sailed his aircraft clear of treacherous rocks. For the long voyage which taxed even the range of a Catalina, Taylor used rockets attached to the fuselage for additional thrust to assist the heavily fuel-laden craft to lift off.

This historic flight confirmed Taylor's reputation as a

122. *A selection of the Lores Bonney (1897–1994) collection of 1920s–1940s memorabilia. Gift of Mrs Lores Bonney, 1984.*
Photograph by Sue Stafford

brilliant aviator and navigator, one who, when all else failed, was able to fly on instinct. In 1934 he had flown with Kingsford-Smith from Sydney to San Francisco, co-piloting the ill-fated Lockheed Altair in which Kingsford-Smith died the following year. In 1939 Captain Taylor made the first crossing of the Indian Ocean, also in a Catalina, establishing an air route between Australia and Africa. And in 1944, again in a Catalina (his first *Frigate bird*), Taylor achieved the first Central Pacific crossing, from Mexico to Australia. Captain P G Taylor was one of

DATE 27/5/1933 JOURNEY FROM Jodhpur TO Karachi

CREW.				CUSTOMS STAMPS.
Duty	Name	Address	Nationality	

Starting Point	No. of Passengers	Cargo		Time Engine run on ground	Max. Revs. per Min.		Time of Departure	Time of Arrival	Landing Point
		Nature	Wt.		on ground	in air			
Jodhpur				10	1800	1820	8	2	Karachi
	409						6 Hrs		

Petrol into Tanks	Oil into Tanks	Weather Conditions	Reasons for Intermediate Landings and Particulars of Damage (if any)	Pilot's Remarks on Journey
19 Top 30 Front	2 gals	Visibility bad oking dust storms		Very easy after previous day, flew low to get the bumps, as felt drowsy several times. Terrified at birds near Hydrobad, had to flee swearing to Karachi Hatch. Very trying.

General Fitness of Aircraft (before Flight) certified. Date entered in A. & E. Logbooks

Signature of Pilot

aviation's great pioneers and one of Australia's great heroes. The Powerhouse Museum is proud to display his *Frigate bird II*, an undoubtedly great aircraft.

australia's greatest woman pioneer air pilot was Lores Bonney (1897–1994) – who lived until the impressive age of 97 years. Unlike so many intrepid heroes of her generation, she did not disappear in mid-flight and her name is not therefore at the centre of any mystery. This fact alone helps to explain why she received no recognition in Australia until 1979, when Terry Gwynn-Jones published a book on her, 48 years after her first record flight. Regrettably, it seems that the main reason for ignoring her was that she was not a man – that and the fact

➤ 122. A selection of the Lores Bonney (1897–1994) collection of 1920s–1940s memorabilia. It includes flying caps, goggles, helmet, overalls, maps, repair kit, a perfume container, course distance calculator and log-book (page illustrated, above). Gift of Mrs Lores Bonney, 1984. Photograph by Sue Stafford

that she was supported by a wealthy husband, a Brisbane manufacturer, who financed her flights and indeed purchased her aircraft for her. In her day she was treated patronisingly by her male counterparts. Nevertheless, her exploits were just as brave and as terrifying as theirs. She survived a mid-air collision. She crash-landed in the surf off a remote island and, hanging upside down with her head under water, she nearly drowned. She flew without radio in a single-engined aircraft and she navigated with rudimentary maps as her only aids. She trained in

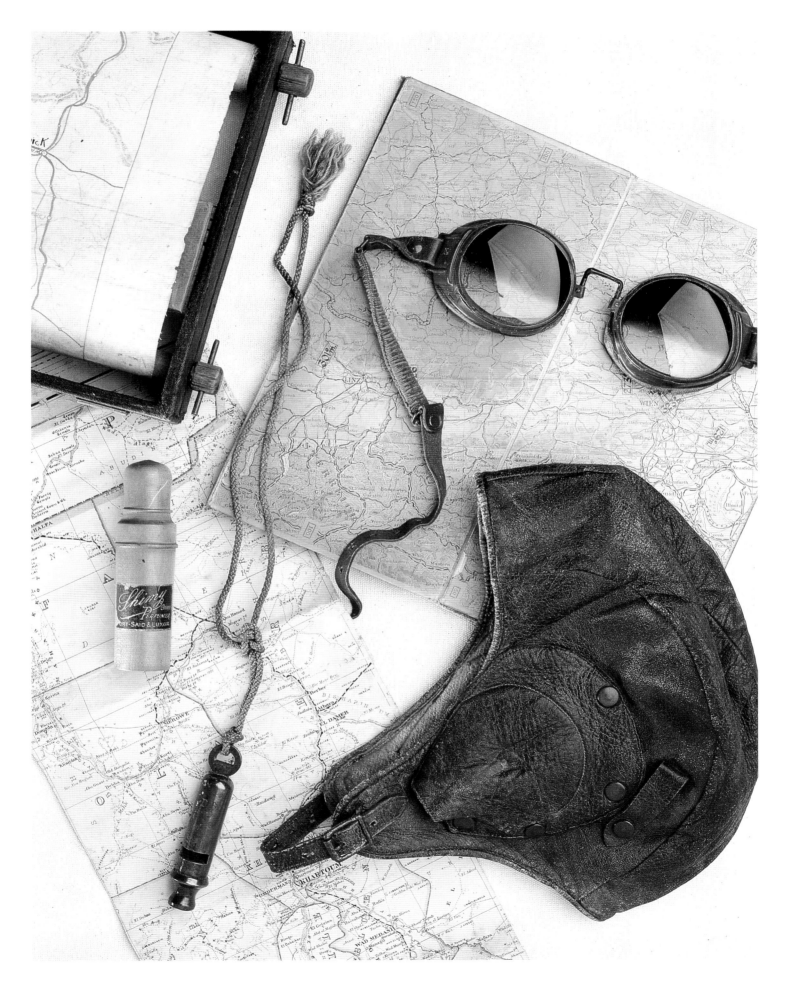

mechanics and carried out necessary maintenance, including complete overhauls, on her de Havilland Moth.

Lores Bonney's first record, in 1931, was a distance flight from Brisbane to Wangaratta in Victoria. Typical of her style, she made the trip to drop in on her father for Christmas! In the same year she became the first woman to circumnavigate Australia by air, using as an excuse to do so her wish to visit friends in Perth. In 1933, she became the first woman to fly from Australia to England, earning herself an MBE. In 1937 Lores Bonney achieved the distinction of being the first person to fly the phenomenal distance from Brisbane to Capetown, South Africa – 29 000 km. Her route encompassed about fifty fuel stops including Singapore, Bangkok, Rangoon, Calcutta, Delhi, Karachi, Bagdad, Cairo and then south over Africa. She was airborne for more than 210 hours.

Journalists at the time concentrated less on Lores Bonney's achievements and more on her appearance. This was fair comment as well as patronisingly sexist. She

123. *Intraocular lens, 1994, from the factory in Eritrea, established by the Fred Hollows Foundation and opened in 1994; diameter .6 cm. Gift of the Fred Hollows Foundation, 1994.*
Photograph by Jane Townsend

dressed stylishly. Her European finishing school education had trained her to look her best in all circumstances and she considered herself to be and to behave like a lady. She always managed to look fresh and cheerful even when she was exhausted after the most gruelling flight.

Besides aviation, medicine is a field in which Australia has much to be proud of and the museum actively collects in the field of medical science. In 1994 we acquired a number of items representing the work of the Fred Hollows Foundation. Before Professor Fred Hollows' untimely death in 1993, Australia realised that it had a hero on its hands. He was made a Companion in the Order of Australia and was named Australian of the Year in 1990, the same year in which he was awarded the Australian

Prime Minister Paul Keating in the Powerhouse Museum in May 1994 to launch a book on Fred Hollows and the Hollows Foundation: Seeing is believing *with text by Simon Balderstone and photography by Michael Amendolia.*

Photograph by Andrew Frolows

Human Rights Medal. Hollows was not the sort of person to seek out these accolades. On the contrary, his whole life was marked by a fierce independence of convention and a distinctly rebellious streak. But official honours gave him a platform from which to speak out on the issues that most concerned him – 'Aboriginal health and the social and political position of Aborigines, and the responsibility we, as privileged citizens of First World countries, bear to the people of the Third World'.

As a leading ophthalmologist, Fred Hollows pioneered the treatment of blinding eye infections amongst Aborigines in outback Australia and then went beyond Australia to devote himself to eradicating cataract blindness in Eritrea, Nepal and Vietnam. Following his death, the Fred Hollows Foundation has continued his work.

The treatment for cataract blindness in developed countries consists in implanting an intraocular lens, made of plastic, behind the iris. This artificial lens returns the patient's vision to normal, or at least obviates the need for

extremely thick and very expensive spectacles. The Hollows Foundation has concentrated on methods of supplying and fitting intraocular lenses at a cost that can be borne in developing – that is, extremely poor – countries and has now established a lens factory in Eritrea, where lenses can be manufactured for as little as $5 instead of $150 in Australia. Cataract blindness is very prevalent in Third World countries and that, as Fred Hollows told me on a visit to the Powerhouse Museum, 'is quite unnecessary'. The work of the Hollows Foundation is carried on by a powerful team which gathers momentum and funds all the time. It is spearheaded by Gabi Hollows, who herself has all the makings of an Australian hero but, like her late husband, would no doubt be impatient with the word. Only the work of the Foundation and service to others considerably less fortunate than most Australians are what matter. As Fred Hollows himself put it: 'To my mind, having a care and concern for others is the highest of human qualities.'

Further reading

Alexander, Edward P, *Museums in motion: an introduction to the history and functions of museums*, American Association for State and Local History, Nashville, 1979.

Anderson, Patricia, *Contemporary jewellery: the Australian experience*, Millennium, Newtown, NSW, 1988.

Aslin, Elizabeth, *The Aesthetic movement: prelude to art nouveau*, Excalibur; New York, 1981.

Australian fashion: the contemporary art, Museum of Applied Arts and Sciences, 1989.

Balderstone, Simon, *Seeing is believing*, with photographs by Michael Amendolia, McGregor Publishers, Gold Coast, Queensland, 1994

Betteridge, Margaret, *Royal Doulton Exhibition 1979*, Museum of Applied Arts and Sciences, Sydney, 1979.

Cochrane, Grace, *The crafts movement in Australia: a history*, New South Wales University Press, Sydney, 1992.

Davis, Pedr, *Charles Kingsford Smith: Smithy, the world's greatest aviator*, Summit books, published by Paul Hamlyn Pty Limited, Sydney, 1977.

Design world: the international journal of design, Number 25, 1992, Design Editorial Pty Ltd.

Dougherty, Kerrie and James, Matthew L, *Space Australia: the story of Australia's involvement in space*, Powerhouse Publishing, Sydney, 1993.

Falk, John H and Dierking, Lynn D, *The museum experience*, Whalesback Books, Washington DC, 1992.

Gwynn-Jones, Terry, *Pioneer Aviator: The remarkable life of Lores Bonney*, University of Queensland Press, Brisbane, 1988.

Hooper-Greenhill, Eileen, *Museums and their visitors*, Routledge, London, 1994.

Hoving, Thomas, *The chase, the capture: collecting at the Metropolitan*, Metropolitan Museum of Art, New York, 1975

Hoving, Thomas, *Making the mummies dance: inside the Metropolitan Museum of Art*, Simon & Schuster, New York, 1993

Impey, Oliver and MacGregor, Arthur, eds, *The origins of museums: the cabinet of curiosities in sixteenth- and seventeenth-century Europe*, Oxford University Press, Oxford, 1986.

Jackson, Linda, *Linda Jackson: the art of fashion*, Fontana, Australia, 1987.

Joseph Wright of Derby, Derby Museums and Art Gallery, 1979.

Muller, Jeffrey M, *Rubens: The artist as collector*, Princeton University Press, New Jersey, 1989.

O'Callaghan, Judith, ed., *The Australian dream: design of the fifties*, Powerhouse Publishing, Sydney, 1993.

Powerhouse Museum, *Decorative arts and design from the Powerhouse Museum*, Powerhouse Publishing, Sydney, 1991.

Powerhouse Museum research series no 3: caring for heritage objects, Powerhouse Publishing, Sydney, 1994.

Renew, Rob, *Making it. Innovation and success in Australia's industries*, Powerhouse Publishing, Sydney, 1993.

Roughley, T C, *The aeronautical work of Lawrence Hargrave*, Technological Museum, Sydney, 1939.

Schofield, Anne and Fahy, Kevin, *Australian jewellery: 19th and early 20th century*, David Ell Press, Sydney, 1990.

Shaw, W Hudson and Ruhen, Olaf, *Lawrence Hargrave: explorer, inventor & aviation experimenter*, Cassell Australia, 1977.

Smith, Dick, *Solo around the world*, Australian Geographic, Sydney, 1992.

Snow, C P, *The two cultures and a second look*, Cambridge University Press, 1959/1964/1986.

Sparke, Penny, *Design in context*, Bloomsbury, London, 1987.

Sumner, Christina, ed., *A material world: fibre, colour & pattern*, Powerhouse Publishing, Sydney, 1991.

Timms, Peter, *Australian studio pottery & china painting*, Oxford University Press, Melbourne, 1986.

Vincent, David, *The Catalina chronicle*, The Catalina National Committee, Adelaide, 1981.

Willis, J L, *From Palace to Powerhouse: the first one hundred years of the Sydney Museum of Applied Arts and Sciences*, unpublished manuscript, Powerhouse Museum Archive, Sydney, 1982.

Wilson, Sir David M, *The collections of the British Museum*, British Museum Publications, London, 1989.

Wilson, Sir David M, *The British Museum: purpose and politics*, British Museum Publications, London, 1989.

Wittlin, Alma Stephanie, *The museum: its history and its tasks in education*, Routledge & Kegan Paul Limited, London, 1949.

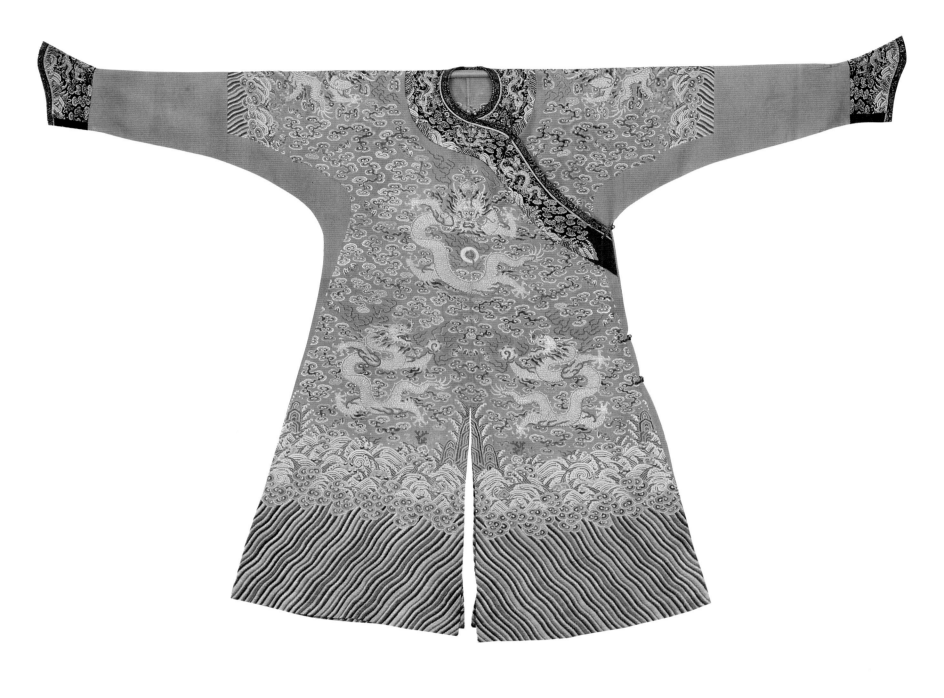

124. *A semi-formal Chinese court robe or jifu from the late 1800s made of gauze-weave silk. The more rigid the gauze, the more even the counted thread work will be. Purchased with funds donated by Ken and Yasuko Myer, 1989.*
Photograph: Powerhouse Museum

List of objects

125. *Woomera, carved and painted, watercolour on mulgawood by Albert Namatjira, (1902–1959), Australia, about 1950; width 13.5 x 75 cm. Purchased 1991.* Photograph by Jane Stafford

Index

 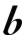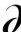

Photography: Most of the photographs in this book were taken by photographers from the Powerhouse Museum photography department: Penelope Clay, John Day, Geoff Friend, Andrew Frolows, Peter Garrett, Lisa Sharkey, Sue Stafford and Jane Townsend.